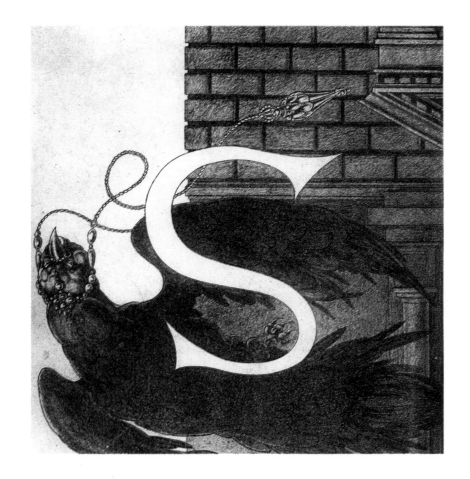

BEARDSLEY

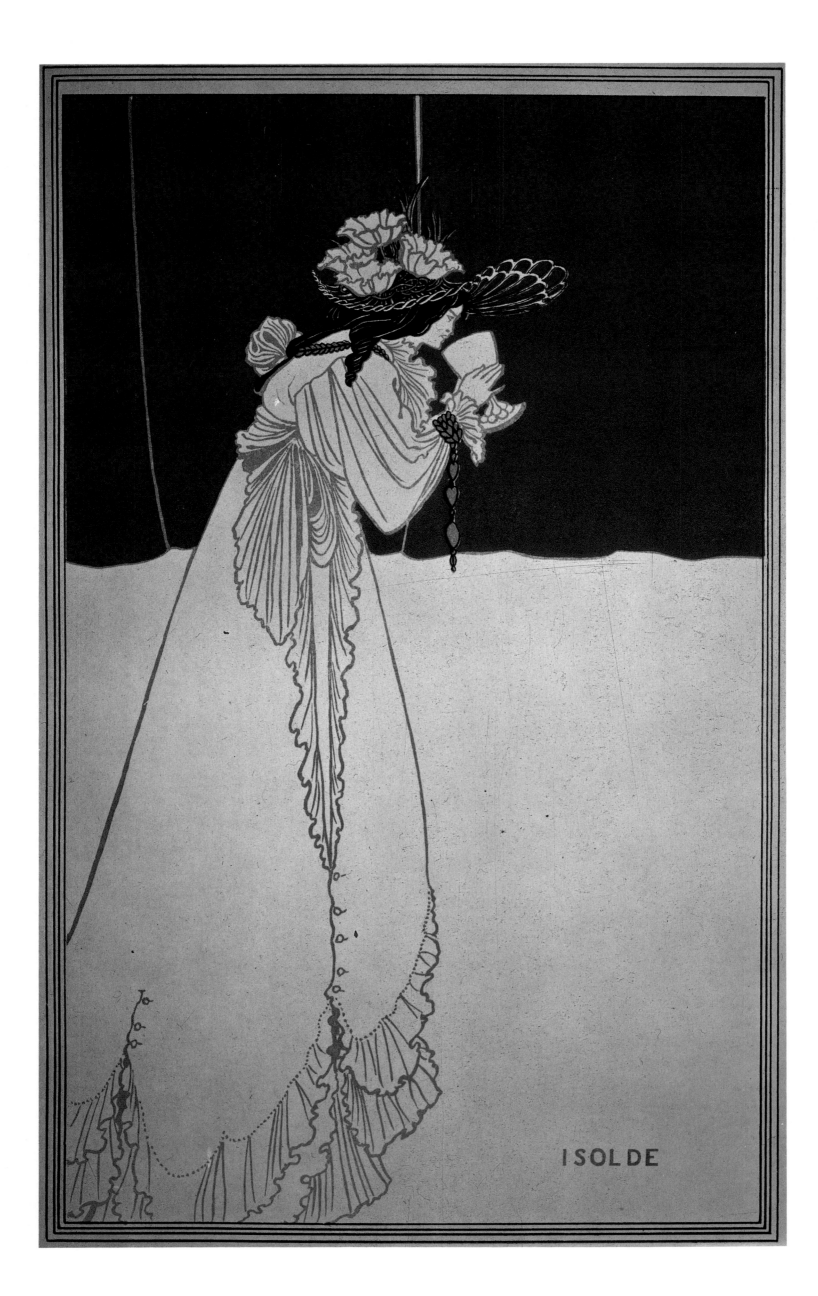

BEARDSLEY

AILEEN REID

SMITHMARK

This edition published in 1994
by SMITHMARK Publishers Inc.
16 East 32nd Street
New York, New York 10016.

SMITHMARK books are available for bulk purchase for sales promotion
and premium use. For details write or telephone the Manager of Special
Sales, SMITHMARK Publishers Inc., 16 East 32nd Street, New York, NY
10016, (212) 532 6600.

Produced by Brompton Books Corp.,
15 Sherwood Place,
Greenwich, CT 06830

ISBN 0-8317-6114-8

Printed in China

10 9 8 7 6 5 4 3 2 1

For Bessie with love

Page 1: *Volpone Adoring his Treasures,*
1898

Page 2: *Isolde,* 1895

Contents and List of Plates

Introduction

The art of Aubrey Beardsley has enjoyed long periods of neglect and short bursts of great popularity. Before the end of his short life his distinctive style of drawing was widely recognized so that one contemporary dubbed the 1890s the 'Beardsley period.' The reasons for both the popularity and the neglect are connected with the extent to which his work was publicly available. Beardsley produced drawings almost exclusively for mechanical reproduction; one result of this method of working was widespread recognition, another that his drawings lacked the respectability of 'high art' which attached to easel paintings or prints where the artist is involved in their production. On the other hand, Beardsley's original drawings, although they are rarely on permanent display, are held in public collections in the manner of 'high art.' There is, therefore, now something of a division between the 'high art' of Beardsley's original drawings and the mechanical reproductions of them. This seems like a truism, except that unlike oil paintings which may also be reproduced mechanically, Beardsley's drawings were produced with the sole purpose of being reproduced mechanically. It can be argued that it does not matter that Beardsley's original drawings are little-known, as the popular, reproduced Beardsley is the 'real' Beardsley.

The difficulties which arise in assessing Beardsley's art do not stem from this distinction between the 'high art' of his original drawings and the popular art of the reproductions. On occasions when Beardsley's work has been presented in a 'high-art' manner, as in the 1966 exhibition at the Victoria and Albert Museum in London, the original process of popularization has been quickly replicated in the production of cards, posters etc. This exhibition spawned one of Beardsley's brief bursts of enormous popularity. For us in the 1990s Beardsley's art is almost inextricably associated with the cultural values of the period of its most recent popularity, the late 1960s and early 1970s, and not with those of the 1890s. In general this association is perhaps not so misleading, as the periods have certain general characteristics in common- social upheaval, non-conformism, 'decadence' – but the loss of the specific contexts of the drawings means that important aspects of their meaning can be missed or misinterpreted.

Aubrey Vincent Beardsley was born in Brighton on 21 August 1872. His parents, Vincent Paul Beardsley (1839-1909) and Ellen Agnus Pitt (1846-1932), were somewhat mismatched and already, apparently, on a downward social spiral by the time that Aubrey was born. Their mismatch was partly social; after they had met on the pier in Brighton, they were obliged to conduct their courtship clandestinely, in the gardens of the Royal Pavilion. The Pitts claimed distant kinship with the Prime Ministers of that name, and Ellen Pitt's father, Surgeon-Major William Pitt (1816-87), was a doctor with the East India Company in Bengal. Her curious middle name is a pun on her mother's family name of Lambe. Vincent Beardsley, although he styled himself a 'gentleman,' had no occupation at the time of his marriage and was the son of a London jeweler. He did, however, have some capital and a small private income from a bequest. Ellen's parents seem to have resigned themselves to their daughter's choice of husband, and the wedding took place from their house in Brighton on 12 October 1870. The marriage got off to a less than propitious start when Vincent Beardsley was threatened, while he was still on honeymoon, with an action for breach of promise by a clergyman's widow.

This and other unspecified acts of profligacy seem to have dissipated most of Vincent Beardsley's money, and although he had various jobs it seems that Ellen provided most of the income to support Aubrey and his sister Mabel, who was a year older. Ellen worked as a governess and music-teacher, and an aptitude for music manifested itself in Aubrey before any artistic interest was shown. His mother claimed that every evening she would play her family a concert of six piano pieces, and that even as a baby Aubrey could beat perfect time as she played. She also encouraged her children to read, and it was said that Beardsley 'seemed to be perfectly conversant with the English language from the first moment of handling a book.' He also seems to have had a highly developed sense of the importance of his own destiny from an early age. His mother related the story of how she had taken him to a service in Westminster Abbey. Afterwards he asked her, 'Mummy, shall I have a bust or a stained-glass window when I am dead? For I may be a great man some day.' On being asked which he would prefer, he opined: 'A bust, I think, because I am rather good-looking.'

Perhaps it was the early manifestation of the symptoms of tuberculosis which led to this way of thinking in a child. Beardsley was only seven years old when his condition was first diagnosed; by this time he had already been sent away to school at Hamilton Lodge, near Brighton, presumably because it was considered to be healthier than London, where his parents had moved shortly after he was born. It was in his second year at Hamilton Lodge that he made his first known drawings, of cathedrals and a carnival among other things. After two years at

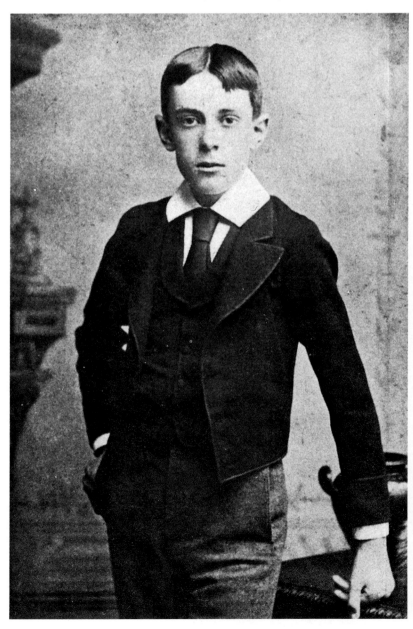

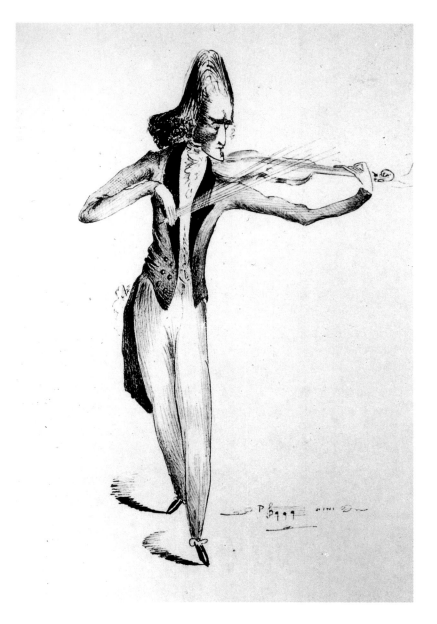

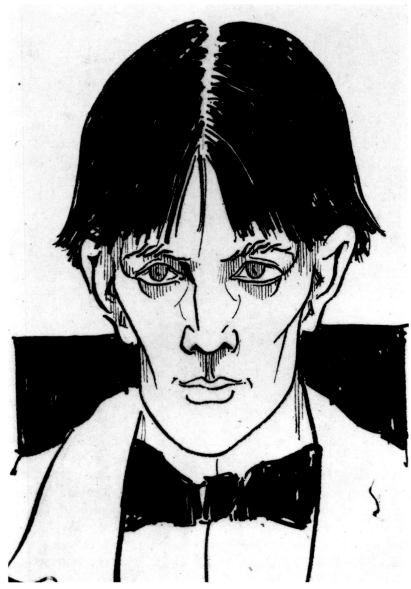

Hamilton Lodge Beardsley spent a further two years in Epsom (with or without his parents is uncertain), perhaps because as a spa it was believed to be good for his health. When he was about eleven years old he received his first artistic commission, from Lady Henrietta Pelham (1813-1905), who had befriended his family. She paid him £30 to decorate menus and guest cards for a wedding in Scotland, and he had already copied some drawings for her by the children's author and illustrator Kate Greenaway (1846-1901). A letter from Beardsley to Lady Henrietta survives in which he says: 'I often do little drawings from my own imagination but in doing figures the limbs are apt to be stiff and out of proportion and I can only get them right by copying.' From surviving examples the drawings do not seem especially precocious, and their awkwardness is difficult to understand in the light of the fluency of his later drawing style.

After a brief return to London, during which Aubrey and Mabel gave musical 'entertainments.' Beardsley returned to Brighton to stay with a great aunt, Sarah Pitt (1815-91), and to attend the Brighton Grammar School. It was there that he first developed his already-existing musical and artistic interests and discovered a dramatic talent. He was remembered, perhaps not surprisingly given the state of his health, as excessively thin, and was nicknamed 'Weasel.' His mother's early insistence on quantity and quality of reading seem to have had a lasting effect on Aubrey. One classmate later described how his 'head was always in a book when he had a moment to spare,' while another recalled that he had:

The oldest eyes I have ever seen, older than the world . . . once he took up a book you could see the intelligence retreat and retreat from those eyes, until the mind deserted them to adventure in space and eternity. I often noticed him lose his identity in this way in the classroom. It was a disconcerting habit; but the masters understood him after a while and would wait for his return.

Far left: This formal photographic portrait shows Aubrey Beardsley aged about 13 years, around the time that he drew some caricatures of E J Marshall, his headmaster at Brighton Grammar School (page 28).

Above left: Beardsley made this drawing, *Paganini*, around 1888.

Above: Shortly after he drew this self-portrait Beardsley described himself: 'I am now eighteen years old, with a vile constitution, a sallow face and sunken eyes, long red hair, a shuffling gait and a stoop.'

Chief among the understanding masters was A W King, teacher of mathematics and housemaster, who encouraged Beardsley in reading as diverse as Samuel Butler's *Erewhon*, Carlyle's *The French Revolution*, the poems of Thomas Chatterton and the stories and poetry of Edgar Allan Poe. He also encouraged Beardsley to make more constructive use of his graphic skills than the caricatures of the headmaster, E J Marshall, which delighted his class-mates (page 28).

In spite of his wide reading, Beardsley was not a dedicated student and shortly before his sixteenth birthday, in July 1888, he left school and went to work as a clerk in an insurance office in London. Not surprisingly he loathed the work, and illustrated his state in a drawing entitled *Le Dèbris* (sic) *d'un Poète*. He was living with his family in Cambridge Street, Pimlico, and he and Mabel exercised their musical and dramatic talents by putting on performances at home under the title of the 'Cambridge Theatre of Varieties.' As well as acting and singing and writing pieces to perform, Beardsley designed and illustrated programs. These are still in the sketchy style he had used for drawings at school, which gives little indication of the fluidity of line displayed in his mature drawings. In 1889, however, he suffered the first acute attack of the tuberculosis diagnosed when he was seven. Although his doctor reassured him that his lungs were not diseased, merely weak, Beardsley spent the winter of 1889 coughing into a basin. His confinement to bed did provide him

7

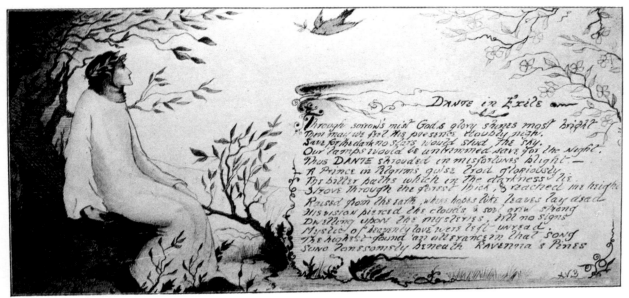

Above: *Dante in Exile*, c. 1890, is clearly influenced by the work of William Blake, but also has some Beardsley flourishes.

Right: *Hamlet Patris Manem Sequitur*, 1891, was Beardsley's first published drawing, and strongly reflects the influence of Burne-Jones.

Far right: William Morris's *La Belle Iseult*, 1858, shows the wealth of medieval detail that Beardsley banished from his art at an early stage.

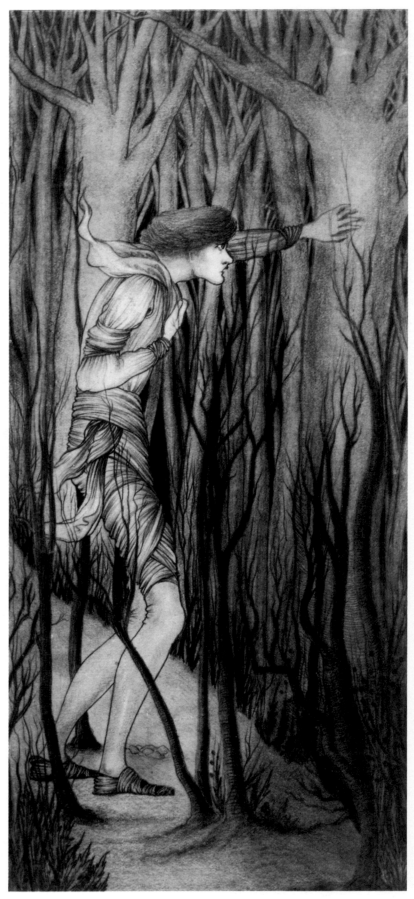

with an opportunity to improve his French, which he claimed in a letter of January 1890 to read as well as English, and to earn some money as a professional writer. He was paid £1-10s by the general-interest magazine *Tit Bits* for an essay entitled 'A Confession Album,' which tells the sad but humorous story of a young man's fiancée jilting him after reading a make-believe 'confession' of infidelity by him.

By 1891 Beardsley's health had stopped deteriorating and death no longer seemed imminent. The year was an influential one for his development as an artist, as it brought him directly or indirectly into contact with two of the most eminent artists of the day, J A M Whistler (1834-1903) and Sir Edward Burne-Jones (1833-98). Before he moved to London, Beardsley had visited the artist G F Watts (1827-1904), whose most famous work is *The Light of the World*, and Watts had offered him encouragement in his ambition to be an artist. Of greater significance was his visit in July 1891 to the home of Edward Burne-Jones. It had been the custom for Burne-Jones to admit visitors to his studio but by the time Mabel and Aubrey appeared in 1891 the practice had been discontinued. However, as Beardsley related in a letter to his old house-master A W King:

I had hardly turned the corner when I heard a quick step behind me, and a voice which said, 'Pray come back, I couldn't think of letting you go away without seeing the pictures, after a journey on a hot day like this,' the voice was that of Burne-Jones, who escorted us back to his house and took us into the studio, showing and explaining us everything. His kindness was wonderful as we were perfect strangers, he not even knowing our names.

By the merest chance I happened to have some of my best drawings with me, and I asked him to look at them and give me his opinion.

I can tell you it was an exciting moment when he first opened my portfolio and looked at the first drawing, *Saint Veronica on the Evening of Good Friday, Dante at the Court of Can Grande della Scala.*

After he had examined them for a few minutes he exclaimed, 'There is *no* doubt about your gift, one day you will most assuredly paint very great and beautiful pictures.'

Then as he continued looking through the rest of them (*Notre Dame de la Lune, Dante Designing an Angel, Insomnia, Post Mortem, Ladye Hero* etc etc), he said, 'All are *full* of thought, poetry, and imagination. Nature has given you every gift which is necessary to become a great artist, I *seldom* or *never* advise anyone to take up art as a profession, but in *your* case, *I can do nothing else.'*

And all this from the greatest living artist in Europe. Afterwards we

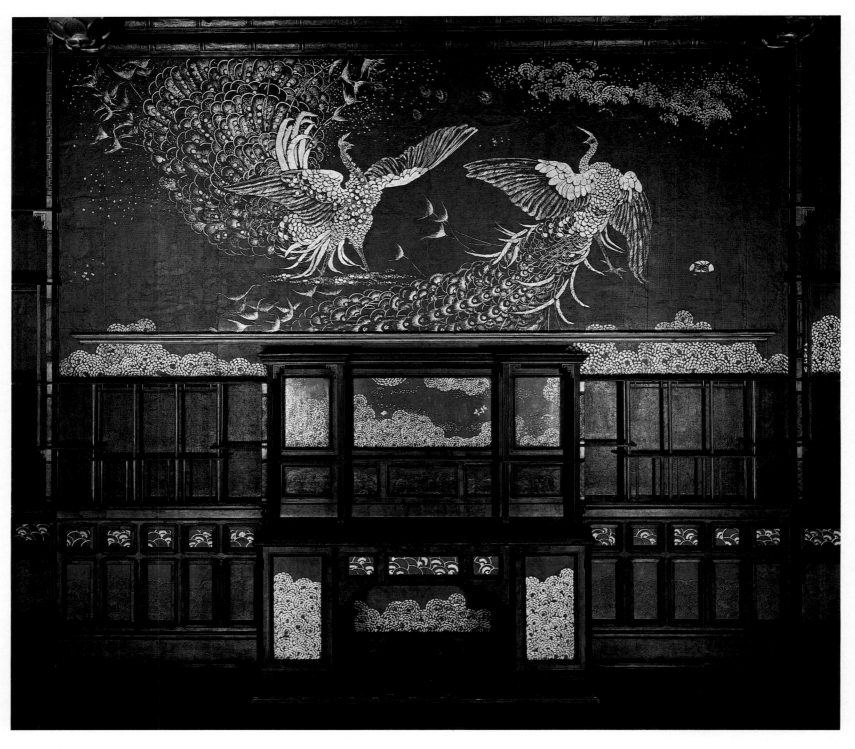

returned to the lawn and had afternoon tea. Mrs Burne-Jones is very charming. The Oscar Wildes and several others were there. All congratulated me on my success, as 'Mr Burne-Jones is a very severe critic.'

During tea B J spoke to me about art training. 'I will,' he said 'immediately find out the very best school for you, where two hours daily study would be quite sufficient for *you*. Study hard, you have plenty of time before you. I myself did not begin to study till I was 23.

'You must come and see me often and bring your drawings with you. Design as much as you can; your early sketches will be of immense service to you later on. Every one of the drawings you have shown me would make beautiful paintings.'

After some more praise and criticism I left feeling, in the words of Rossetti, 'A different crit'ter.' We came home with the Oscar Wildes – charming people.

The influence which contact with Burne-Jones had on Beardsley can clearly be seen from drawings he made in 1891. *Hamlet Patris Manem Sequitur* (page 8) began life as a pencil drawing and was to be Beardsley's first published drawing when it appeared in November 1891 in *The Bee*, the journal of the Blackburn Technical Institute of which A W King was now Secretary. Like another drawing, probably of 1892, *Die Götterdämmerung* (page 30), the Hamlet drawing has the exaggerated features and medievalizing drapery of Burne-Jones and the Pre-Raphaelites; both also make use of shading in a way that Beardsley was soon to abandon. Other influences can be detected mingled with that

of Burne-Jones, no doubt because of Beardsley's many visits to the British Museum and the National Gallery. When he went to see the Royal Collection at Hampton Court, he was profoundly impressed by the Mantegna engravings he saw – 'an art training in themselves' – and he used the figure of St John in *The Entombment* as the basis for the figure of Mary Magdalen in *The Litany of Mary Magdalen*, a drawing of 1891.

In the same month that Beardsley first met Burne-Jones, July 1891, he went to look at the 'Peacock Room' (page 10), 49 Prince's Gate, which J A M Whistler had decorated for the shipowner F R Leyland in 1876-77. The panelling in this room is influenced by Japanese woodwork, and Whistler's decoration includes the peacock, the archetypal symbol of the Aesthetic Movement, as well as decorative motifs he had seen in Japanese prints and textiles. Beardsley expresses his enthusiasm for the Peacock Room in a letter of July 1891 to his schoolfriend G F Scotson-Clark, which he filled with watercolor and pen drawings (page 11) illustrating Whistler's painting *La Princesse de la Pays de la Porcelaine* (page 12), which hung in the Peacock Room, as well as various peacocks. Whistler had collected Japanese prints from the late 1850s and had been one of a handful of connoisseurs who had popularized them in Britain by the late 1870s. In the 1880s Japanese prints and other oriental impedimenta such as fans and blue-and-white porcelain were *de rigeur* for anyone with pretensions to taste, and by 1891 Japanese prints were widely available and Beardsley would have had ample oppor-

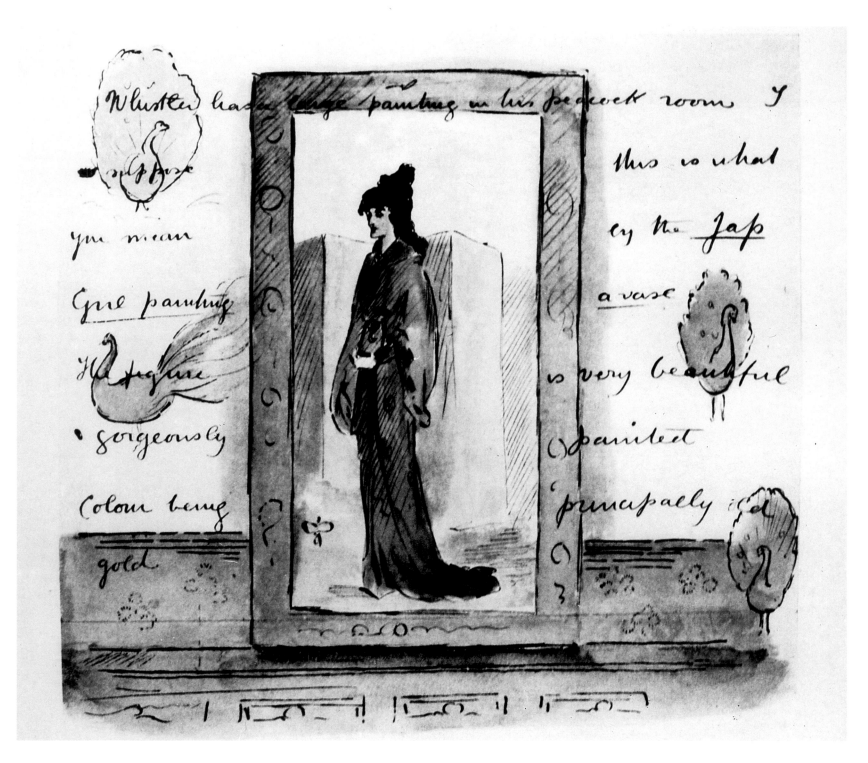

The handwritten annotations on the drawing read:

Whistler has a large painting in his peacock room I / this is what / you mean / ey the *Jap* / Gye painting / a vase / HA figure / is very beautiful / gorgeously / painted / Colour being / principally / gold

tunity for studying Japanese art.

Perhaps the single most important lesson which Beardsley derived form Japanese prints, no doubt finding in them an expression of his own natural artistic inclinations, was the power of line. When Beardsley met Burne-Jones, the grand old man had assumed that Beardsley's drawings were merely studies for paintings and that it was as a painter that Beardsley was destined to make his mark. Certainly Burne-Jones had recommended Fred Brown at the Westminster School of Art to Beardsley as a teacher. Brown was a painter, a founder of the avant-garde New English Art Club, and for a while Beardsley studied conscientiously with him for his statutory two hours in the evening, while he worked by day in the insurance office. However, in December 1891 he wrote to A W King:

I am anxious to say something somewhere on the subject of *lines* and line drawing. How little the importance of outline is understood by some of the best *painters*. It is this feeling for harmony in *line* that sets the old masters at such an advantage to the moderns, who seem to think that harmony in *color* is the only thing worth attaining. Could you reproduce a drawing purely in line?

Soon after this speculation, Beardsley met the antiquary and art critic Aymer Vallance (1862-1943), who immediately recognized the graphic power of Beardsley's work. Vallance was well connected and was certain that Beardsley's work would appeal to William Morris, leading light of the Arts and Crafts Movement,

Above left: James McNeill Whistler painted the 'Peacock Room' in 1878 for the shipping magnate F R Leyland. When Leyland paid him in pounds not guineas Whistler painted the missing shillings between the peacocks' claws.

Above: Beardsley visited the 'Peacock Room' in Prince's Gate, London, in July 1891. He wrote of his favorable impressions of its sumptuousness, and drew *La Princesse du Pays de la Porcelaine* (page 12), which hung there.

who was looking for a frontispiece for a Kelmscott Press edition of *Sidonia the Sorceress*. Morris was not, however, impressed by Beardsley's work; officially he resented the borrowings from Burne-Jones. More plausibly he might not have liked the obvious departures from anything medieval which Beardsley was already introducing, partly under the influence of his Japanese studies. Some time early in the summer of 1892 Beardsley began working in 'an entirely new method of drawing and composition, something suggestive of Japan, but not really Japonisque . . . The subjects were quite mad and a little indecent. Strange hermaphroditic creatures wandering about in Pierrot costumes or modern dress; quite a new world of my own creation.' In another letter he described the twenty or so drawings he produced in a couple of months as 'fantastic in conception but perfectly severe in execution.' In June 1892 Beardsley went to Paris with an introduction from Burne-Jones to Pierre Puvis de Chavannes, President of the Ecole des Beaux-Arts. Beardsley reported with pride that Puvis de Chavannes had introduced him to another artist as 'un jeune artiste anglais qui fait des choses

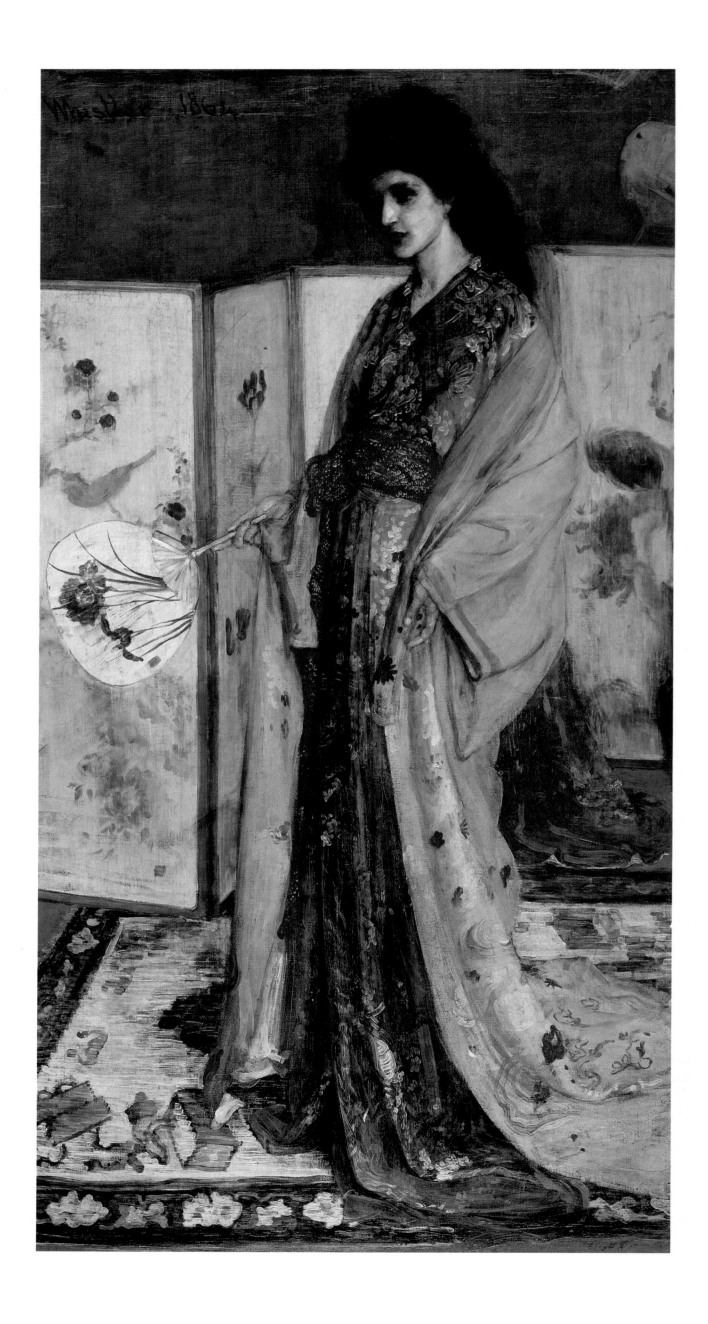

étonnantes,' which perhaps made up for the coolness of Morris's appraisal.

By this time Beardsley had sold a few of his drawings, some to a clergyman in Brighton. His real breakthrough, however, came in the fall of 1892. Ever since his move to London, Beardsley had been in the habit of frequenting antiquarian bookshops. One of these belonged to Frederick Evans, who was also an enthusiastic amateur photographer and came to know Beardsley from his frequent lunchtime visits to his shop in Queen Street, Cheapside. They discovered a shared taste for Wagner and occasionally attended performances together. Evans also discovered Beardsley's artistic activities and bought or exchanged for books several of his drawings. One of Evans's other customers was the publisher J M Dent, who discussed with Evans his plans to produce an illustrated version of Sir Thomas Malory's *Morte Darthur*. What he had in mind was something similar to the books produced by Morris's Kelmscott Press but at a lower price. The Kelmscott Press books, true to Morris's Arts-and-Crafts principles, were hand-printed from hand-carved blocks; Dent proposed to emulate the medievalizing style of the Kelmscott illustrations, but to produce them by a modern line-block method of reproduction. He was looking for an illustrator for this project, and just as he wanted to avoid the expense of Morris's printing methods, neither did he want to pay a Morris-sized fee for the illustrations. It took little time for Evans to secure the commission for Beardsley. He showed Dent some of Beardsley's work which he had in the shop and introduced the two men. As a further demonstration of his skill Beardsley produced *The Achieving of the Sangreal* for Dent.

Dent was entranced by Beardsley's work and commissioned him to produce what ultimately were to be 20 full- and double-page illustrations and nearly 550 borders, ornaments, chapter headings, initials, and tailpieces for a fee of around £250. It was a huge undertaking for an artist as inexperienced as Beardsley but it provided him with the opportunity of leaving the insurance office, 'to the great satisfaction of said office and myself. If there ever was a case of the [square] boy in the [round] hole, it was mine.' The *Morte Darthur* illustrations display a considerable diversity of style. The drawings for *The Achieving of the Sangreal. How Sir Arthur Saw the Questing Beast* (page 29), and one that Beardsley did at the same time for Burne-Jones, *Siegfried* (page 41), form a distinct group. All are highly decorated and have profuse, hair-line ornament in areas which would otherwise have been left blank. They reflect his intense study of the engraving style of such Old Masters as Mantegna and Dürer, coupled with features of Japanese decorations such as can be seen in the dragon's scales in the *Questing Beast* drawing. The varying extent to which medievalizing and Japanese influences are evident in the drawings, together with the fact that they were produced over a considerable period of time, account for the diversity of the illustrations and embellishments of the *Morte Darthur*. This is a particularly evident in the border decorations. Some follow reasonably closely the orthodox Kelmscott Press medieval style, with complex intertwining floral ornament, while others are made up of a mixture of Japanese-inspired ornament with elements whose only divinable source is Beardsley's imagination.

At the same time as he commissioned Beardsley to illustrate the *Morte Darthur*, Dent asked him to draw tiny illustrations for a series of volumes of the collected witticisms, *Bon Mots*, of Oliver Goldsmith, Charles Lamb, Richard Brinsley Sheridan, Sydney Smith and others. These vignettes, 'some not more than

Left: Beardsley described Whistler's *La Princesse du Pays de la Porcelaine*, 1864, as 'very beautiful and gorgeously painted.'

Right: Beardsley, like many artists of his generation, was much influenced by Japanese woodblock prints. In the fall of 1892 he described how he had developed a new style: 'I struck out a new style and method of work which was founded on Japanese art but quite original . . . [the drawings] were extremely fantastic in conception but perfectly severe in execution.'

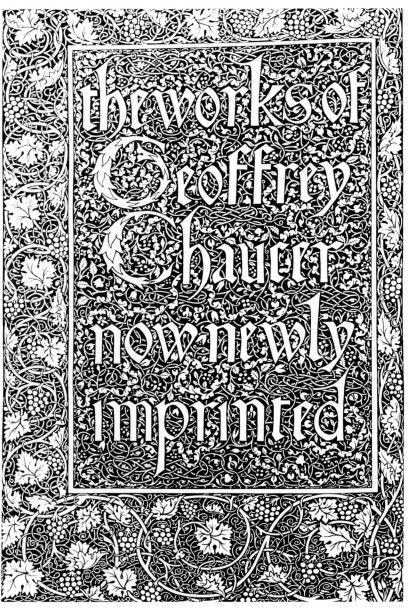

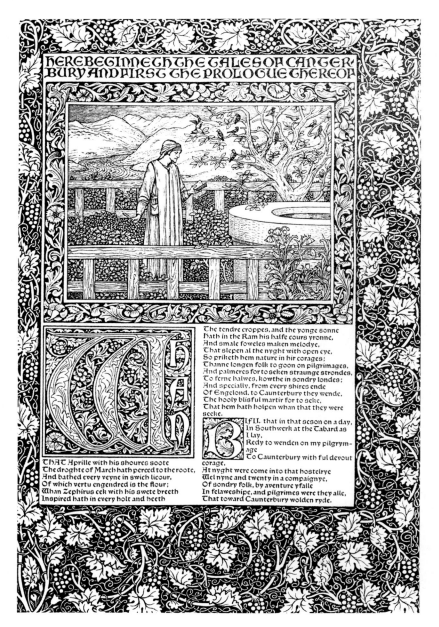

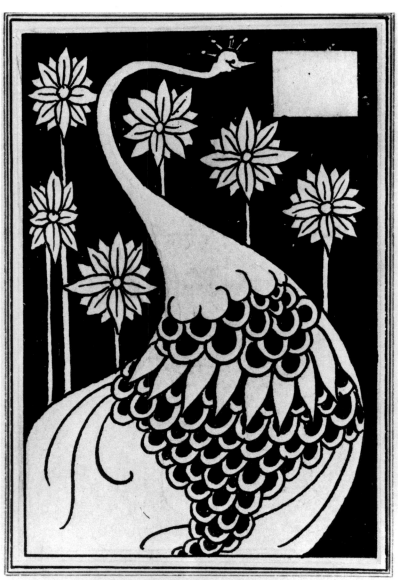

Above: William Morris's Kelmscott Press published this fine edition of *The Works of Geoffrey Chaucer*. Beardsley's mentor Burne-Jones designed the illustrations and Morris himself designed the borders. In producing an edition of Malory's *Morte Darthur* with illustrations by Beardsley, J M Dent hoped to emulate the appearance (and the popularity) of Kelmscott Press books without the expense of their well-known illustrators and craft-based production.

Left: As well as full-page illustrations (pages 29, 32-38) Beardsley designed hundreds of smaller chapter-openers for the *Morte Darthur*. Some reveal the influence of J M Whistler's Japanese-inspired work, and of the Aesthetic Movement generally. They frequently have no direct relevance to the text.

an inch high, and the strokes to be counted on the fingers,' imposed none of the constraints on Beardsley that the *Morte Darthur* illustrations did, and he gave free reign to his taste for the grotesque. Some are exercises in seventeenth-century-style penmanship; others recall, with a sinister twist, his Kate Greenaway days; some are mutant creatures with heads sprouting from their stomachs. What they all have in common is the economy of line referred to by Beardsley.

Meanwhile Aymer Vallance, not deterred by William Morris's rebuff, was still promoting Beardsley as the new boy-wonder of art. He showed some of his drawings to C Lewis Hind, at that time an editor of the *Art Journal*. Hind was then seeking to establish a new art magazine and had produced a dummy issue of it to attract financial backing. The backer he found, Charles Holme, told him: 'What we need, Hind, is a sensational send-off article for the first number.' Both agreed that Beardsley was that sensation. Hind's description of Beardsley at their first meeting gives us a vivid picture of the artist at the age of 20:

I saw a tall youth of blonde complexion with a prominent nose . . . projecting from his thin, hatchet face; hair lightish cut in a fringe and falling

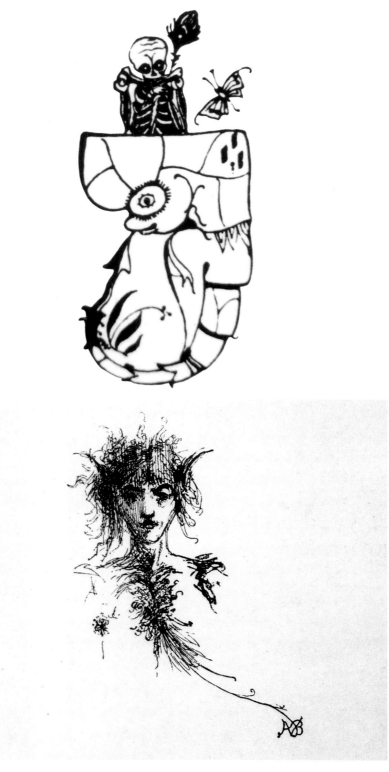

Above: In some of the chapter-openers to the *Morte Darthur* Beardsley treats familiar Pre-Raphaelite subjects to his sinuous, flowing line.

Above right: This swollen-headed fetus, one of the tiny illustrations to the *Bon Mots of Smith and Sheridan*, was a recurring motif in Beardsley's art. The skeleton and the butterfly (Whistler's signature-motif) reflect two further preoccupations.

Right: In his earliest drawings Beardsley employed a frenetic, broken line quite different from his later smooth and sinuous style.

Below right: This caricature of Queen Victoria as a Degas ballet dancer (Beardsley's suggestion for a design for the new coinage) was considered much too scandalous to publish by the editor of the *Pall Mall Budget.*

evenly over his forehead. I have never seen such strong capable hands with fingers full of latent power.

It was agreed that the article on Beardsley should be written by the American art critic Joseph Pennell and the first issue of *The Studio*, as the magazine was to be called, was scheduled for February 1893. However, by February Lewis Hind had become editor of a journal called the *Pall Mall Budget* and it was there that Beardsley made his professional debut as an artist. He produced several lightweight caricatures of contemporary 'personalities' such as the actors Henry Irving and Ellen Terry, French novelist Emile Zola and Pope Leo XII. One drawing, a design for the new coinage that was then planned, was considered too risky to publish – it depicted Queen Victoria in the guise of a Degas ballet dancer (right).

In a letter of February 1893 to his old friend Scotson-Clark, Beardsley describes the variety of enterprises he is now involved in and his satisfaction with them all:

the work I have already done for Dent [the *Morte Darthur*] has simply made my name. Subscribers crowd from all parts. William Morris has

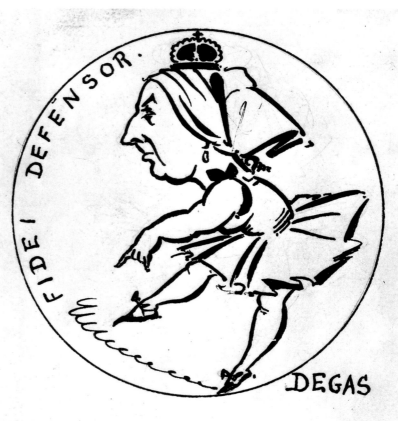

Right: Beardsley leaving Hampstead Church in July 1894 after the unveiling of a memorial to John Keats. W R Sickert has not spared Beardsley in his depiction of him as thin and stooped, walking through the graveyard. Beardsley was fascinated by Keats who had died of tuberculosis at the age of 25, as Beardsley himself was to do in 1898.

Far right: The *cul-de-lampe,* or endpiece illustration, to Wilde's *Salome* shows the burial of Salome.

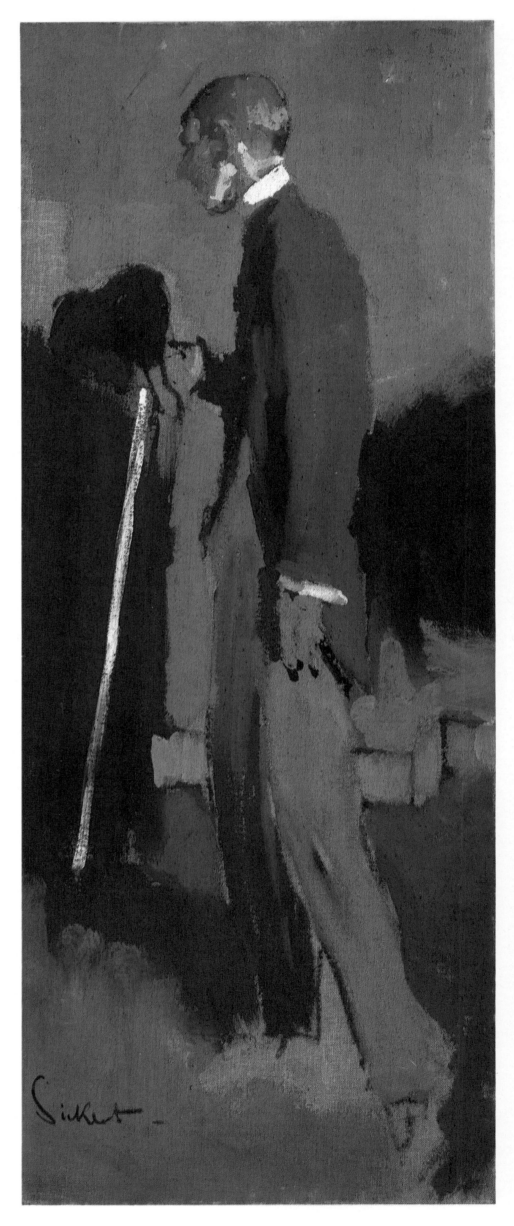

sworn a terrible oath against me for daring to bring out a book in his manner. The truth is that while his work is a mere imitation, mine is fresh and original. Anyhow, all the good critics are on my side, but I expect there will be more rows when the book appears.

Better than the *Morte Darthur* is the book that Lawrence and Bullen have given me, the *Vera Historia* (page 44) of Lucian. I am illustrating this entirely in my new manner, or, rather, a development of it. The drawings are certainly the most extraordinary things that have ever appeared in a book both in respect to technique and conception. They are also the most indecent. I have thirty little drawings to do for it 6 inches by 4. L and B give me £100 for the work. Dent is giving me £250 for the *Morte*.

Joseph Pennell has just written a grand article on me in the forthcoming number of *The Studio*, the new art magazine which has by the way a grand cover by me. I should blush to quote the article! but will so far overcome my modesty to send you a copy on publication. It will be profusely illustrated with my work. My weekly work in the *Pall Mall Budget* has created some astonishment as nobody gave me credit for caricature and wash-work, but I have blossomed out into both styles and already far distanced the old men at that sort of thing. Of course the wash drawings are most impressionist, and the caricatures in wiry out-

line. This last week I did the new Lyceum performance, *Becket*.

My portrait of Irving made the old black-and-white duffers sit up; and my portrait of Verdi, this week, will make them sit up even more. I get about £10 a week from the *Pall Mall* and can get off all the work they require on Sunday. Clark, my dear boy, I have fortune at my feet. Daily I wax greater in facility of execution. I have seven distinct styles and have won success in all of them.

The article in *The Studio* served as advance publicity for the *Morte Darthur*, as several of the *Morte Darthur* designs were included, but it also proved a valuable medium for soliciting new commissions. One of the drawings in *The Studio* illustrated the climactic moment in Oscar Wilde's *Salome* when Salome kisses the severed head of John the Baptist. Wilde had written the play for Sarah Bernhardt and it had already been in rehearsal when the French censor had stepped in to prevent the representation on stage of Biblical characters. The play was published in French and later translated into English by Wilde's lover, Lord Alfred Douglas; it is a measure of Beardsley's interest in the play, and of his claim that he now read French as well as he did English, that it was the French version that he read and illustrated in his drawing *J'ai*

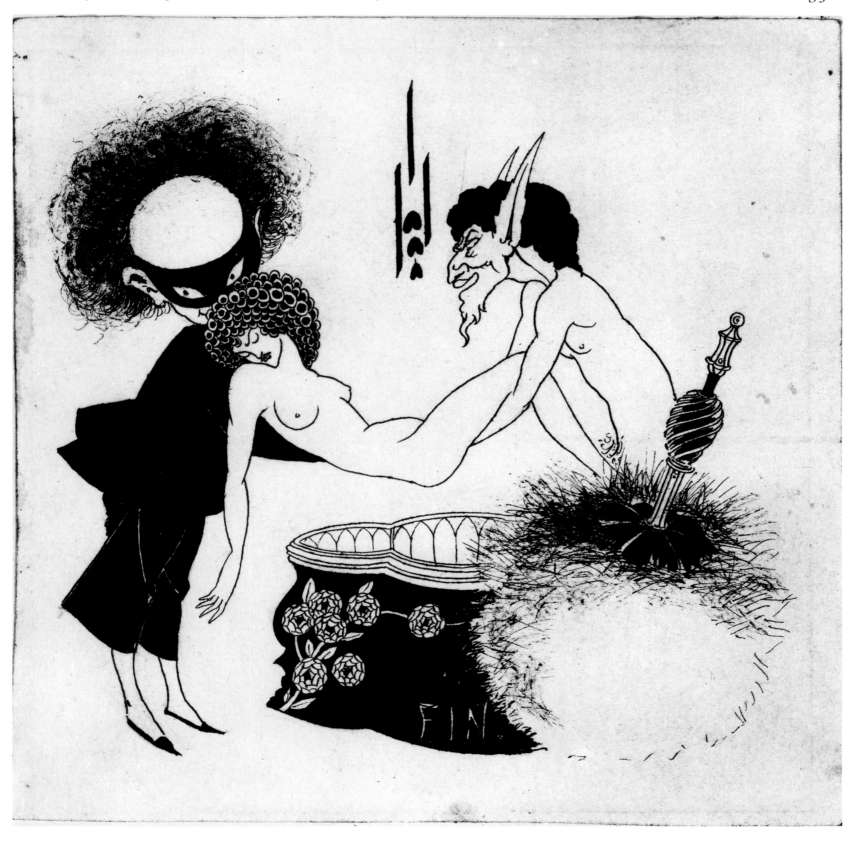

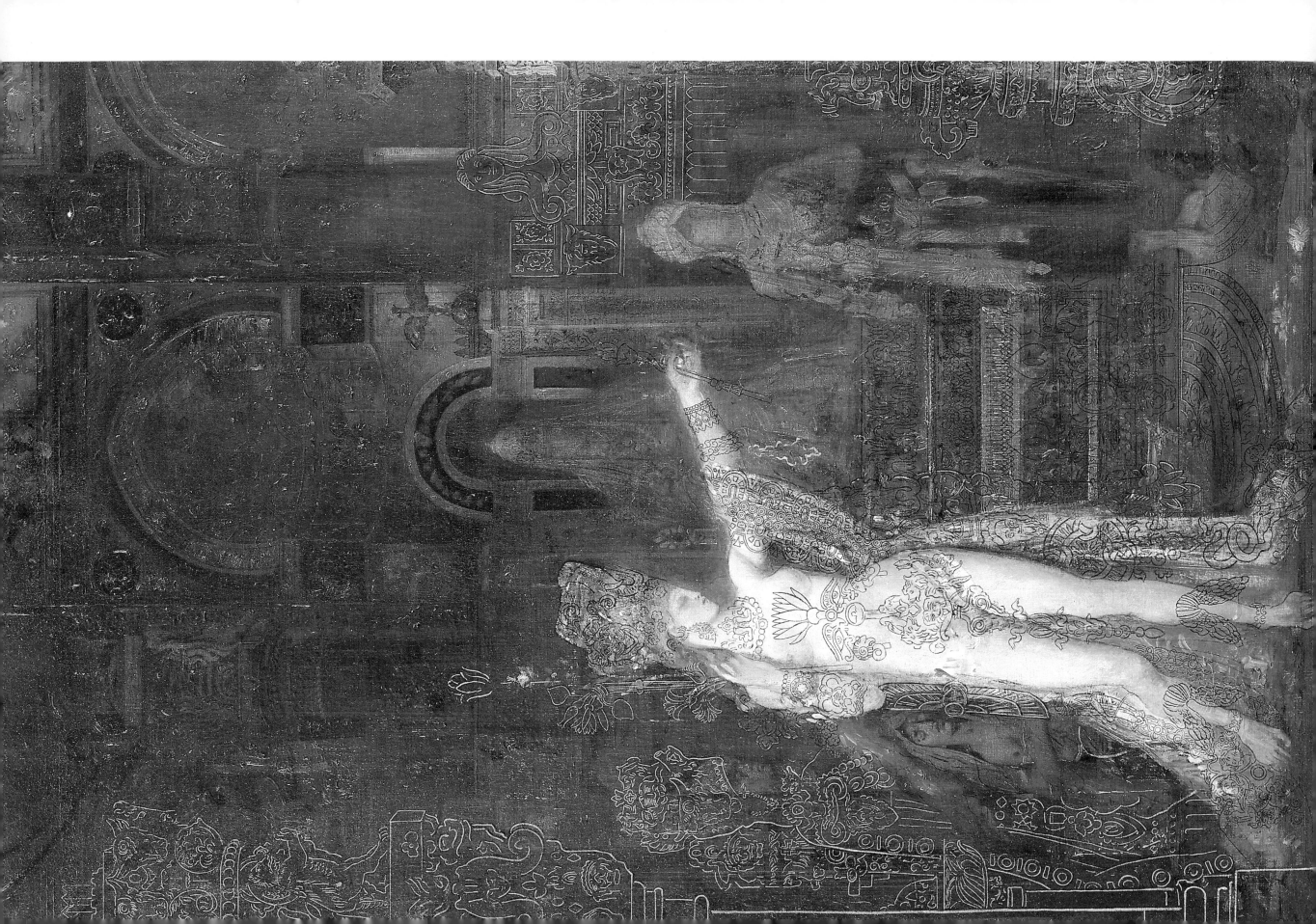

Baisé ta Bouche, Iokanaan. Wilde had already met Beardsley and he certainly saw the *Salome* drawing before its publication in April 1893, for in March of that year he presented Beardsley with a Paris edition of his play inscribed: 'For Aubrey: for the only artist who, besides myself, knows what the dance of the seven veils is, and can see that invisible dance. Oscar.' Although Beardsley would apparently have preferred the task of translating *Salome* he was quite happy to accept the commission from publisher John Lane of producing ten full-page illustrations and a cover design for the English edition.

As Beardsley produced each drawing and delivered it to John Lane, it was examined very closely. He was known to delight in concealing improper details for the unsuspecting viewer to happen upon among the decorative flourishes of his drawings, and *Salome* was no exception. When the drawing entitled *Enter Herodias* (page 57) was delivered, Lane and his partner Elkin Mathews insisted that Beardsley conceal with a fig-leaf the exposed genitalia of Herodias' male attendant. What they missed, apart from the obviously phallic candlesticks, was the contrast between the reaction – or rather significant lack of it – of the exposed attendant to Herodias' nudity and that of the fetus-headed attendant on her left, whose clothing is clearly under some strain. Even Beardsley's emblematic signature at this date is a sexually ambivalent symbol of penetration. Wilde claimed that he was not entirely satisfied with the *Salome* illustrations on the grounds that they were Japanese whereas his play was 'Byzantine.'

In a letter of April 1893 to A W King, Beardsley said: 'I'm off to Paris soon with Oscar Wilde.' He did go to Paris in May of that year, but with Joseph and Elizabeth Pennell not with Wilde. There he met Whistler, who does not seem to have been taken with Beardsley either personally or professionally. Beardsley is usually characterized rather vaguely as a 'decadent,' whose inspiration and tastes were personal and largely impenetrable; in fact, however, the extent to which in 1893 and 1894 he was influenced by, if only in a superficial way, the French Symbolist movement should not be underestimated. Beardsley's illustrations to *Salome* are usually criticized for failing to illustrate the text of the play. What this view fails to take into account is the inappropriateness of literal illustration to a play which is a highly symbolic and mannered interpretation of its Biblical sources. Wilde acknowledged the debt he owed to the work of Gustave Flaubert, in particular to the *Temptation of Saint Anthony*, first published in 1876, and to such French artists working in a Symbolist genre as Gustave Moreau (left) and Odilon Redon. Beardsley certainly knew of Moreau's work as he described it as 'ravishing' in a letter of 1896.

His debt to Redon, however, is one that has been little explored. It has been noted that among the *Bon Mots* grotesques are two spiders, one with human features, and one with just an open eye, on its back, which seems to be directly related to Redon's lithograph *L'Araignée*, which shows a spider with two wide-open eyes on its back. An even more direct quotation from Redon is a drawing which seems not to date from later than 1891 and shows a creature composed of a winged head, silhouetted against the sun or moon and holding a burning heart in its hand. This relates very closely to a Redon lithograph *Le Chimère* not only in design but in technique, which is quite different from Beardsley's usually clean-cut black and white. Close examination of Beardsley's drawings – for instance the *Third Tableau of 'Das Rheingold'* (page 94) which has a serpent-like creature strongly

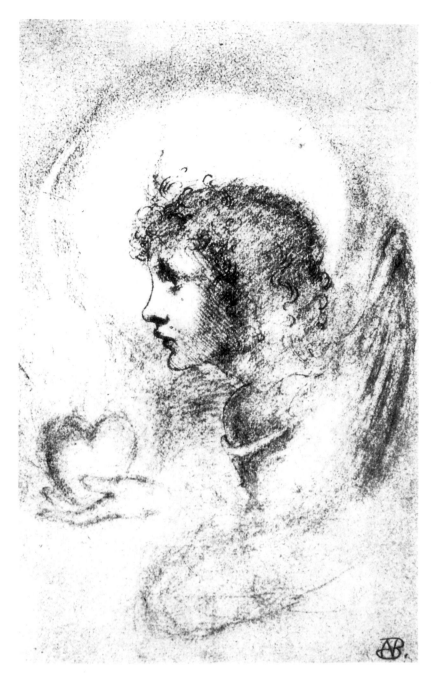

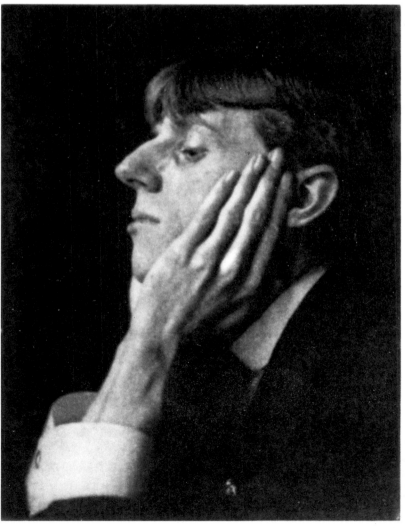

Left: Beardsley greatly admired the work of the French Symbolist painter Gustave Moreau, whose *Salome Dancing* (1874–76) was a landmark of Symbolist painting.

Above right: In this early drawing Beardsley seems already to be aware of the work of Odilon Redon whose work was then little known in Britain.

Right: Frederick H Evans, who introduced Beardsley to J M Dent, took this photograph of Beardsley.

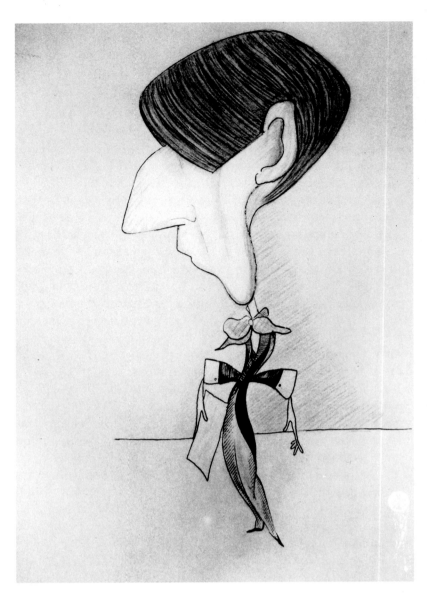

reminiscent of Redon's lithographic illustrations to Flaubert's *Temptation of Saint Anthony* – reveal many such resonances, although only the early drawing of the winged head at all emulates Redon's technique. This influence is significant because Redon's work was almost unknown in Britain at this time. One critic who did promote him, however, was Arthur Symons, who published an article in 1890 entitled 'Odilon Redon: A French Blake.' Symons was to become a close associate of Beardsley, and published a book on him in the year of Beardsley's death; he certainly knew Beardsley by 1895, and might have know him in 1893, when he organized a lecture by the French poet Paul Verlaine about which Beardsley knew. Beardsley could have seen Redon's work in Paris in 1892 or 1893, and certainly must have seen it in London in November 1893. In a letter of that month to Robert Ross he says: 'There is a very jolly exhibition of French work at the Grafton now. Affiches, lithographs, and all that sort of thing.' The catalogue of this exhibition reveals that among the prints exhibited were one or more by Redon, possibly the first time his work was exhibited in Britain.

Another aspect of contemporary French culture which influenced the *Salome* drawings is Joris Karl Huysmans' novel *A Rebours*, first published in 1884. In *The Picture of Dorian Gray* Wilde describes his hero's reaction to the novel: 'It seemed to him that in exquisite raiment, and to the delicate sounds of flutes, the sins of the world were passing in dumb show before him. Things he had dimly dreamed of were suddenly made real to him.' Beardsley certainly admired *A Rebours*, perhaps not least because he could identify with the hero, Duc Jean des Esseintes, 'a frail young man of thirty, anaemic and nervous, with hollow cheeks, eyes of a cold, steely blue, a small but still straight nose, and long, slender hands.' When Beardsley's improving fortunes allowed him to take the lease of a house in Cambridge Street, Pimlico (he had previously lived in the same street), he decorated several rooms rather startlingly in orange and black, in imitation of

some of des Esseintes' decorations. More specifically relevant to *Salome* is the description of a painting of Salome's dance in des Esseintes' gallery:

Her face wore a thoughtful, solemn, almost reverent expression as she began the wanton dance that was to rouse the dormant passions of the old Herod; her breasts quiver and, touched lightly by her swaying necklets, their rosy points stand pouting; on the moist skin of her body glitter clustered diamonds; from bracelets, belts, rings, dart sparks of fire; over her robe of triumph, bestrewn with pearls, broidered with silver, studded with gold, a corselet of chased goldsmith's work, each mesh of which is a precious stone, seems ablaze with coiling fiery serpents, crawling and creeping over the pink flesh like gleaming insects with dazzling wings of brilliant colors, scarlet with bands of yellow like the dawn, with patterned diapering like the blue of steel, with stripes of peacock green.

There seems little doubt from this where Beardsley drew his inspiration for *The Peacock Skirt* (page 49); inasmuch as Wilde was equally enthralled by *A Rebours*, it is only appropriate that Beardsley's conception of Salome should have been shaped by forces beyond Wilde's play.

In spite of Wilde's professed reservations about the *Salome* illustrations, Beardsley fitted well into Wilde's social circle, its air of high camp clearly in keeping with Beardsley's predilections. He was often to be found dining in the company of Wilde, Frank Harris, Max Beerbohm, William Rothenstein and Robert Ross in such venues as the Café Royal with its 'smoky acres of painted goddesses and cupids and tarnished gilding, its golden caryatids and its filtered, submarine illumination, composed of

tobacco smoke, of the flames from chafing dishes and the dim electric light within.' Beardsley swiftly donned the Wildean mantle of affectation, apologizing on one occasion for appearing so wan, explaining that he had caught a cold by inadvertantly leaving the tassel off his cane. Wilde's and Beardsley's mutual admiration was never more than guarded, however. Wilde must have been aware that Beardsley included several caricatures of him in the *Salome* drawings: in the moon in *The Woman in the Moon* frontispiece (page 47), as Herod in *The Eyes of Herod*, barely visible beneath a cloud in *A Platonic Lament*, and in the foreground of *Enter Herodias* (page 57). He can hardly have minded this, however, given the huge amount of publicity generated by the drawings when the edition was published in 1894. Although Beardsley had, at his publishers' insistence, expunged some of the more obviously indecent passages from his *Salome* drawings, the critics were none the less scandalized. *The Times* found them: 'fantastic, grotesque, unintelligible for the most part, and, so far as they are intelligible, repulsive.' What so offended the critics seems to have been the way Beardsley contrived to allude to the most craven, sadistic, and depraved acts in a way that was comprehensible without being explicit enough to be censorable.

By the time *Salome* appeared Beardsley was involved in the project for which he is perhaps now best remembered, *The Yellow Book*. It had come into being as a result of an apparently chance meeting between Beardsley and an American expatriate novelist called Henry Harland. Harland was also tubercular and it is said that the two men first met in the waiting room of their specialist's surgery. On the afternoon of New Year's Day, 1894, Beardsley and Mabel lunched with the Harlands and it was agreed that Beardsley and Harland should be respectively art editor and literary editor of a new quarterly. It was named *The Yellow Book*, apparently by Beardsley, and the small format and yellow binding were intended to suggest French novels of the day, which were bound in yellow paper. It was to be published by John Lane and Elkin Mathews, and Beardsley's cover of the prospectus for *The Yellow Book* mischievously caricatured Mathews as a severe, bespectacled pierrot. In spite of the scandal-by-association that was later to afflict it, the idea of *The Yellow Book* was ostensibly to produce a magazine 'representative of the most cultural work which was then being done in England, prose and poetry, criticism, fiction and art, the oldest school and the newest side by side, with no hall-mark except that of excellence and no prejudice against anything but dullness and incapacity.' It would be naive, however, to take these words at face value; Beardsley and Harland must have been well aware of the frisson of excitement that would be generated by the French-novel association, particularly after the critical reception of *Salome*.

Beardsley, in his role as art editor, received contributions from Joseph Pennell, Charles Conder, Walter Crane, Walter Sickert and Frederic Leighton, an eclectic mixture affirming the editors' professed criteria for inclusion. The writers were equally various and included Edmund Gosse, Arthur Symons, George Moore and, in lead position, Henry James. Mindful of the latitude Beardsley had taken with *Salome*, Lane examined carefully Beardsley's own contributions to *The Yellow Book*, and rejected one drawing, *The Fat Woman* (page 66), when he realized it caricatured Whistler's wife (Beatrice Philip, widow of the architect and designer E W Godwin). Beardsley complained bitterly at the exclusion:

I shall most assuredly commit suicide if *The Fat Woman* does not appear in No. 1 of the *Yellow Book*. I have shown it to all sorts and conditions of men – and women. All agree that it is one of my best efforts and extremely witty. Really I am sure you have nothing to fear. I should not press the matter a second if I thought it would give offence. The block is such a capital one too, and looks so distinguished. The picture shall be called 'A Study in Major Lines.'

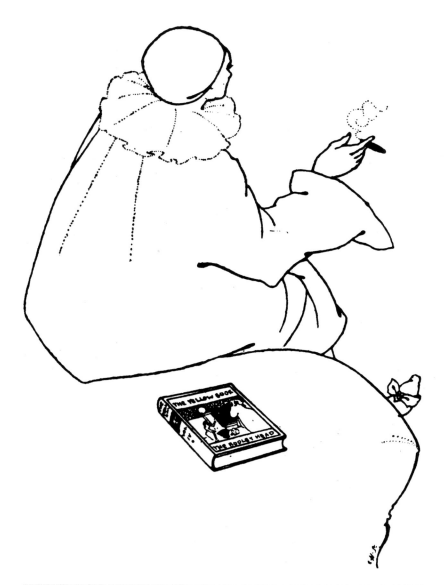

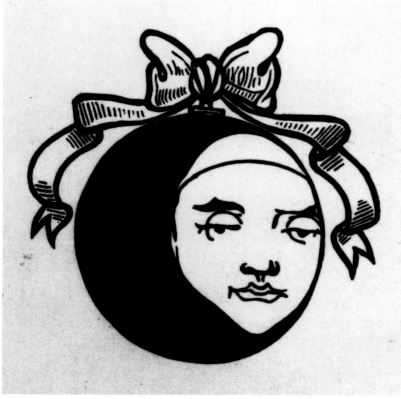

Top: The pierrot figure was another recurring motif in Beardsley's later years.

Above: Beardsley made several designs for covers and endpapers (pages 82-83 and 84-85) for the 'Pierrot's Library' book series. This design was used on the back covers.

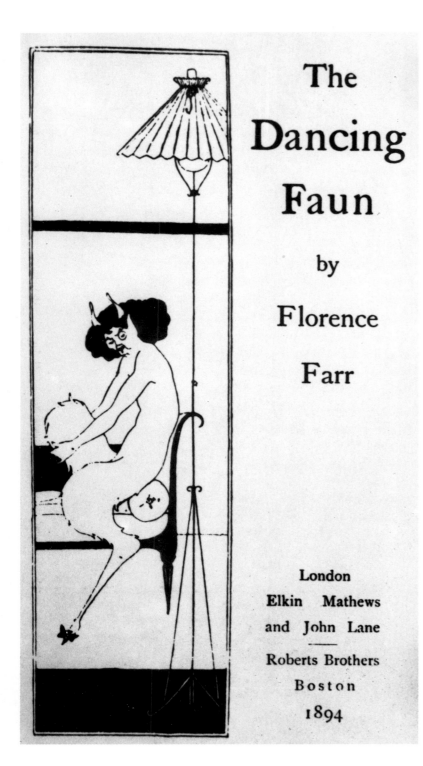

The
Dancing
Faun

by

Florence
Farr

London
Elkin Mathews
and John Lane

Roberts Brothers
Boston
1894

Left: Beardsley took a long time to forgive Whistler for the coolness with which he received Beardsley and his drawings in Paris in 1893; the faun figure in this book-jacket design is a caricature of Whistler.

Below and right: The *Yellow Book*, of which Beardsley was art editor and for which he designed covers and illustrations, brought him much public acclaim. Although it was something of a *succès de scandale* it stayed on the right side of respectability until the trial of Oscar Wilde in April 1895. Ironically Wilde had never contributed to the *Yellow Book*, but its 'bohemian' aura and Wilde's friendship with Beardsley were enough to damn Beardsley and he was dismissed by the *Yellow Book*'s publishers.

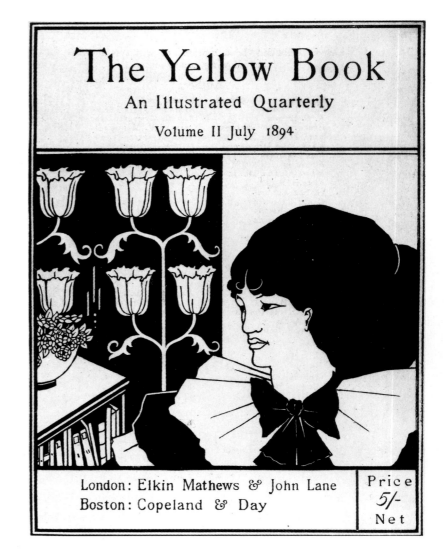

It is this title which gives the lie to Beardsley's protestations of innocence, for it is in the style of Whistler's own painting titles. Beardsley had never forgiven his former hero Whistler for the coolness of his treatment of him and his art, and caricatured Whistler himself on more than one occasion (left and page 68).

The first volume of *The Yellow Book* elicited a similarly outraged reception to that accorded to *Salome*. *The Westminster Gazette* stormed that: 'As regards certain of his inventions in this number, especially the thing called "The Sentimental Education," (page 70) . . . we do not think that anything would meet the case except a short Act of Parliament to make this kind of thing illegal.' All this delighted Beardsley, helped volume one of *The Yellow Book* to go to a third printing, and provided quotations for the prospectus for the second volume. Some of the more conservative contributors to the first volume, including Leighton, declined to be associated with the second volume, but James produced another lengthy short story, apparently for the money. It was also around this time that Beardsley produced his only known attempts at oil painting. On one side of a canvas he painted *A Caprice* (page 64), based on a drawing he made for volume three of *The Yellow Book*, and on the other he painted a curious picture of a masked woman contemplating a white mouse (page 65). He thought so little of the work that when he moved from his house in Cambridge Street, Pimlico, he left it behind. This is not to say that he had no feeling at all for color, or that he never used color. Several drawings which had begun life

in black and white, such as *The Sentimental Education* (page 70) or *J'ai Baisé ta Bouche, Iokanaan*, he later embellished with watercolor. In other cases where he made a design in black and white which ultimately was to be in flat color, such as magazine and book covers (page 39) or theater posters (page 61), he would offer his advice as to which colors should be used. As he later said: 'I have no great care for color, I only use flat tints, and work as if I were coloring a map, the effect aimed at being that produced on a Japanese print.'

While Beardsley worked long and hard on *The Yellow Book*, he accepted other commissions as well. This was perhaps partly because he had suffered a further lapse in his health, and must have realized that he did not now have very long to live. One such piece of work was a frontispiece for a volume of plays by John Davidson (page 59), in which all the figures are caricatures of prominent figures of the day and acquaintances of Beardsley's. Wilde appears as Bacchus with bound ankles, Mabel naked behind Henry Harland, disguised as a faun, theater manager Augustus Harris is in evening dress and Richard Le Gallienne, the writer, appears in *commedia dell'arte* costume. Beardsley justified the inclusion of Harris as he 'owes me half a crown.' Other projects included four startling illustrations to the stories of Edgar Allan Poe, which he had long wanted to work on as their dark and, on occasion, repulsively grotesque content seemed particularly suited to his art.

Although his health continued to deteriorate, everything

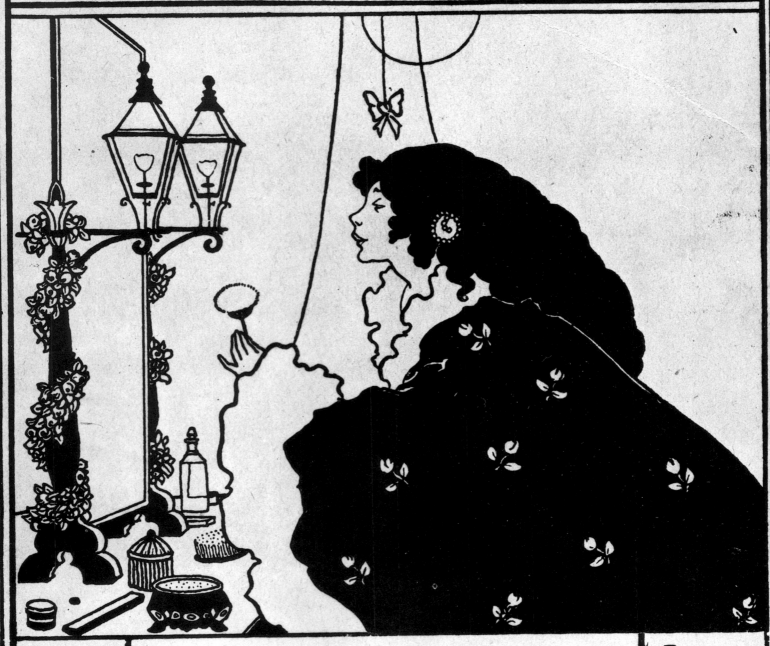

The Yellow Book

An Illustrated Quarterly

Volume III October 1894

Price
$1.50
Net

London: John Lane
Boston: Copeland & Day

Price
5/-
Net

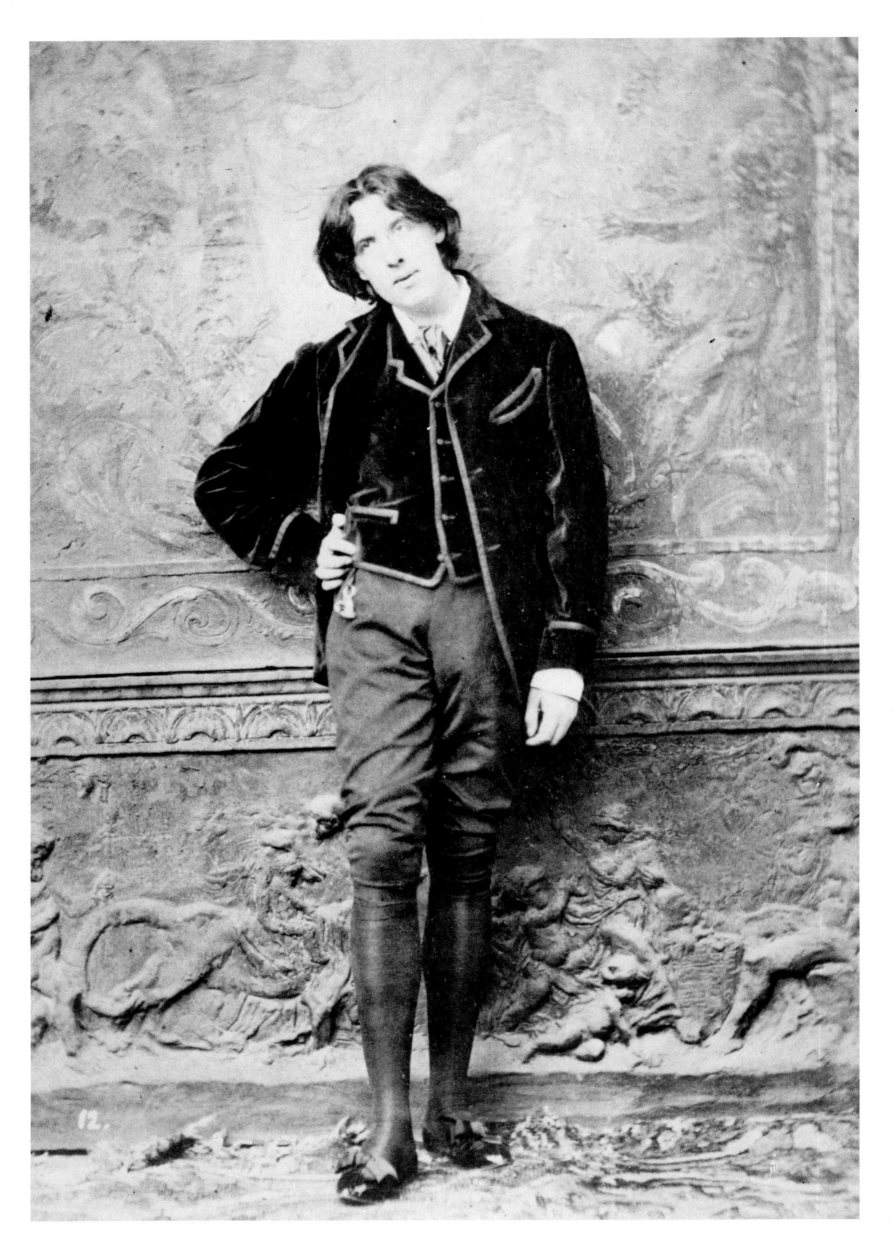

seemed to be going well for Beardsley professionally when, in April 1895, Oscar Wilde was arrested. Wilde had been conducting a liaison for some time with Lord Alfred Douglas whose father, the Marquess of Queensberry, had accused Wilde of 'posing as a somdomite (sic).' Wilde had been ill-advised enough to sue Queensberry for libel, the only result of which was his own arrest on charges of indecency when Queensberry's private detectives produced evidence to substantiate the original claim. Wilde's arrest unleashed a torrent of salacious interest and outraged attacks on anything that was associated in the public mind with him. Unfortunately for Beardsley, this included himself and *The Yellow Book*. 'Arrest of Wilde, *Yellow Book* under his arm,' the headlines read. Ironically, what Wilde had under his arm at his arrest was a yellow-bound French novel, not *The Yellow Book*, to which he had never contributed. John Lane was in New York at the time of Wilde's arrest and threatened with desertion by some of his authors, he dismissed Beardsley from his position as art editor of *The Yellow Book*. There is no evidence that Beardsley was ever active homosexually (or heterosexually), perhaps unsurprisingly given the state of his health throughout his short adult life, but his choice of associates, mannerisms, and art were enough to damn him. On 25 May 1895 Oscar Wilde was sentenced to two years' hard labor, the maximum sentence allowed for the offenses. Beardsley wrote of it: 'I imagine it will kill him.'

Beardsley, deprived of his main source of income, had to give up his lease on 114 Cambridge Street in July 1895. Although he had several other London addresses after this time, he spent much of the remaining three years of his life in France, or in guest-houses on the south coast of England. Beardsley's dismissal by Lane may have made him a pariah to conventional publishers, but he was just what Leonard Smithers was looking for. Smithers (1861-1907) had been a solicitor in Sheffield before he settled in London about 1890. He had a bookshop and publishing business in Arundel Street, off the Strand, which specialized in pornography and exotica; his catalogue offered two books bound in human skin. He had approached Arthur Symons, probably on the strength of a poem about a prostitute which Symons had written for *The Yellow Book*, with the idea of starting a literary quarterly to usurp the now-emasculated *Yellow Book*. Symons and Smithers agreed that Beardsley was the one possibility for the post of art editor. Beardsley agreed and furnished the journal with its title *The Savoy*; in naming it after the new hotel, Beardsley hoped to suggest modernity, opulence, and magnificence. Smithers originally took Beardsley on at £25 per week, although it seems that that figure dwindled and money was paid only irregularly.

The first issue of *The Savoy* appeared in January 1896 and, confirming Smithers' hopes, 14 out of 35 of *The Yellow Book*'s contributors were to write for it. Beardsley's cover design reflected a new interest in eighteenth-century art (as well as in Claude Lorrain) that was to be seen in various guises in his work from now on. It also featured a *putto* about to urinate on a copy of *The Yellow Book*, a detail (omitted from the published version) reflecting Beardsley's feelings about his dismissal. *The Savoy* continued as a quarterly until July 1896 when it became monthly. It seems to have enjoyed some success, in spite of its banishment from railway bookstalls because it contained work by Beardsley; when Symons asked the manager responsible to point out a Beardsley which offended, he pointed to a drawing by William Blake.

As well as providing Beardsley with an income until its demise in December 1896, *The Savoy* was also the vehicle for extracts from Beardsley's novel, which he sometimes titled *Under the Hill*, sometimes *Venus and Tannhäuser*. It is a rambling erotic fantasy (published in expurgated form), with characters whose names vary (Abbé Aubrey, Chevalier Tannhäuser, Abbé Fanfreluche) from one extract to the next. Illustrating this seems to have inspired Beardsley to produce some of his wildest and most

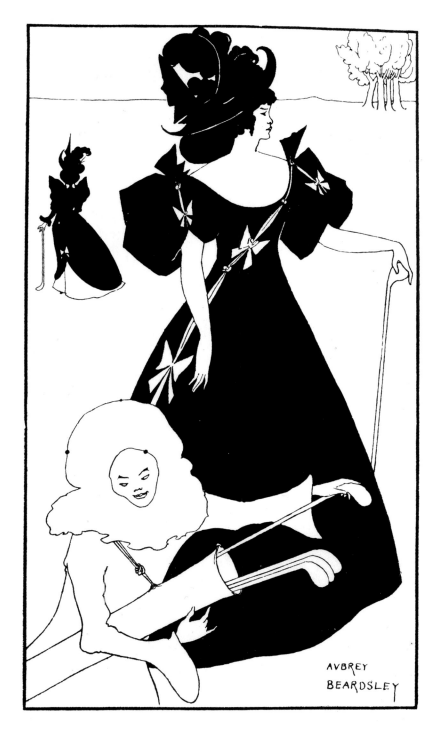

Left: Oscar Wilde photographed by Napoleon Sarony during his American tour in 1882. Ten years later when he met Beardsley, Beardsley was already assuming the mantle of boy genius and young asthete that Wilde had worn with such panache from the mid-1870s.

Above: This golf-club invitation demonstrates the use Beardsley made of the unmodulated areas of black he had seen in Japanese woodblock prints.

opulent eighteenth-century-style drawings (page 91). It was this style that he also used for nine illustrations (pages 87 and 88) to an edition by Leonard Smithers of Alexander Pope's *The Rape of the Lock*, originally published in 1714. These are extraordinary virtuoso performances, quite different from the simple massed black-and-white of the *Salome* illustrations and much of his earlier work. A profusion of closely drawn lines and scenes executed only in a cloud of dots justify the use of the description 'embroideries' on the title page.

As he had boasted at the beginning of his success, however, Beardsley was always adept at working in a variety of styles. He demonstrated this forcibly in another and quite different Smithers project of the time, his illustrations to Aristophes' *Lysistrata*. This is an anti-war satire which tells of Athenian women going on a sex strike to force their husbands to sue for peace. Beardsley's drawings (pages 97-103), reproductions of which were seized by the police as obscene as recently as 1966, are among the most powerfully simple and unadorned that he ever produced. But they are, undeniably, lubricious and Beardsley was some-

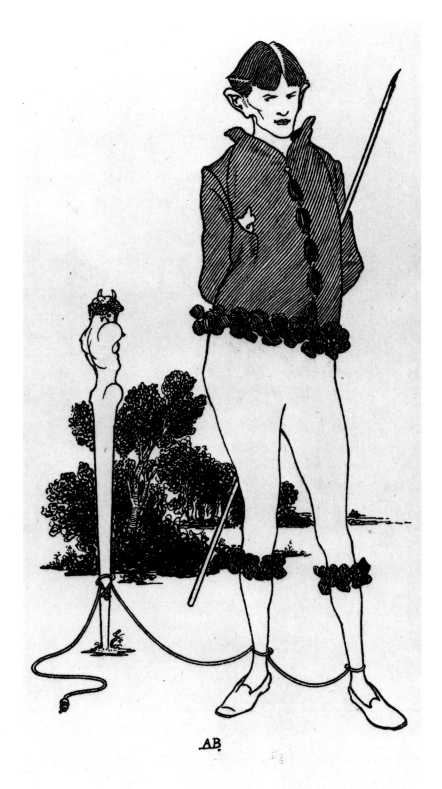

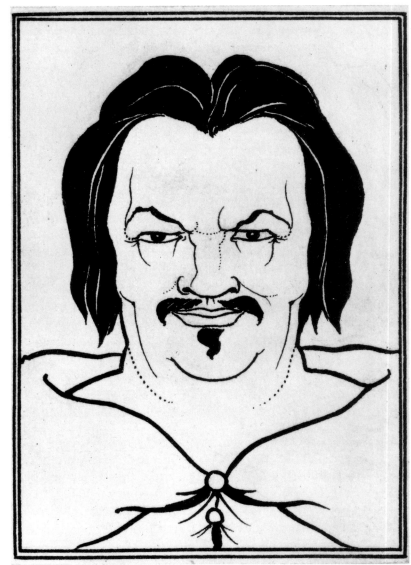

Above left: This late self-portrait verges on caricature and is pregnant with symbolism.

Above: This portrait of Balzac is almost an abstract exercise in symmetry.

Right: At the very end of his life, when he was starting to illustrate Ben Johnson's *Volpone* (pages 110 and 111), Beardsley was beginning to develop a new style using washes of gray as well as black.

what concerned about the reaction of his other principal benefactor in his last years, Marc-André Raffalovich.

Raffalovich was a poet of French and Russian origin and enormous fortune. Beardsley had designed a frontispiece (page 77) for his poems which the publisher had rejected on the grounds that the figure of Love was 'hermaphrodite.' Raffalovich showered Beardsley with gifts and with money; Beardsley addressed him as 'Mentor' in his frequent letters to him. Raffalovich provides a curious contrast with Smithers; although he conducted a homoerotic relationship for years with the poet John Gray and had written in French a study of homosexual love, he was a devout Christian and converted to Roman Catholicism in 1896. Beardsley, in the grips of an obviously terminal illness, followed him and was received into Catholic Church in March 1897. It is easy to be cynical about Beardsley's motives for the conversion. He was still in regular correspondence with the pornographer Smithers and admitted in a letter to his friend Herbert Pollitt: 'This morning I was closeted for two mortal hours with my Father Confessor, but my soul has long since ceased to beat.' On the other hand he did not abandon his faith when his health improved dramatically for a few months after his conversion. In that time he was working on illustrations for Ben Jonson's *Vol-*

pone, which reveal that he was still capable of developing powerful and new modes of artistic expression (pages 110 and 111). Beardsley moved to Menton in November 1897 in the vain hope of a reprieve for his health. He did not leave his room after 26 January 1898. His last letter was to Smithers:

Jesus is our Lord and Judge

Dear Friend

I implore you to destroy *all* copies of *Lysistrata* and bad drawings. Show this to Pollitt and conjure him to do same. By all that is holy *all* obscene drawings.

Aubrey Beardsley

In my death agony.

He died nine days later, on 16 March 1898, aged 25.

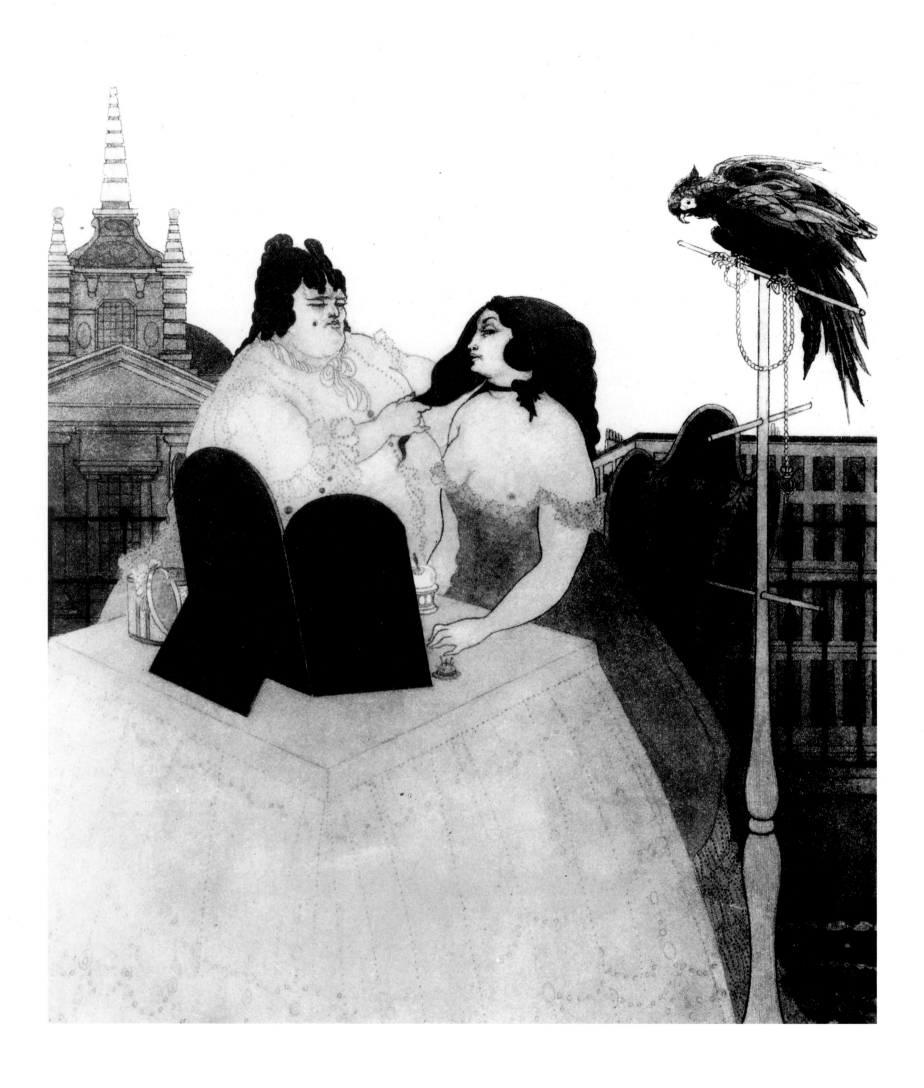

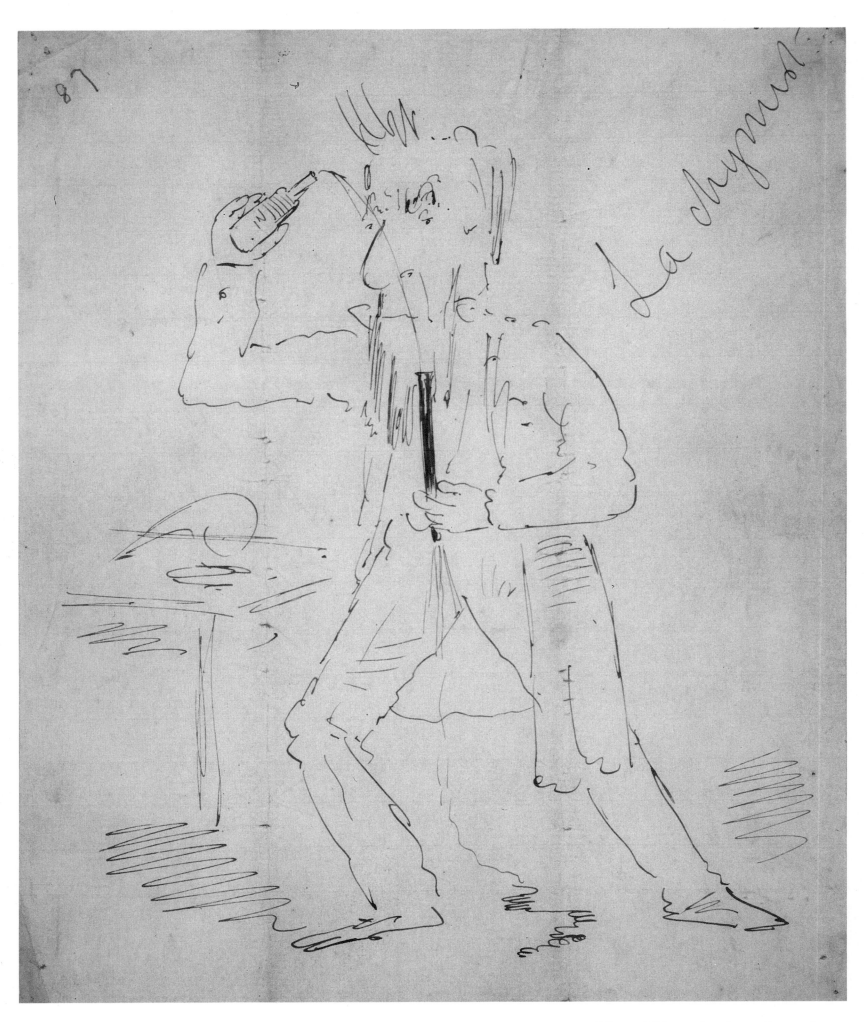

Le Chymist, c. 1885-88
Pen and violet ink
7¾ × 6¼ inches (19.7 × 15.9 cm)
(Reproduced larger than actual size)
Princeton University Library

**How King Arthur Saw the
Questing Beast,** 1893
Ink and wash drawing
14¾ × 10½ inches (38 × 27 cm)
Courtesy of the Trustees of the Victoria
and Albert Museum, London

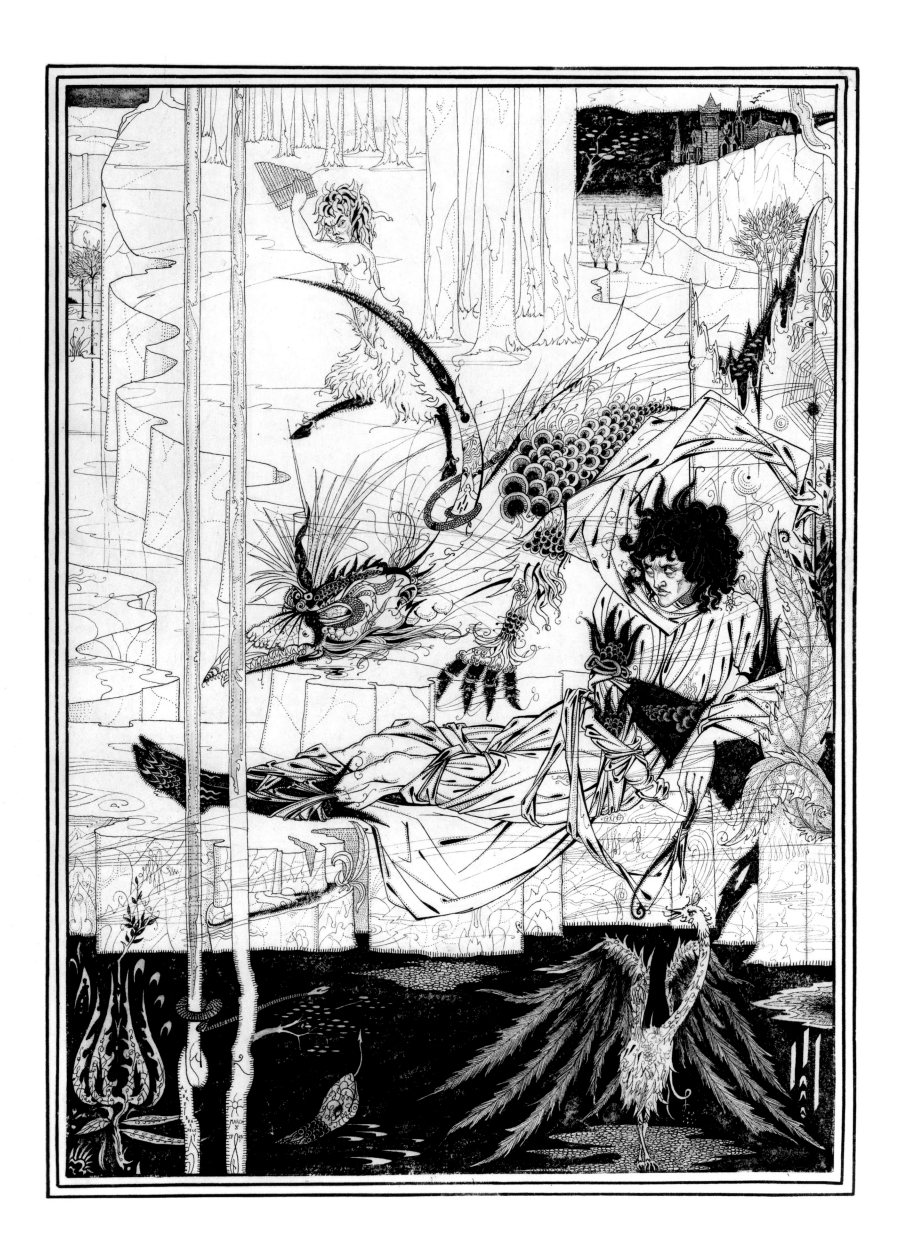

Die Götterdämmerung, 1892
Pen, ink, wash, and Chinese white
12⅛ × 20¼ inches (30.8 × 51.4 cm)
Princeton University Library

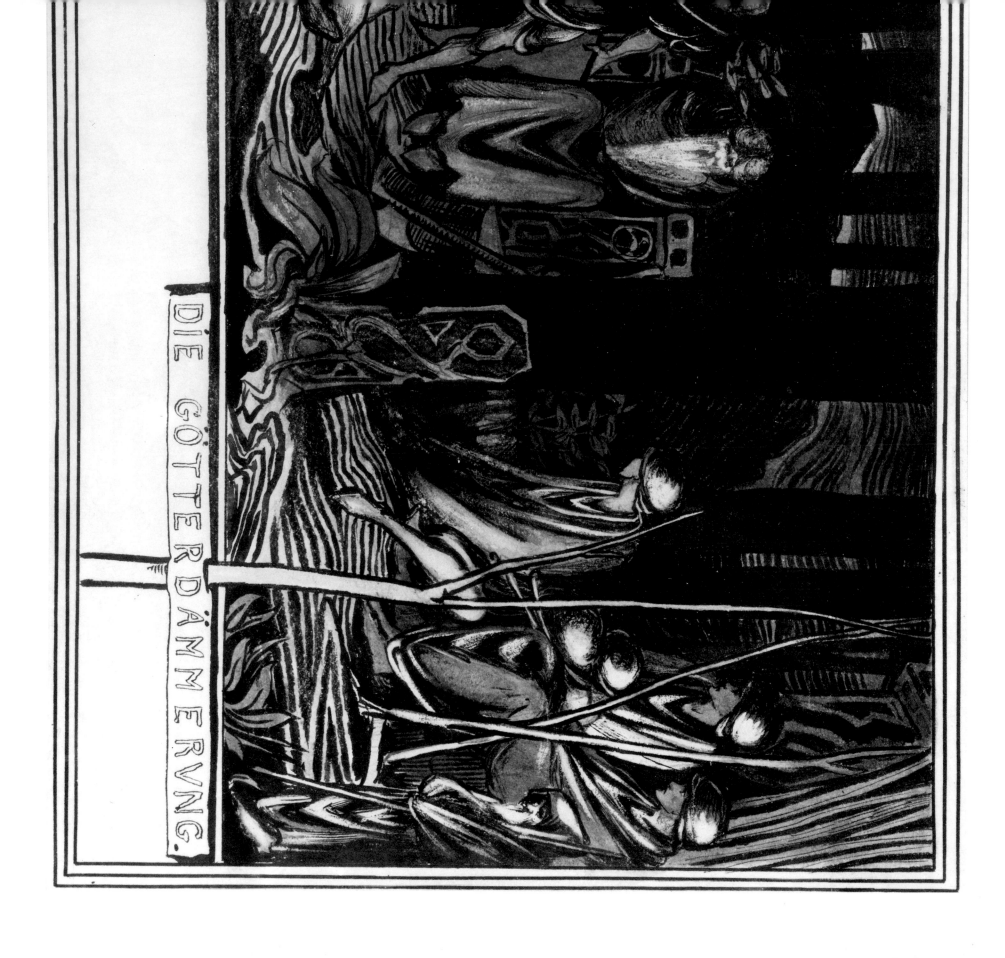

DIE GÖTTERDÄMMERVNG.

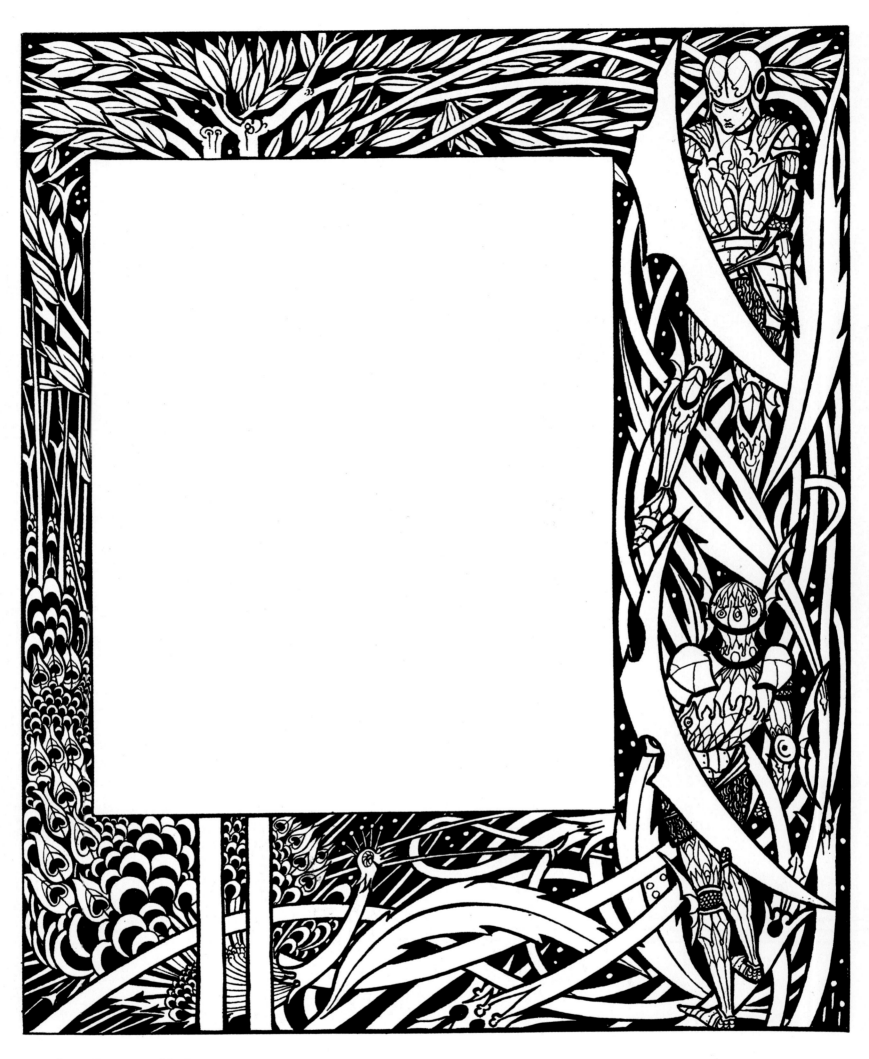

Design for a Full-Page Border to the Beginning of Chapter I, Book 3 of 'Le Morte Darthur, 1893-94
Indian ink
11¼ × 9¼ inches (28.6 × 23.5 cm)
Princeton University Library

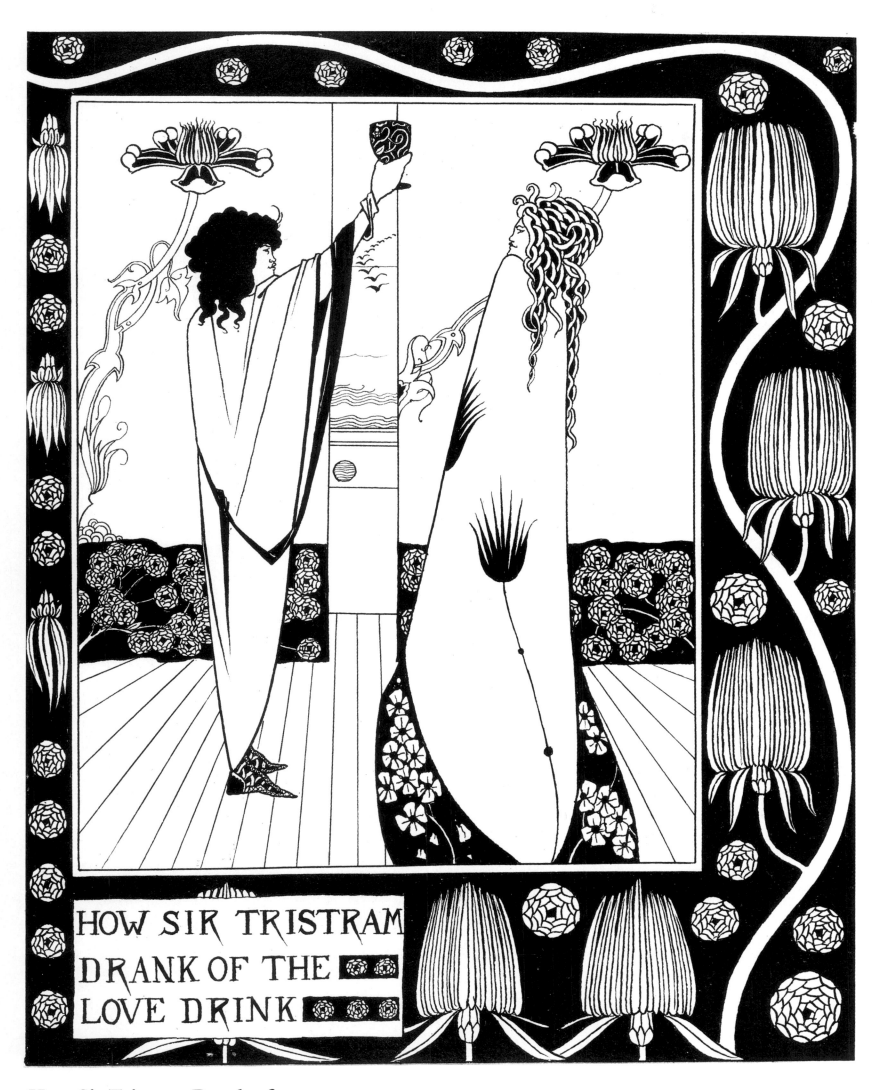

***How Sir Tristram Drank of
the Love Drink,*** 1893-94
Indian ink and pencil
11 × 8¹¹⁄₁₆ inches (28.2 × 21.2 cm)
Fogg Art Museum, Harvard
University, Cambridge, Massachusetts
Bequest of Scofield Thayer

***How a Devil in Woman's
Likeness Would Have
Tempted Sir Bors,*** 1893-94
Indian ink
Double drawing, 10$\frac{1}{16}$ × 7$\frac{5}{8}$; 10$\frac{3}{8}$ × 7$\frac{1}{2}$
inches (25.6 × 19.6; 26.7 × 19.2 cm)
The Art Institute of Chicago
Deering Collection, 1927. 1624

How Queen Guenever Rode on Maying, 1893
Double-page illustration to Chapter I,
Book 19 of *Le Morte Darthur*
Indian ink
8⅛ × 6⅝ inches (20.6 × 16.8 cm)
8⅛ × 6⅝ inches (20.6 × 16.8 cm)
(Reproduced larger than actual size)
Courtesy of the Trustees of the Victoria
and Albert Museum, London

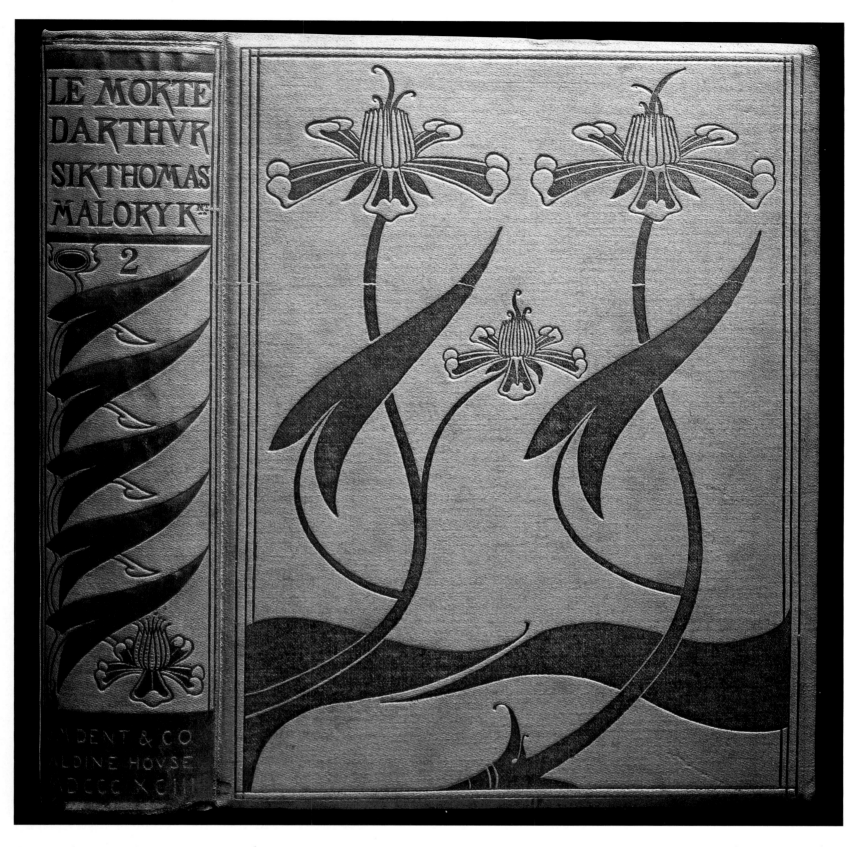

***How Queen Guenever Made
Her a Nun,*** 1893-94
Illustration to Chapter IX, Book 2 of *Le
Morte Darthur*
From the line-block
Private Collection

***Front Cover and Spine of
'Le Morte Darthur,' Vol 2,***
1893
Designs stamped in gold and vellum
Private Collection

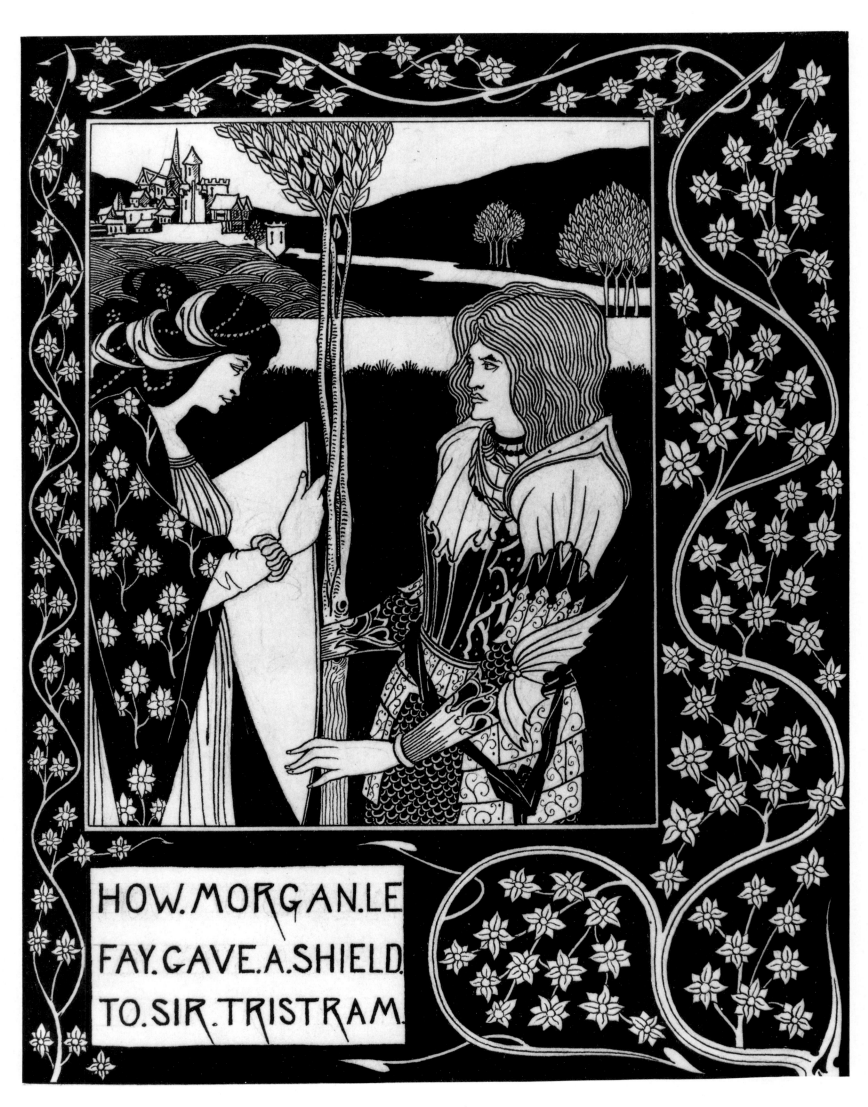

**How Morgan Le Fay Gave a
Shield to Sir Tristram,** 1893-94
Indian ink
10⅝ × 8⁵⁄₁₅ inches (27 × 21.1 cm)
Fitzwilliam Museum, Cambridge

**Illustration to 'Siegfried,'
Act II,** c. 1892-93
Indian ink and wash
15¾ × 11¼ inches (40 × 28.6 cm)
Courtesy of the Trustees of the Victoria
and Albert Museum, London

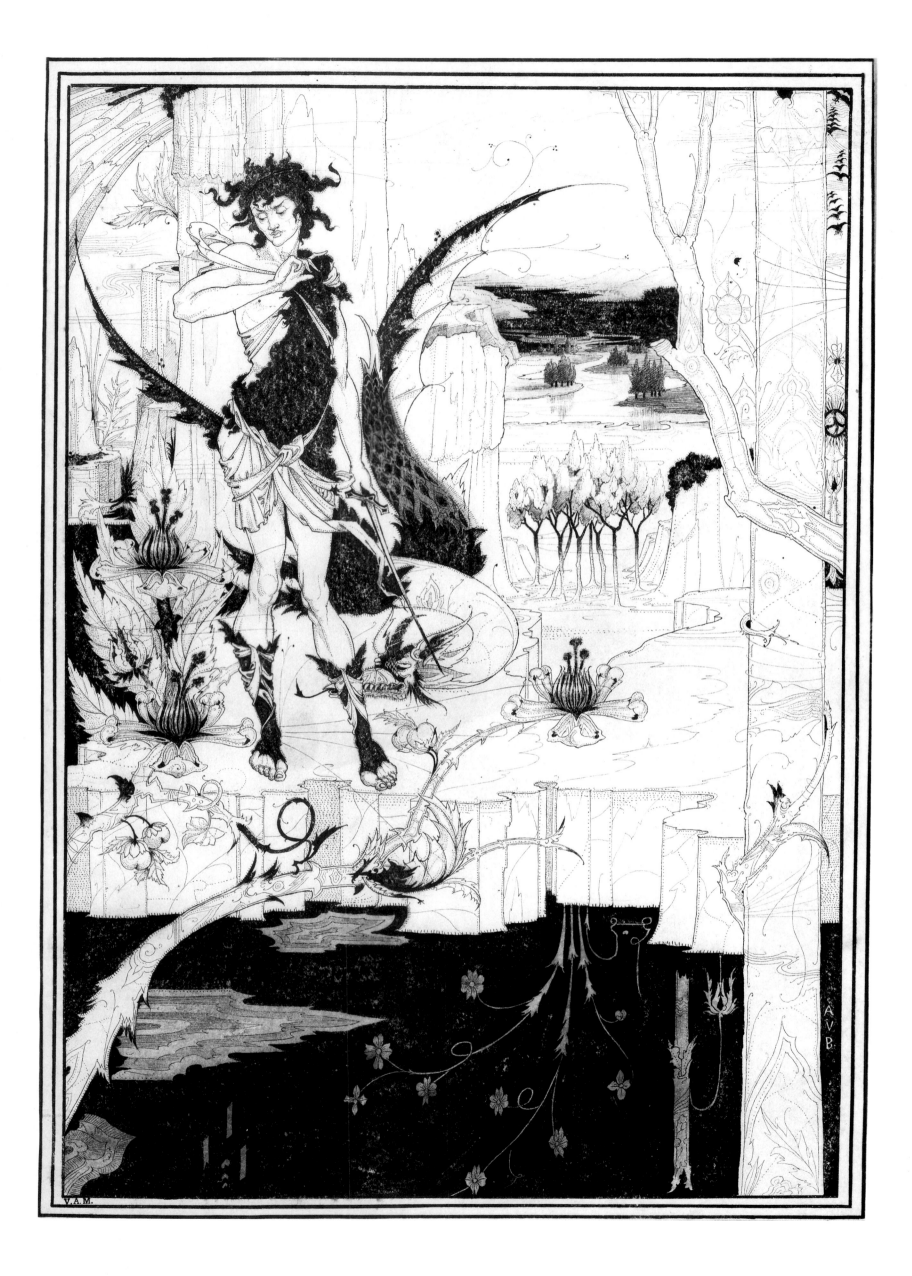

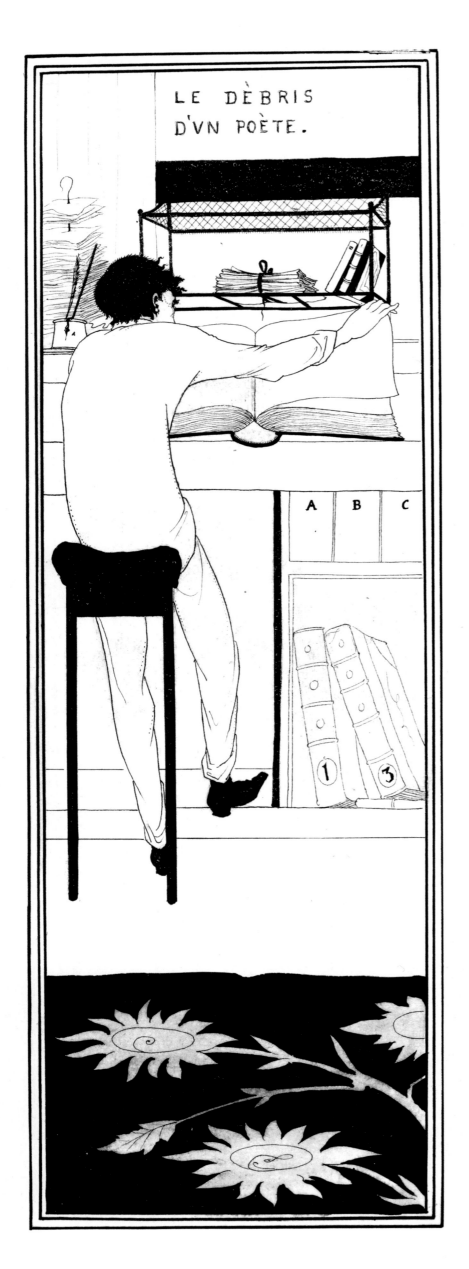

LE DÈBRIS
D'VN POÈTE.

Dreams, 1894
Drawing for illustration facing page 209
of *Lucian's True History*
Indian ink and pencil
5¹⁵⁄₁₆ × 4⅜ inches (15.2 × 11.3cm)
(Reproduced larger than actual size)
Fogg Art Museum, Harvard
University, Cambridge, Massachusetts
Bequest of Scofield Thayer

Le Dèbris d'un Poète, c. 1892
Indian ink and wash
13 × 4⅞ inches (33 × 12.4 cm)
Courtesy of the Trustees of the Victoria
and Albert Museum, London

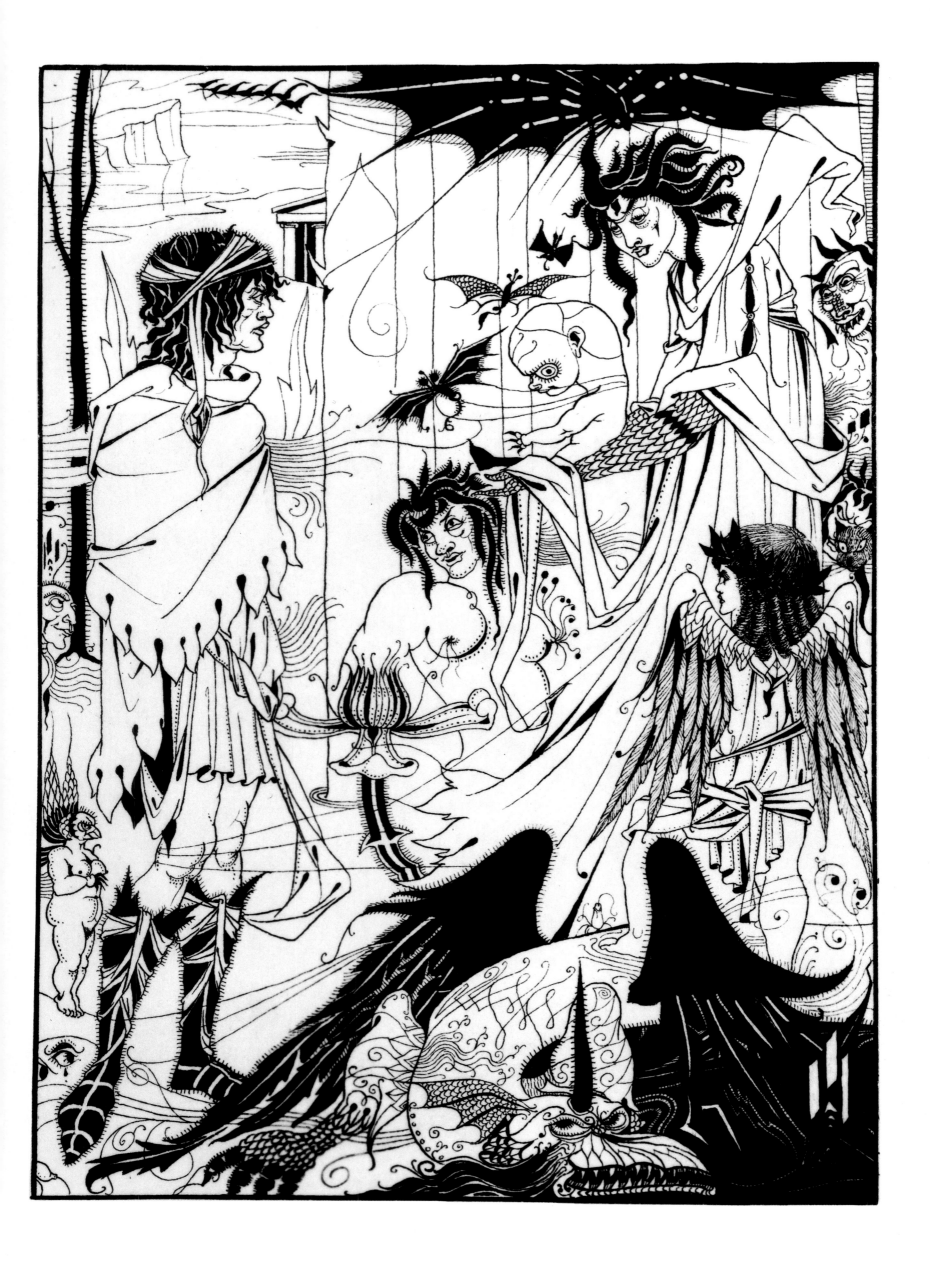

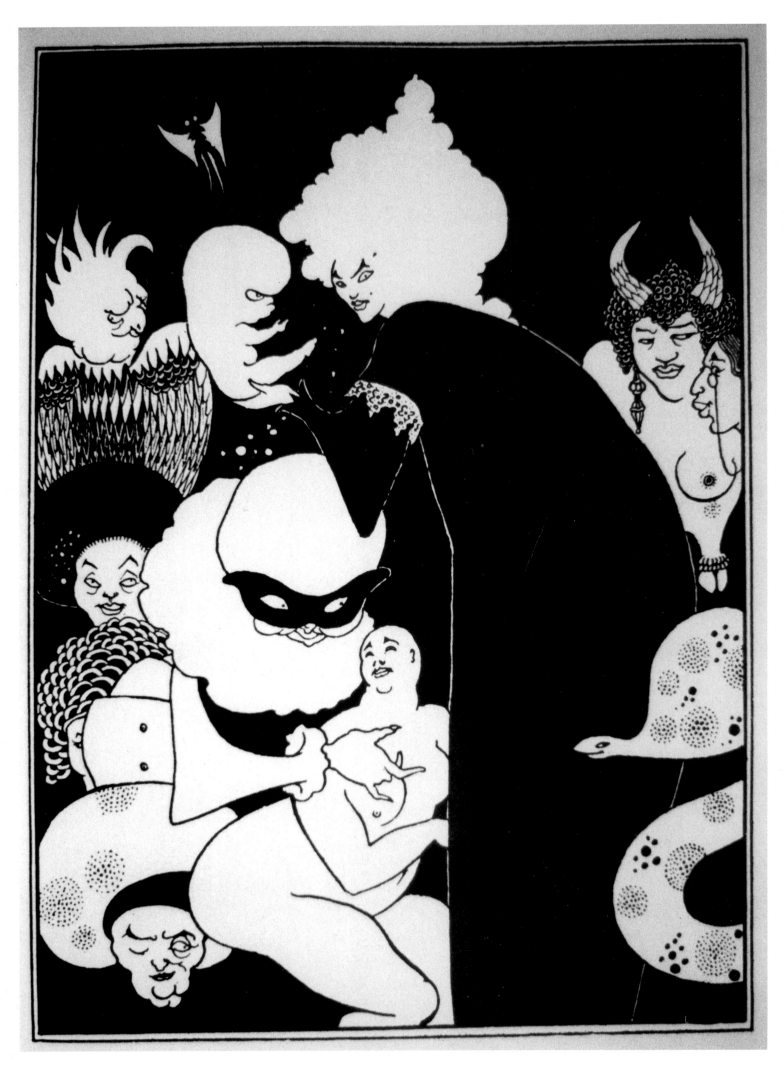

Lucian's Strange Creatures,
1894
From the line-block
9 × 5 inches (22.9 × 12.7 cm)
Private Collection

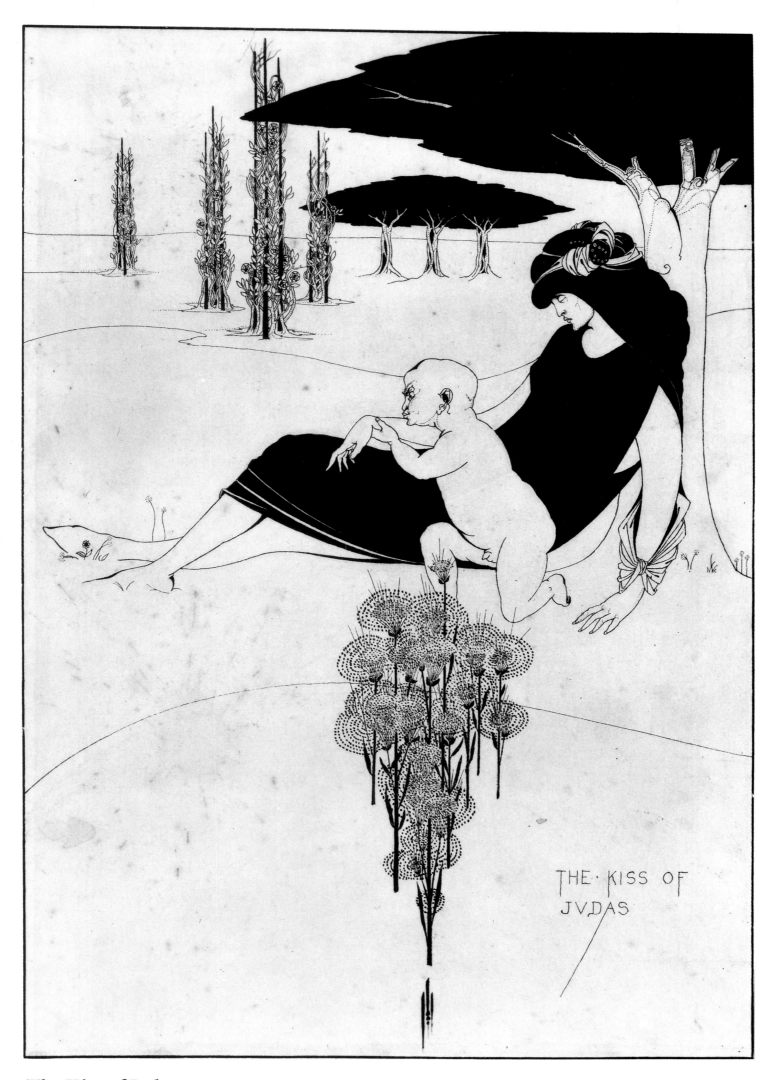

The Kiss of Judas, 1893
Indian ink
12¼ × 8⅝ inches (31.4 × 22 cm)
Courtesy of the Trustees of the Victoria
and Albert Museum, London

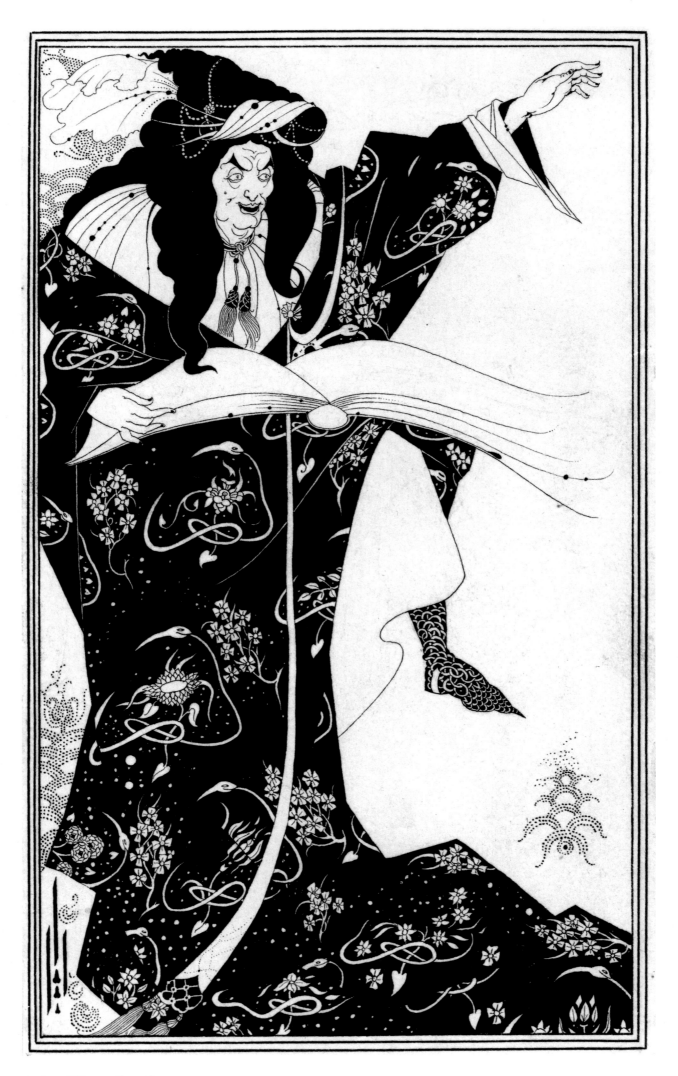

Virgilius the Sorcerer, 1893
Design for frontispiece to *The Wonderful*
History of Virgilius the Sorcerer of Rome
Indian ink
9 × 5½ inches (22.8 × 13.8 cm)
(Reproduced larger than actual size)
The Art Institute of Chicago
Gift of Robert Allerton, 1925.928

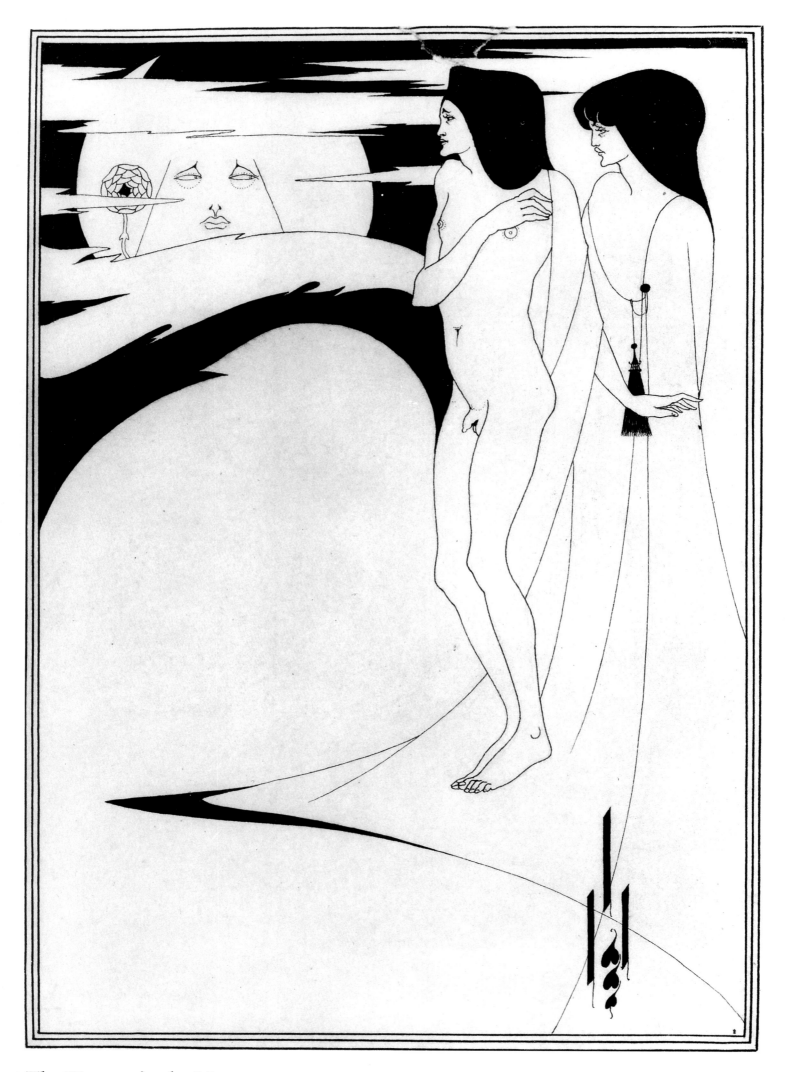

The Woman in the Moon,
1894
Indian ink and pencil
8¾ × 7¾ inches (23 × 16.5 cm)
(Reproduced larger than actual size)
Fogg Art Museum, Harvard
University, Cambridge, Massachusetts
Grenville L Winthrop Bequest

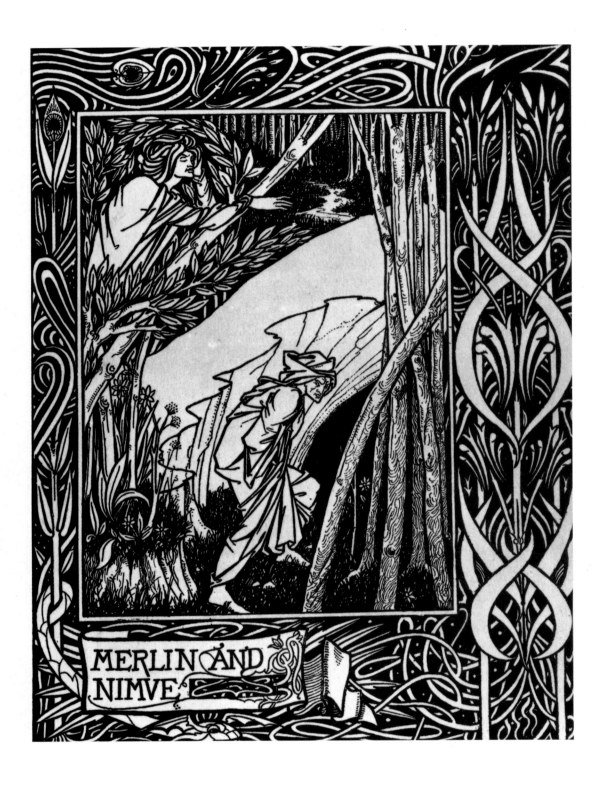

Merlin and Nimue, 1893-94
Full-page illustration to *Morte Darthur*,
Chapter 1, Book IV
From the line-block
Courtesy of the Trustees of the Victoria
and Albert Museum, London

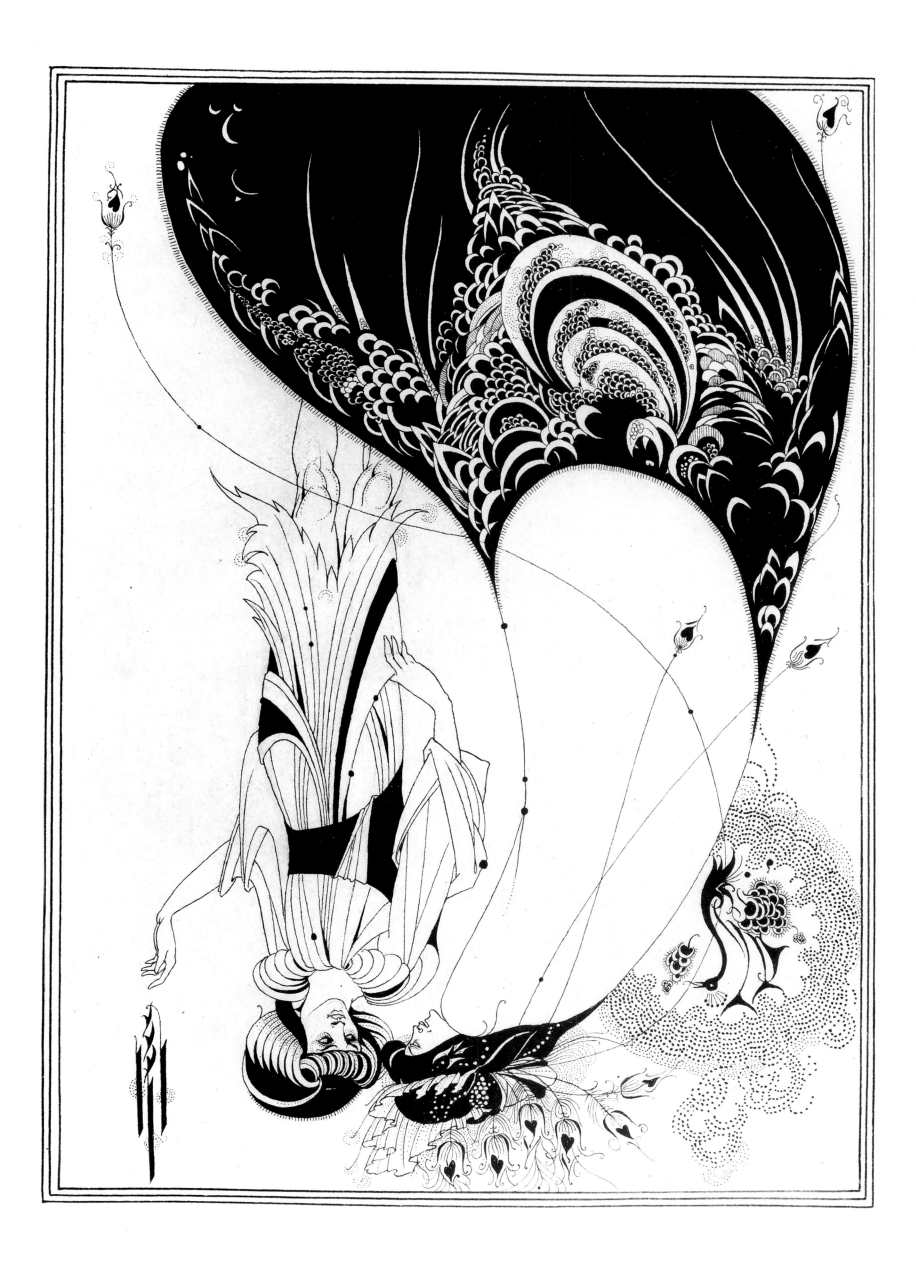

The Bon-Mots of Sydney Smith and R Brinsley Sheridan, 1893-94
Line-block and letter-press with Indian ink and wash drawing
1¹⁵⁄₁₆ × 1¹³⁄₁₆ inches (4.9 × 4.6 cm)
Courtesy of the Trustees of the Victoria and Albert Museum, London

The Black Cape, 1894
Drawing from *Salome*
Indian ink
8⅞ × 6¼ inches (22.4 × 15.9 cm)
(Reproduced larger than actual size)
Princeton University Library

Sydney Smith. 27

SIR RODERICK MURCHISON, according to Sydney Smith, would be found giving "not *swarries*, but *quarries*; all the ladies having ivory-handled hammers and six little bottles for each to try the stones."

—⋁⋁⋁—

MACAULAY had told Sydney Smith that meeting him was some compensation for missing Ramohun Roy. Sydney broke forth: "Compensation! Do you mean to insult me? A beneficed clergyman, an ortho-dox clergyman, a nobleman's chaplain, to be no more than compensation for a Brahmin; and a heretic Brahmin, too, a fellow who has lost his own reli-gion and can't find another; a vile heterodox dog, who, as I am credibly in-formed eats beef-steaks in private! A man who has lost his caste! who ought to have melted lead poured down his nostrils, if the good old *Vedas* were in force as they ought to be."

—⋁⋁⋁—

ON Mrs Austin explaining that she was no relation to Miss Austen, Sydney Smith said to her, "You are quite wrong; I always let it be inferred that I am the son of Adam Smith."

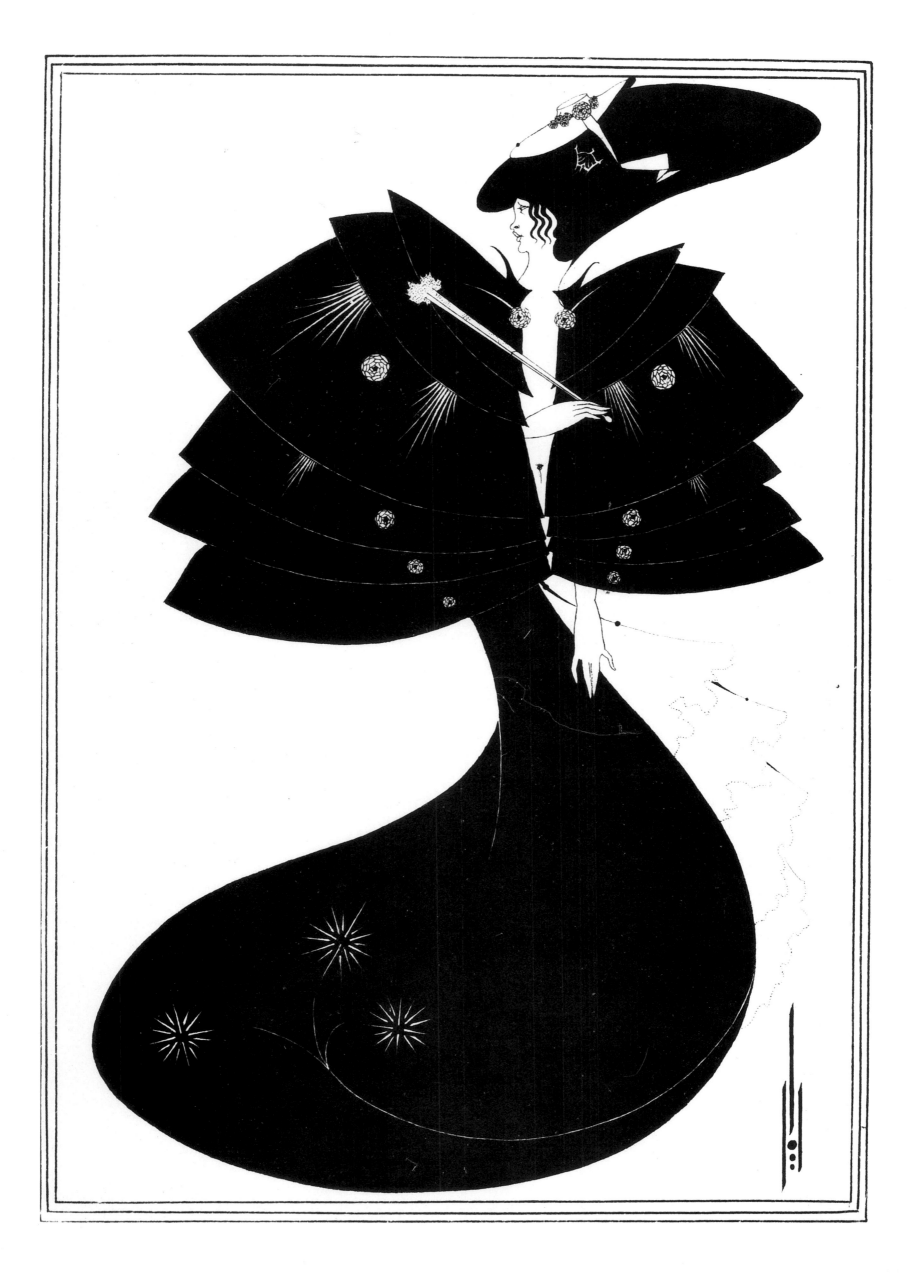

Incipit Vita Nova, 1894
Indian ink and Chinese white over
pencil on brown paper
7¹⁵⁄₁₆ × 7¹³⁄₁₆ inches (20.2 × 19.8 cm)
Courtesy of the Trustees of the Victoria
and Albert Museum, London

The Stomach Dance, 1894
Drawing from *Salome*
8¾ × 6⅞ inches (23 × 16.8 cm)
(Reproduced larger than actual size)
Fogg Art Museum, Harvard
University, Cambridge, Massachusetts
Grenville L Winthrop Bequest

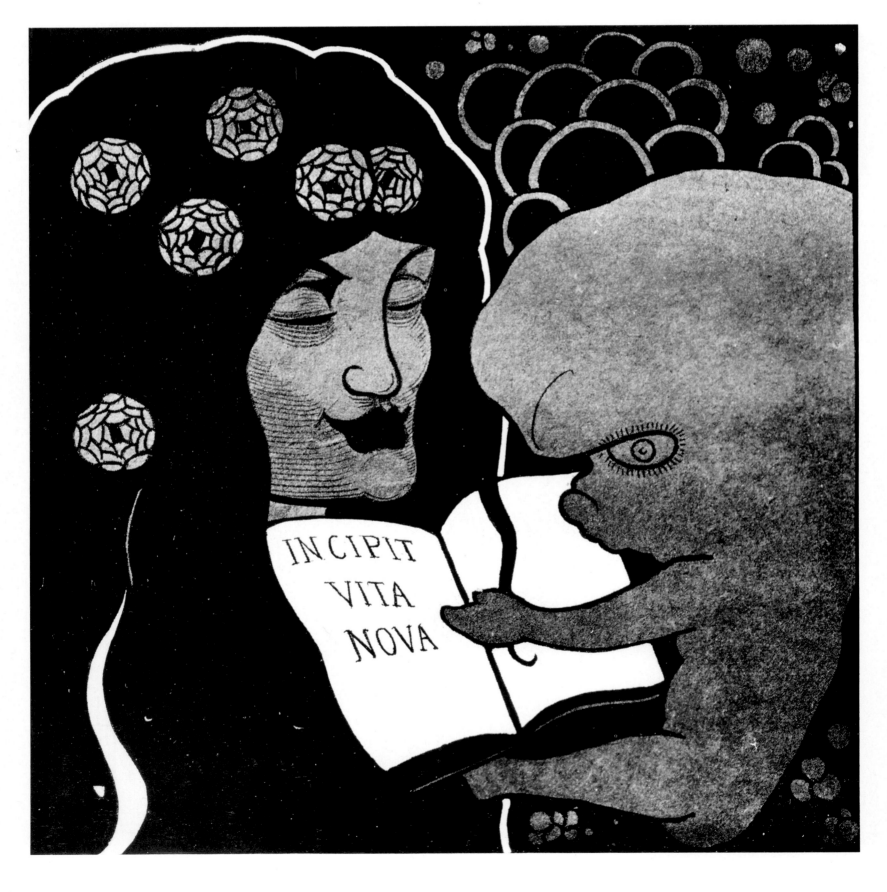

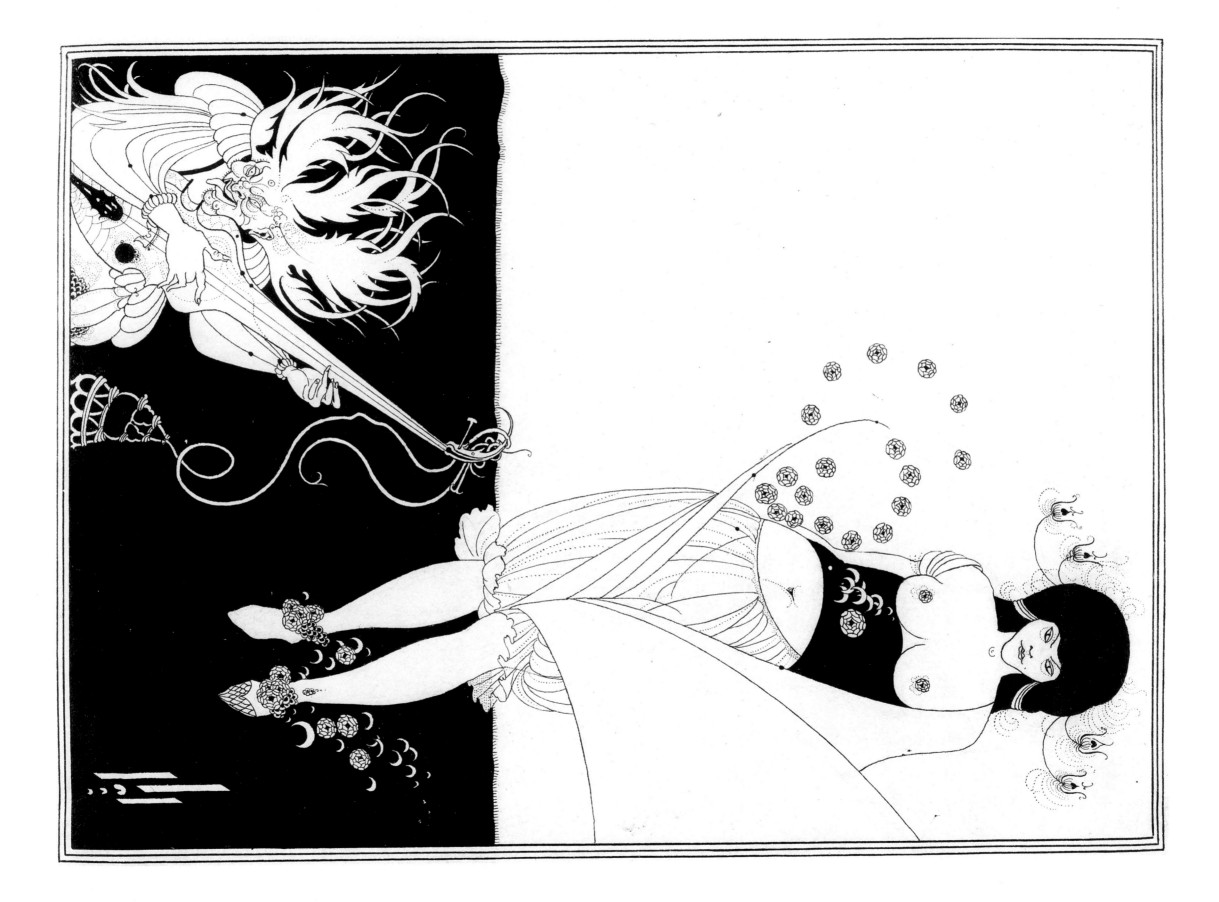

A Platonic Lament, 1894
Illustration intended for *Salome*
From the line-block
Courtesy of the Trustees of the Victoria
and Albert Museum, London

The Toilet of Salome, 1894
Drawing from *Salome*
Indian ink
8⅞ × 6¼ inches (22.4 × 13.4 cm)
(Reproduced larger than actual size)
Courtesy of the Trustees of the British
Museum, London

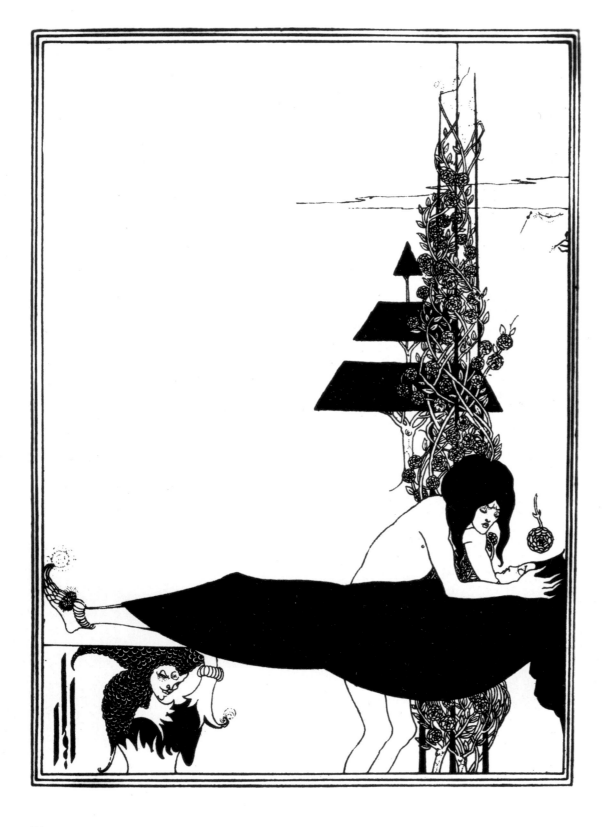

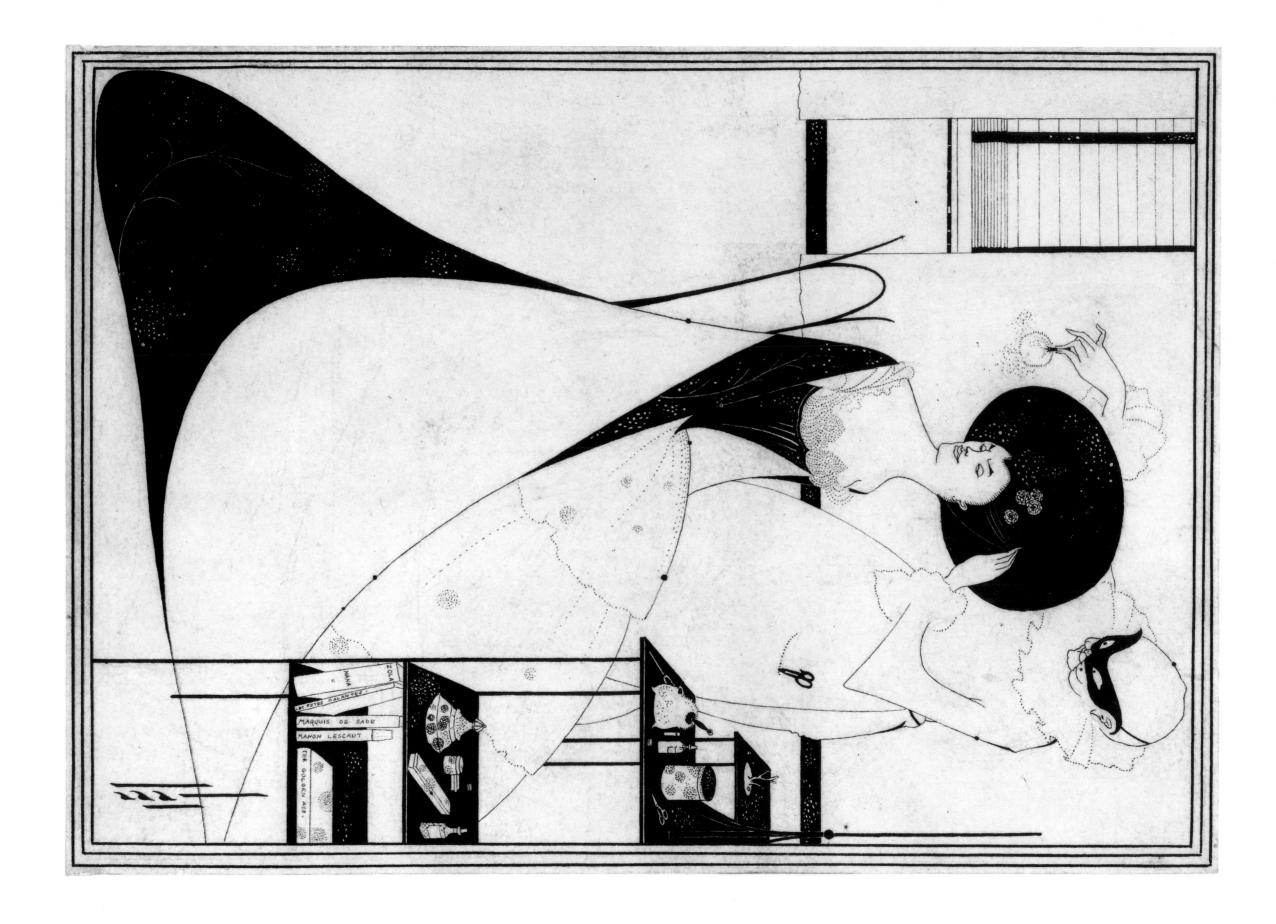

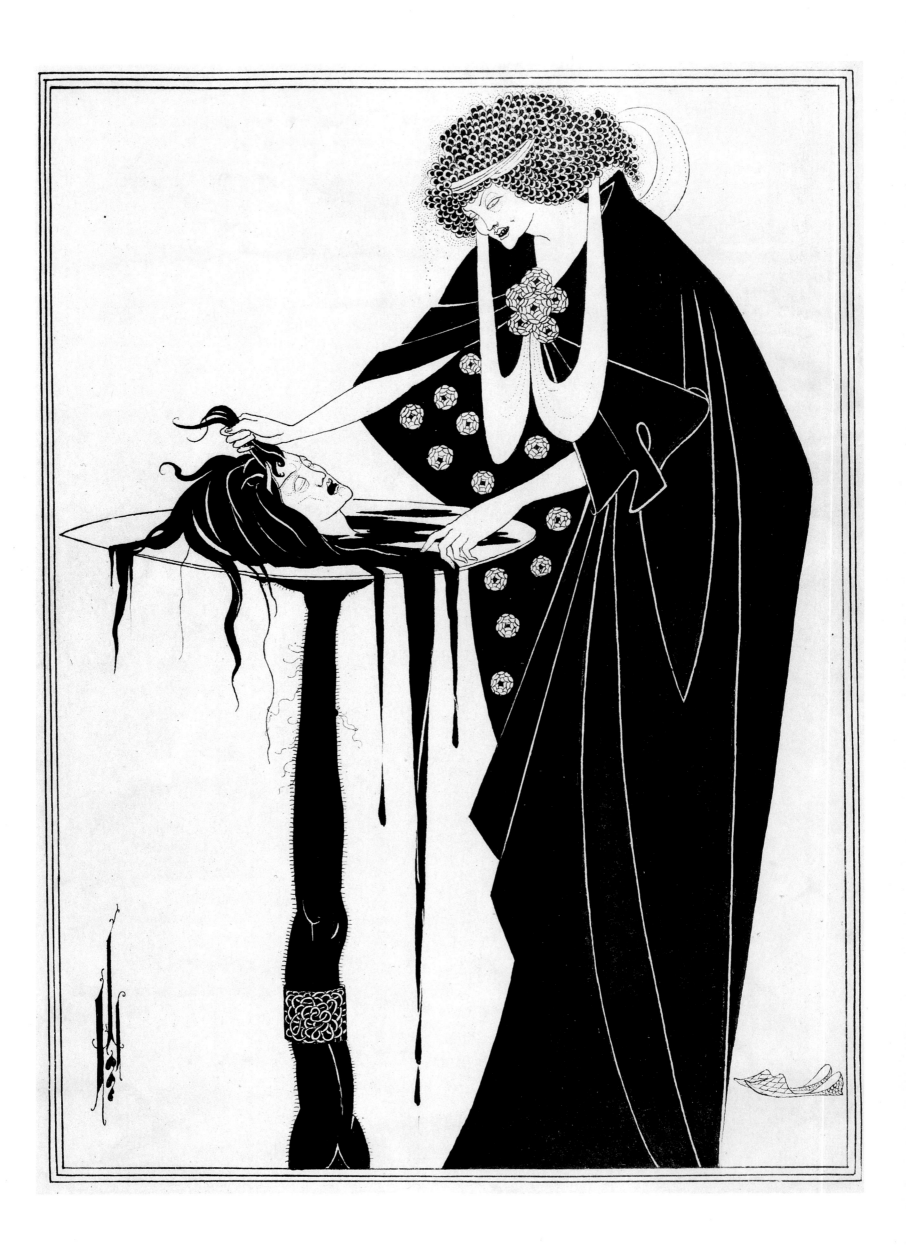

Because one figure was undressed
This little drawing was suppressed
 It was unkind —
 But never mind
Perhaps it all was for the best —

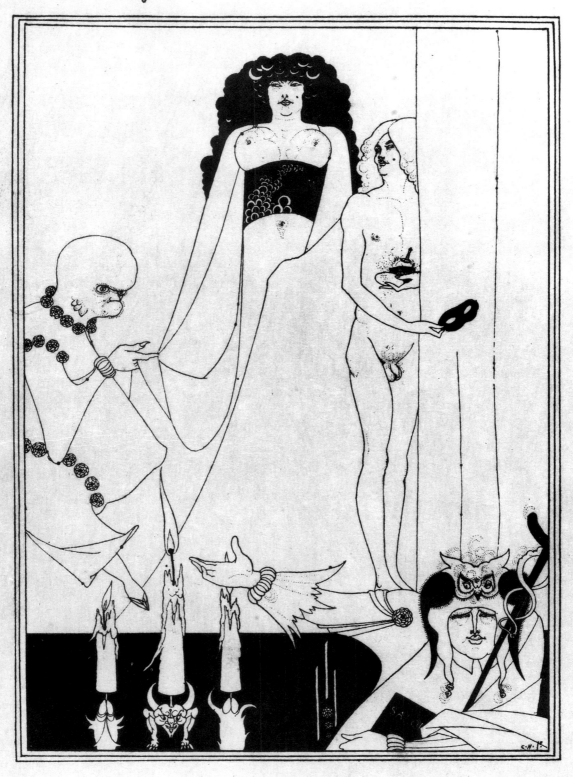

alfred Lambart from Aubrey Beardsley

The Dancer's Reward, 1894
8¾ × 6¼ inches (22.6 × 14.3 cm)
(Reproduced larger than actual size)
Fogg Art Museum, Harvard
University, Cambridge, Massachusetts
Grenville L Winthrop Bequest

Enter Herodias, 1894
Proof of the first state of an illustration
to *Salome*, inscribed by Beardsley
From the line-block
7 × 5⅙ inches (17.8 × 12.9 cm)
Princeton University Library

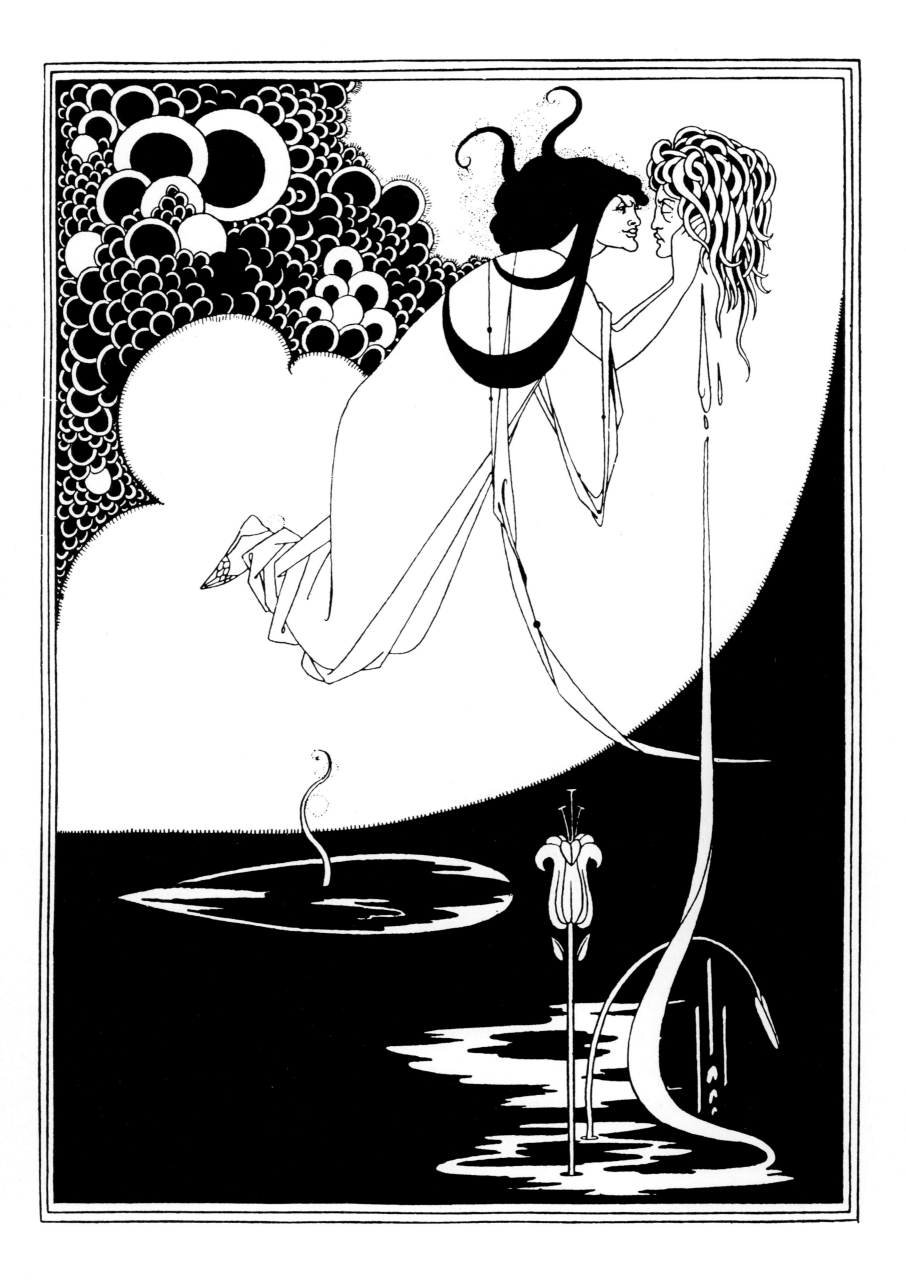

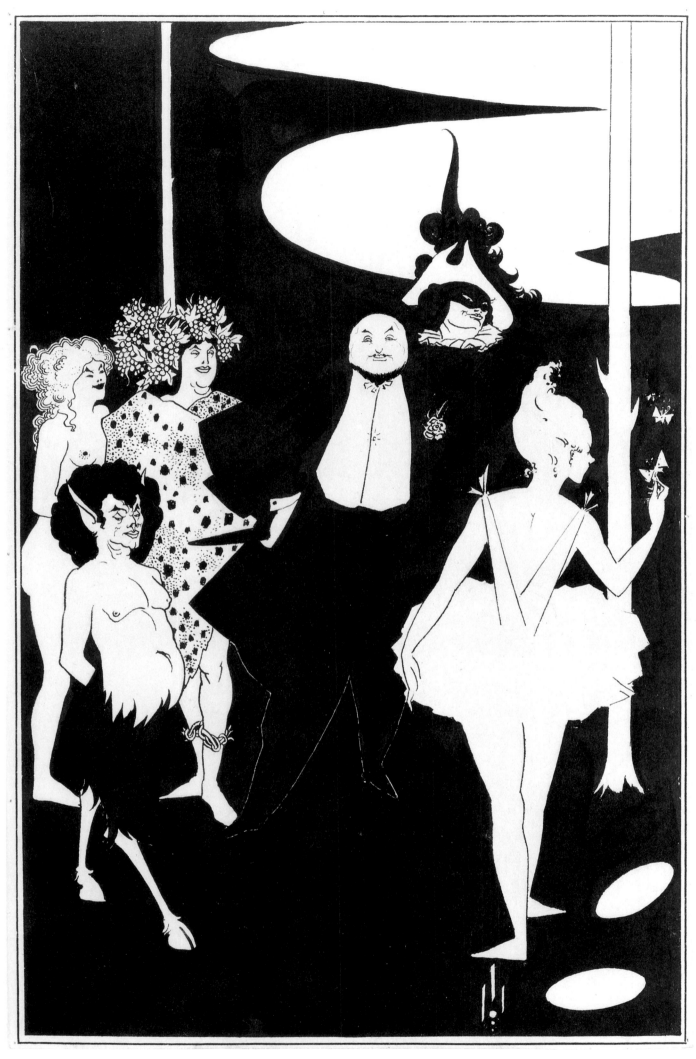

The Climax, 1804
Illustration to *Salome*
From the line-block
Private Collection

**Design for the Frontispiece
to 'Plays' by John Davidson,**
1894
Watercolor drawing
11¼ × 7⅜ inches (28.6 × 18.7 cm)
Tate Gallery, London

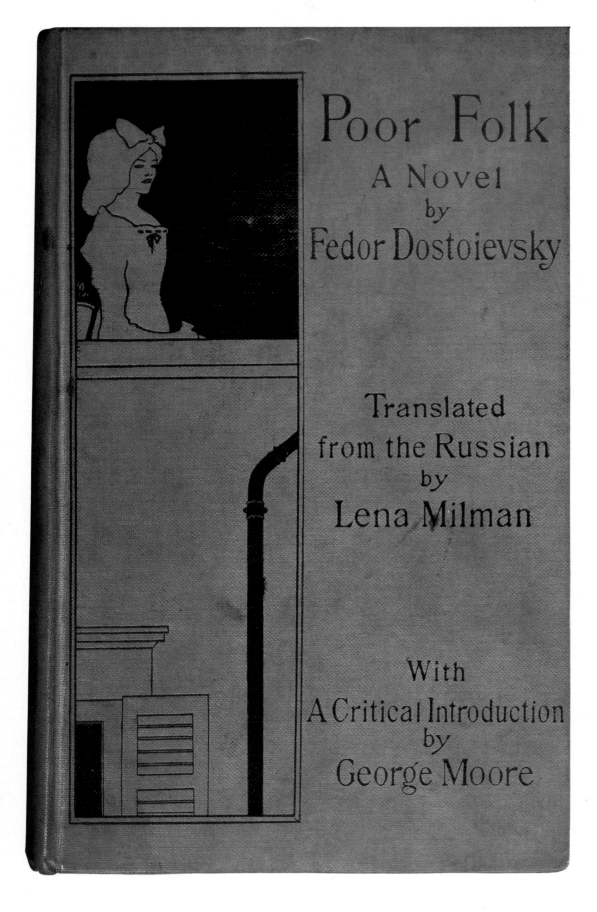

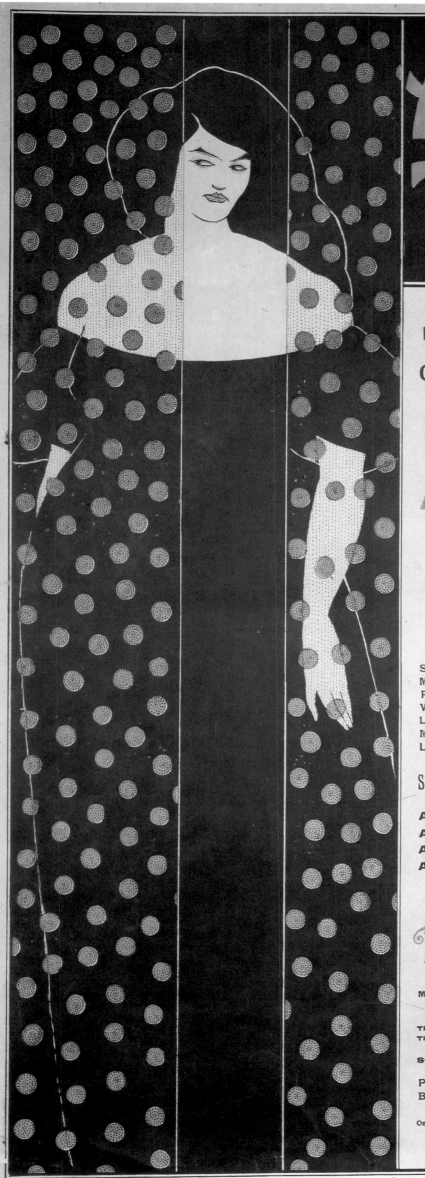

AVENUE THEATRE

(Licensed by the LORD CHAMBERLAIN to GEORGE PAGET, Esq)

Northumberland Avenue, Charing Cross, W.C.

Manager - Mr. C. T. H. HELMSLEY

ON THURSDAY, March 29th, 1894,

And every Evening at 8-50,

A New and Original Comedy, in Four Acts, entitled,

A COMEDY OF SIGHS!

By JOHN TODHUNTER.

Sir Geoffrey Brandon, Bart.	-	Mr. BERNARD GOULD
Major Chillingworth	-	Mr. YORKE STEPHENS
Rev. Horace Greenwell	-	Mr. JAMES WELCH
Williams	-	Mr. LANGDON
Lady Brandon (Carmen)	-	Miss FLORENCE FARR
Mrs. Chillingworth	-	Miss VANE FEATHERSTON
Lucy Vernon	-	Miss ENID ERLE

Scene - THE DRAWING-ROOM AT SOUTHWOOD MANOR

Time—THE PRESENT DAY—Late August.

ACT I.	-	AFTER BREAKFAST
ACT II.	-	AFTER LUNCH
ACT III.	-	BEFORE DINNER
ACT IV.	-	AFTER DINNER

Preceded at Eight o'clock by

A New and Original Play, in One Act, entitled,

The LAND OF HEART'S DESIRE

By W. B. YEATS.

Mr. JAS. WELCH. Mr. A. E. W. MASON, & Mr. G. R. FOSS: Miss WINIFRED
FRASER. Miss CHARLOTTE MORLAND, & Miss DOROTHY PAGET.

The DRESSES by NATHAN, CLAUDE, LIBERTY & Co., and BENJAMIN.
The SCENERY by W. T. HEMSLEY. The FURNITURE by HAMPDEN & SONS.

Stage Manager - - - - Mr. G. R. FOSS

Doors open at 7-40, Commence at 8. Carriages at 11.

PRICES :--Private Boxes, £1 1s. to £4 4s. Stalls, 10s.6d.
Balcony Stalls. 7s. Dress Circle. 5s. Upper Circle (Reserved), 3s.
Pit, 2s.6d. Gallery, 1s.

On and after March 26th, the Box Office will be open Daily from 10 to 5 o'clock, and 8 till 10. Seats
can be Booked by Letter, Telegram, or Telephone No. 35297.

NO FEES. **NO FEES.** **NO FEES.**

STAFFORD & Co. NETHER LY NOTTINGHAM.

E 283-1925.

Front Wrapper of 'The Idler', 1894
Black on salmon-colored paper
From the line-block
Courtesy of the Trustees of the Victoria and Albert Museum, London

La Dame aux Camélias, 1894
Indian ink and watercolor
11 × 7⅛ inches (28.6 × 18.4 cm)
(Reproduced larger than actual size)
Tate Gallery, London

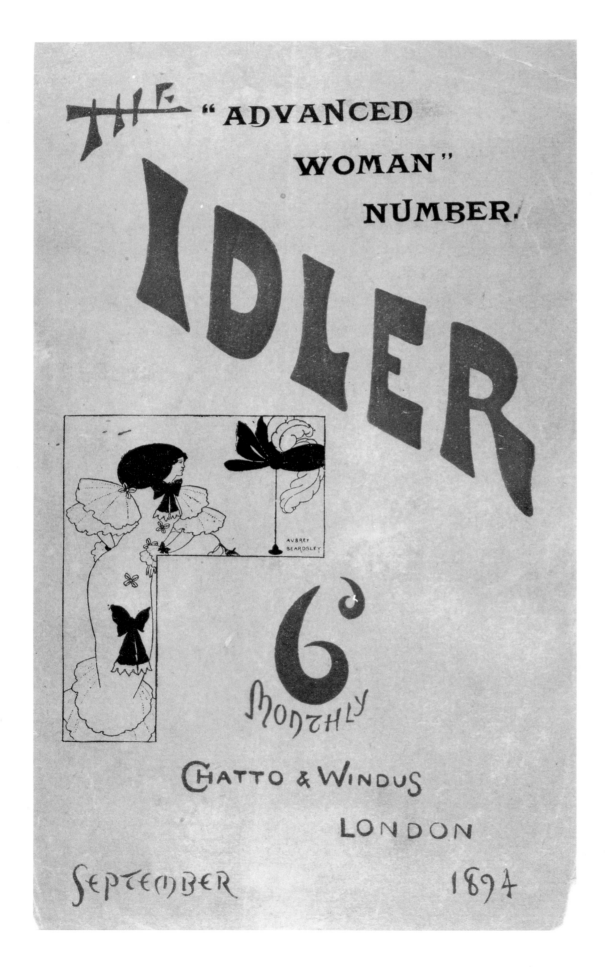

THE "ADVANCED WOMAN" NUMBER.

IDLER

AUBREY BEARDSLEY

6
MONTHLY

CHATTO & WINDUS

LONDON

SEPTEMBER 1894

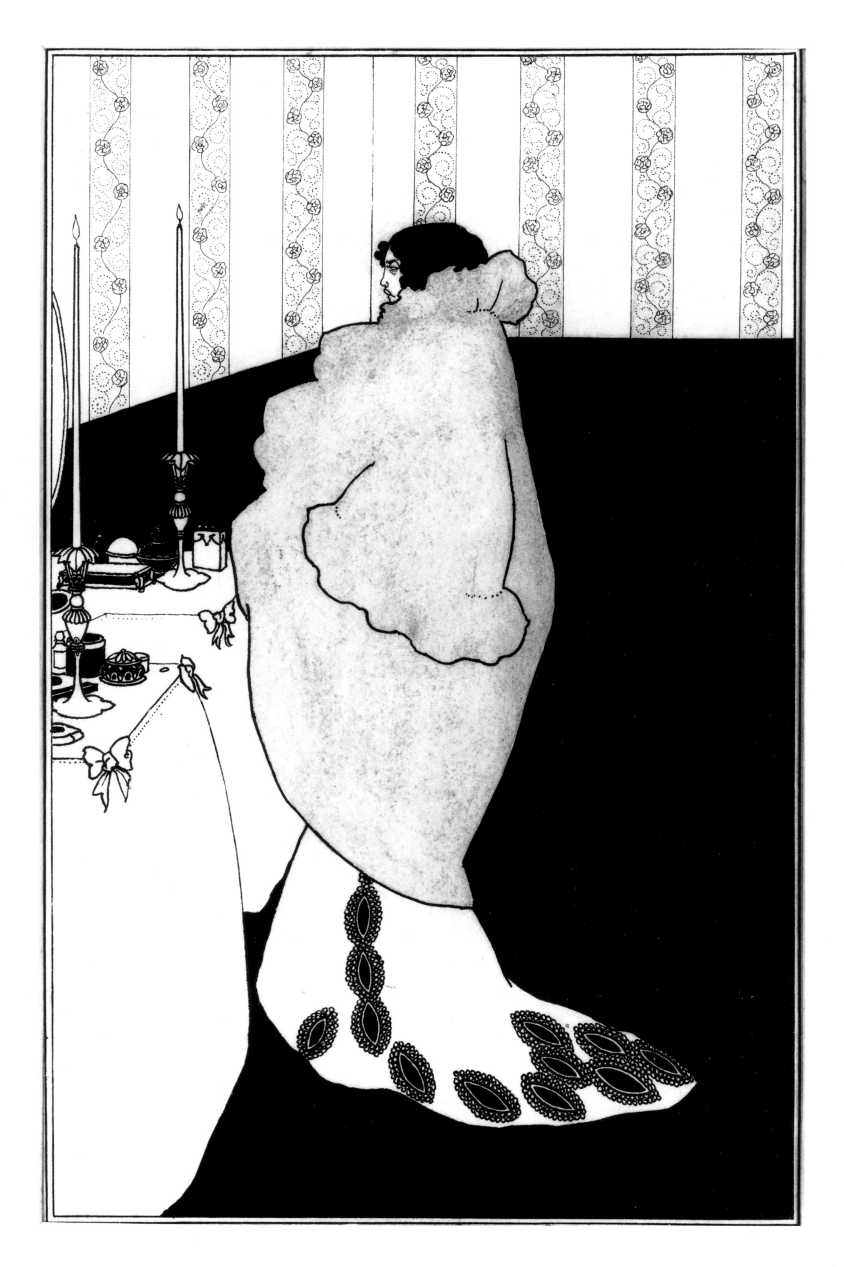

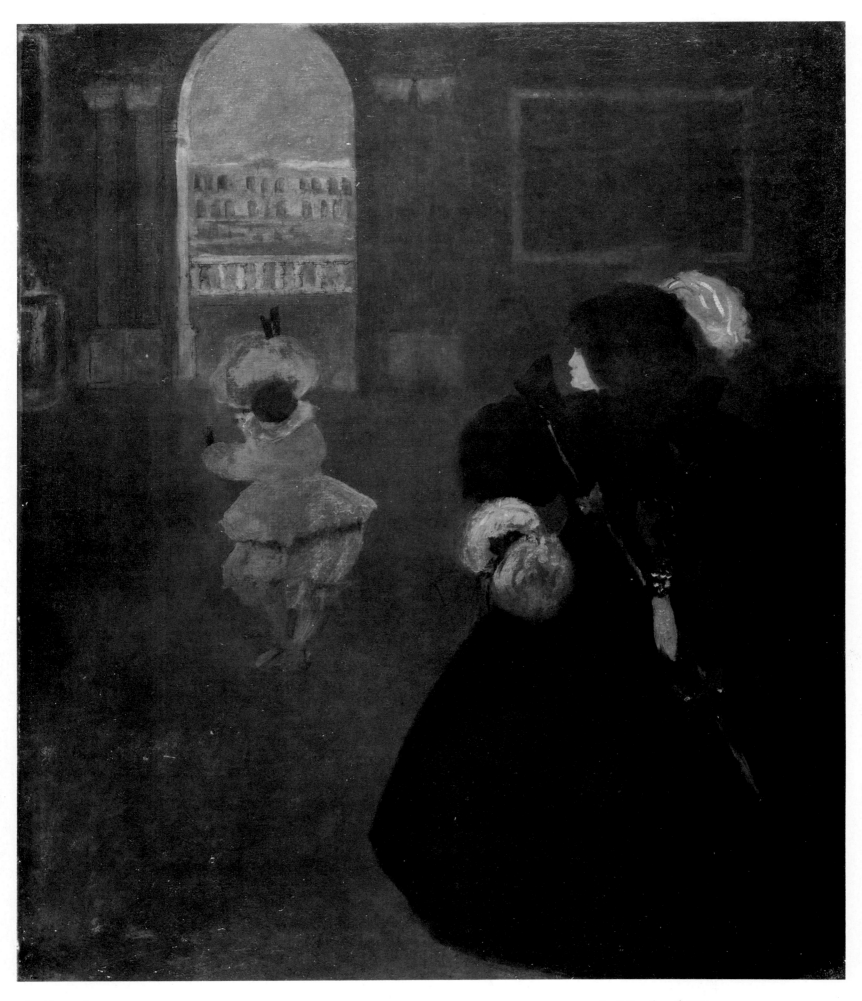

A Caprice, c. 1894
Oil on canvas
30 × 25 inches (76.8 × 64 cm)
Tate Gallery, London

A Masked Woman, c. 1894
Oil on canvas
25¾ × 20¼ inches (65.9 × 51.8 cm)
Tate Gallery, London

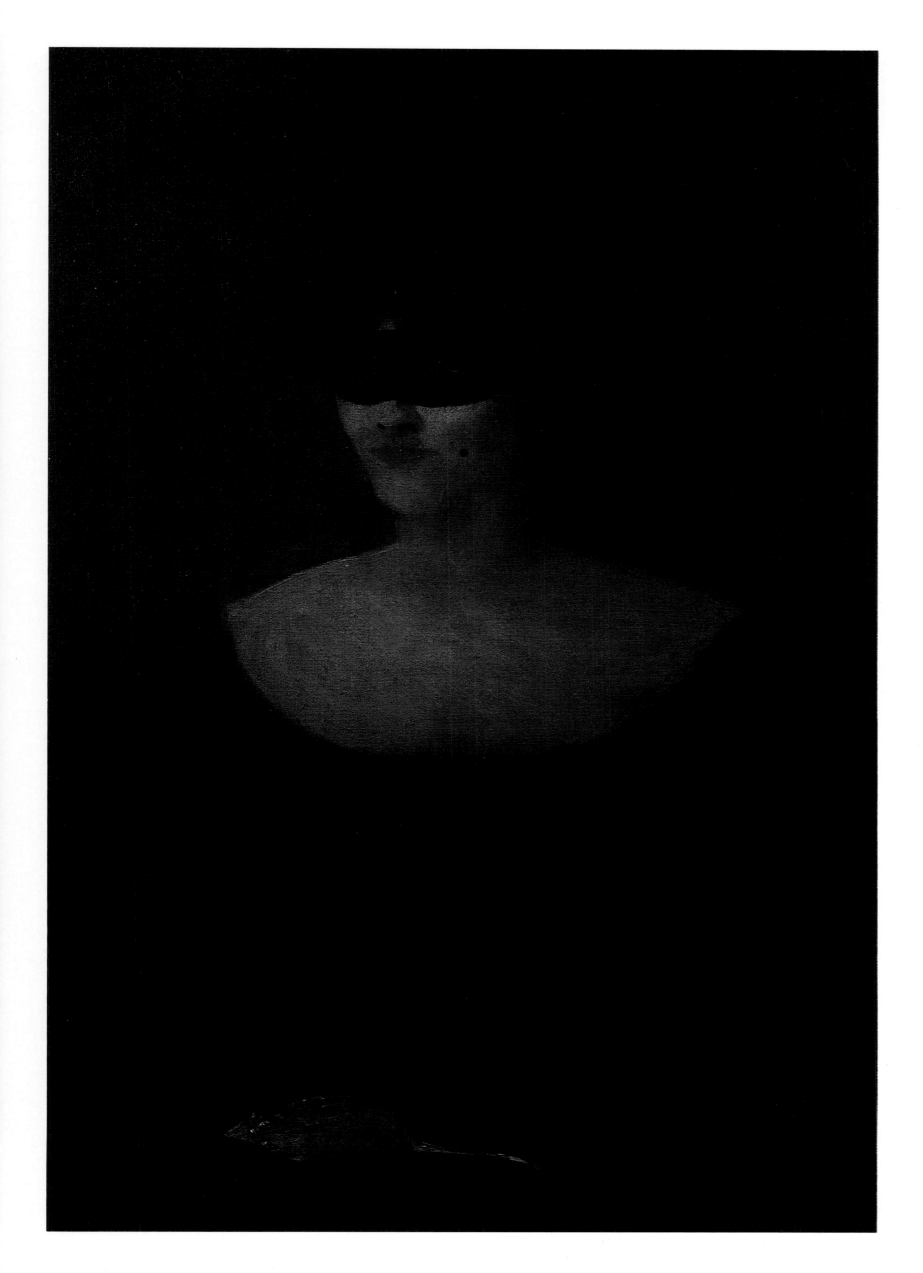

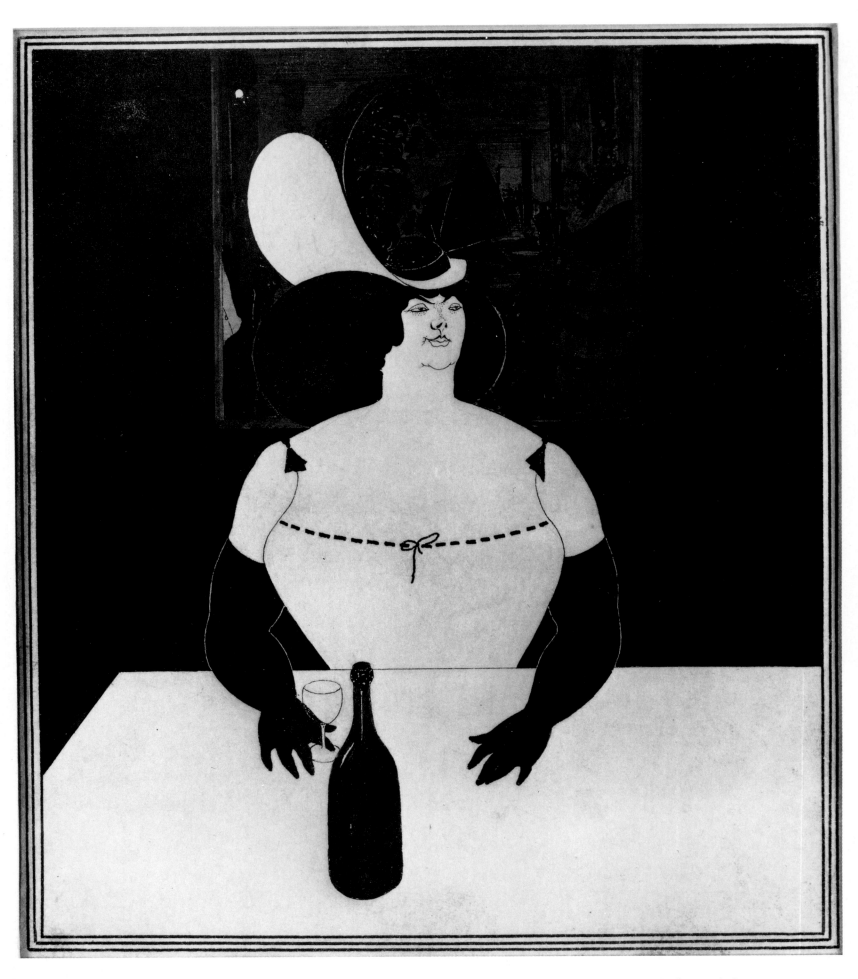

The Fat Woman, c. 1894
Indian ink and wash
7 × 6⅜ inches (17.9 × 16.4 cm)
(Reproduced larger than actual size)
Tate Gallery, London

**Poster Advertising
'Children's Books',** 1894
Color lithograph
30 × 20 inches (76.2 × 50.8 cm)
Courtesy of the Trustees of the Victoria
and Albert Museum, London

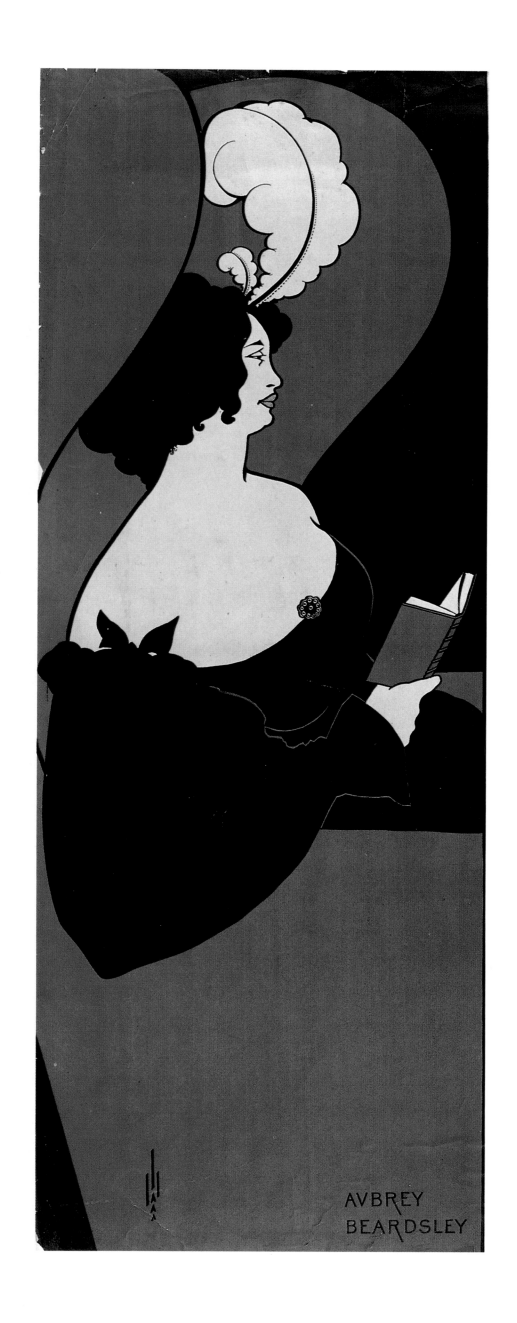

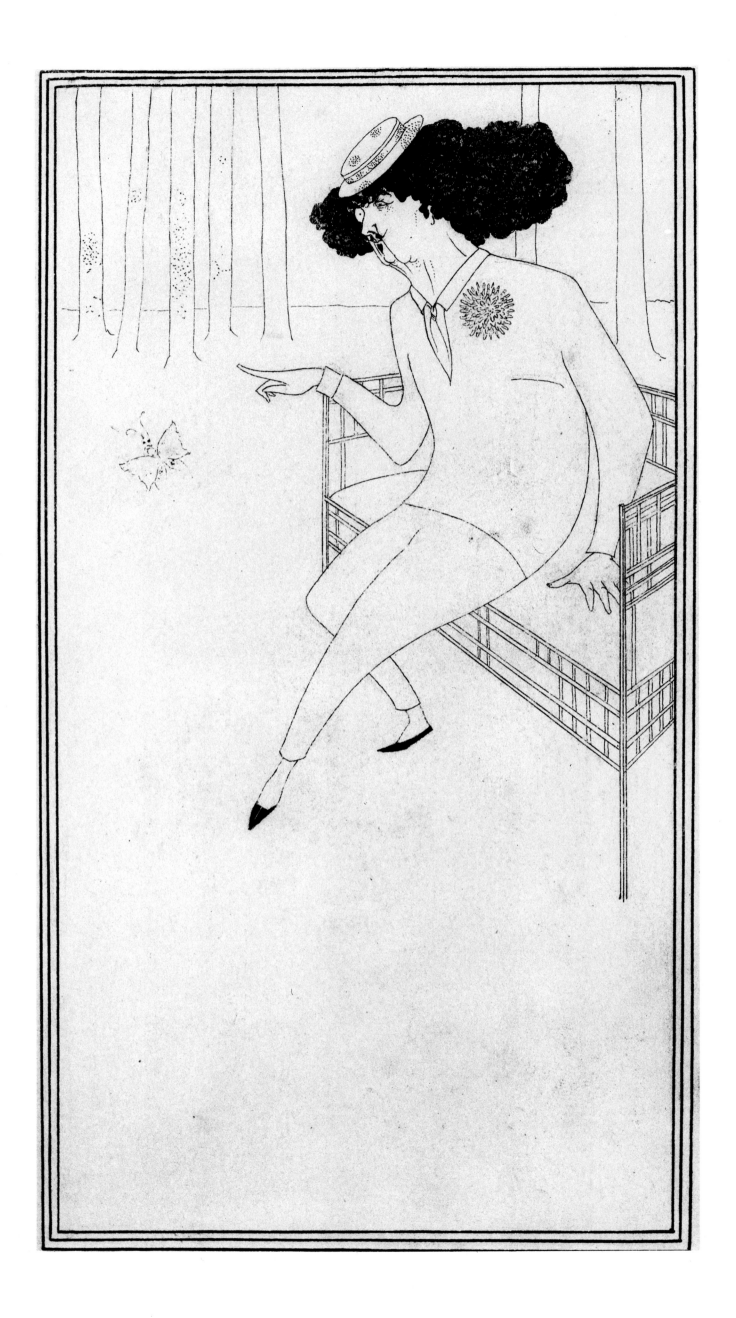

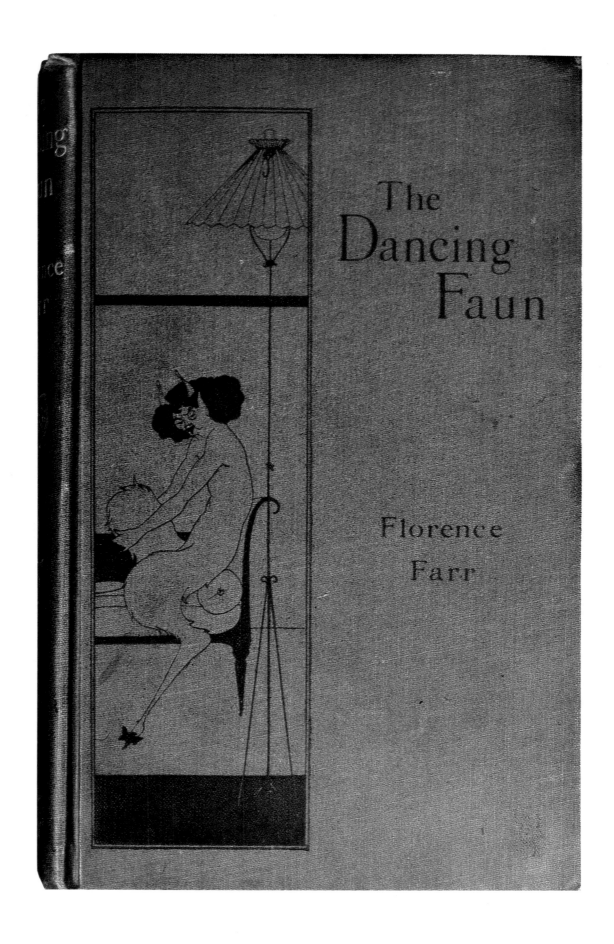

Caricature of Whistler on a Garden Seat Pointing to a Butterfly, c. 1893-94
Indian ink
8⅝6 × 4⅝ inches (21.1 × 11.8 cm)
National Gallery of Art, Washington
Rosenwald Collection

Cover of 'The Dancing Faun', 1894
Cloth stamped with title and design in black
Private Collection

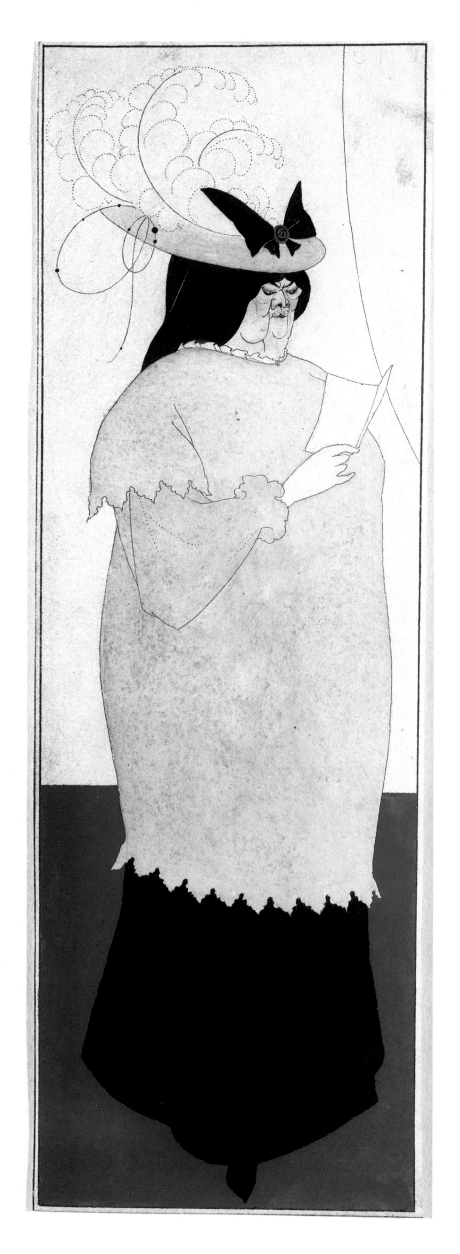

Part of the Drawing 'L'Education Sentimentale', 1894
Indian ink, pencil, and watercolor
10⅝ × 3½ inches (27 × 9 cm)
Fogg Art Museum, Harvard University, Cambridge, Massachusetts
Grenville L Winthrop Bequest

Self-portrait 'Par les Dieux Jumeaux Tous les Monstres Ne Sont Pas en Afrique', 1894
From the line-block
Courtesy of the Trustees of the Victoria and Albert Museum, London

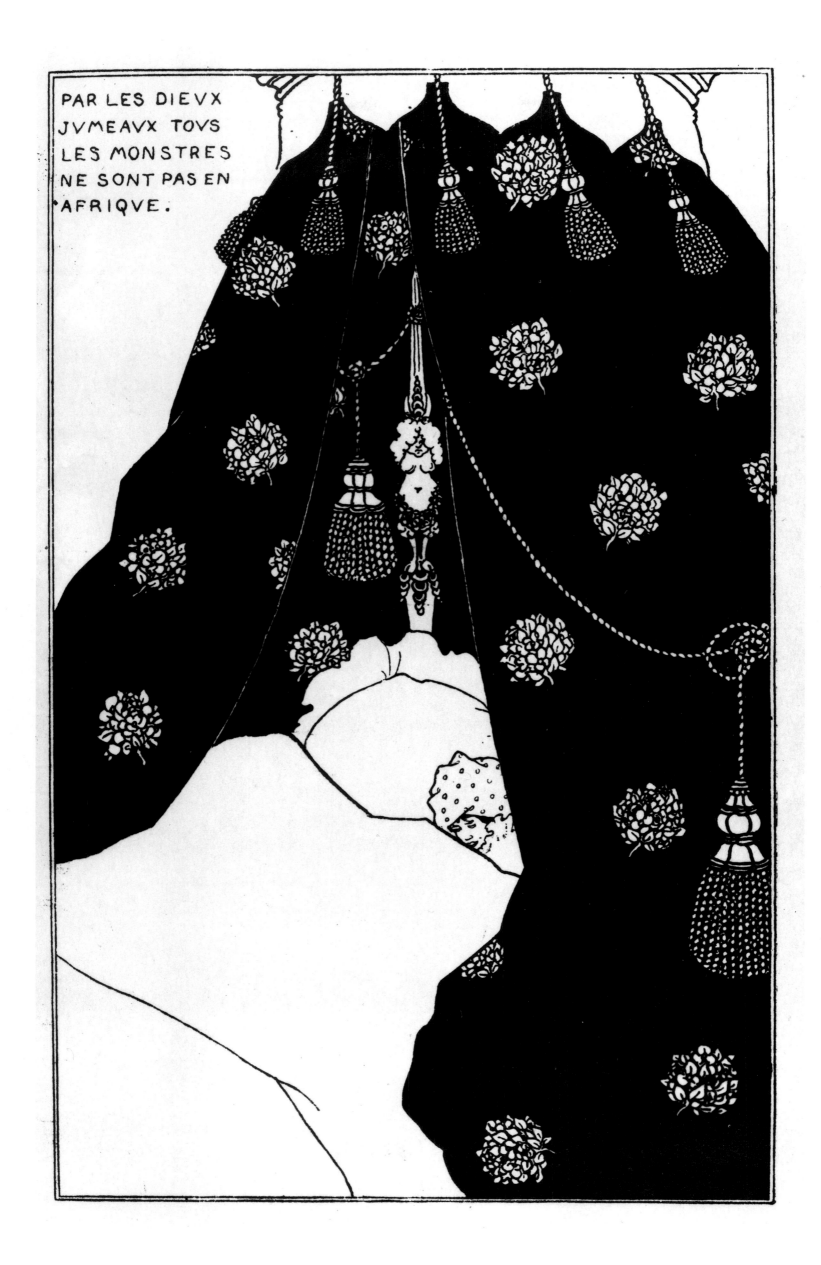

PAR LES DIEVX
JVMEAVX TOVS
LES MONSTRES
NE SONT PAS EN
AFRIQVE.

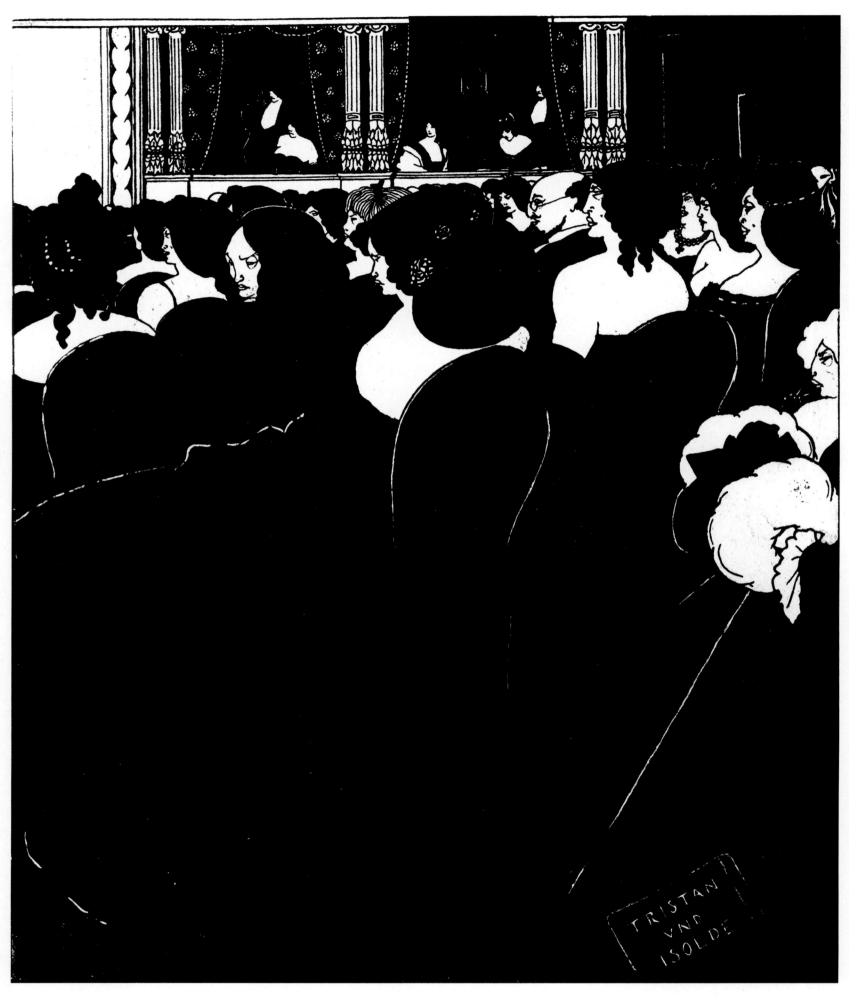

The Wagnerites, 1894
Indian ink touched with white
8⅛ × 7 inches (20.8 × 17.9 cm)
(Reproduced larger than actual size)
Victoria and Albert Museum, London

**The Mysterious Rose
Garden,** 1895
Indian ink over pencil
8¹³⁄₁₆ × 4⅞ inches (22.4 × 12.2 cm)
(Reproduced larger than actual size)
Fogg Art Museum, Harvard
University, Cambridge, Massachusetts
Grenville L Winthrop Bequest

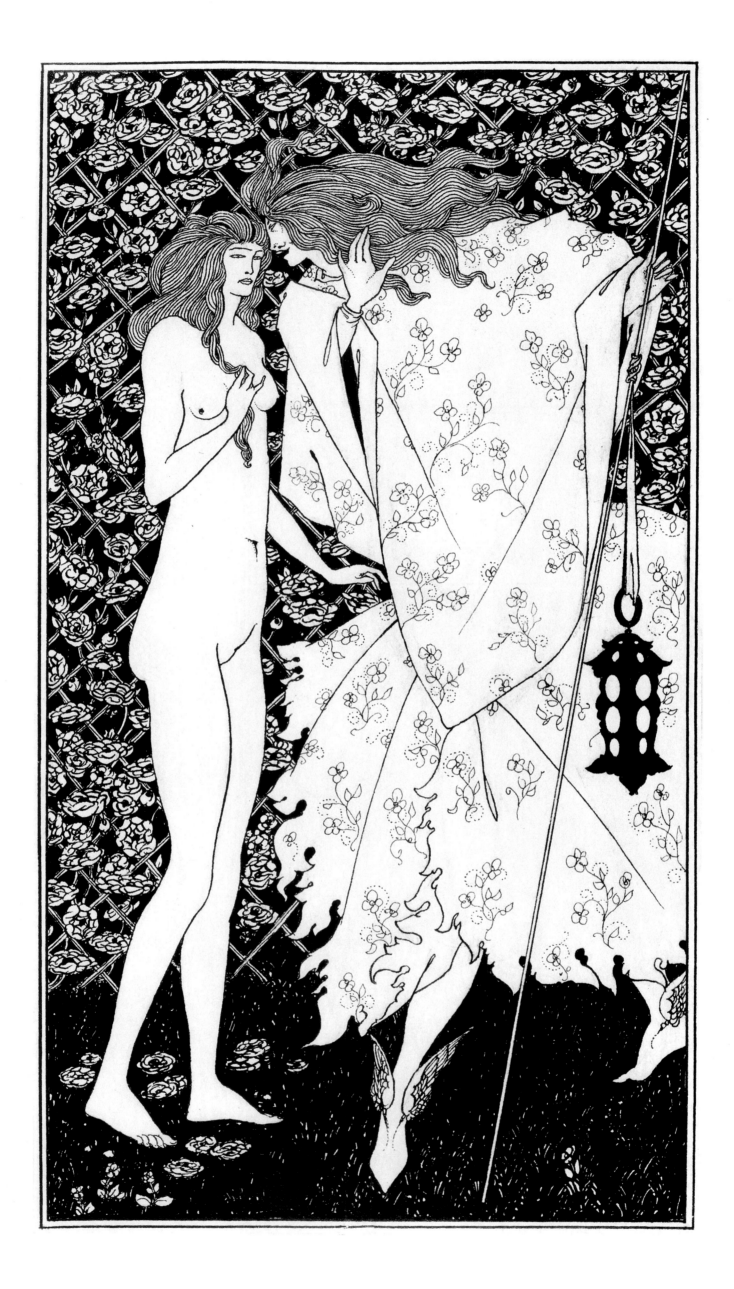

Design for 'The Yellow Book' Prospectus, 1894
Indian Ink
9½ × 6⅛ inches (24.1 × 15.6 cm)
Courtesy of the Trustees of the Victoria
and Albert Museum, London

Drawing for the Frontispiece to 'A Full and True Account of Wonderful Mission of Earl Lavender. . .', 1895
Indian ink
10⅛ × 6 3/16 inches (25.9 × 15.6 cm)
(Reproduced larger than actual size)
Fogg Art Museum, Harvard
University, Cambridge, Massachusetts
Grenville L Winthrop Bequest

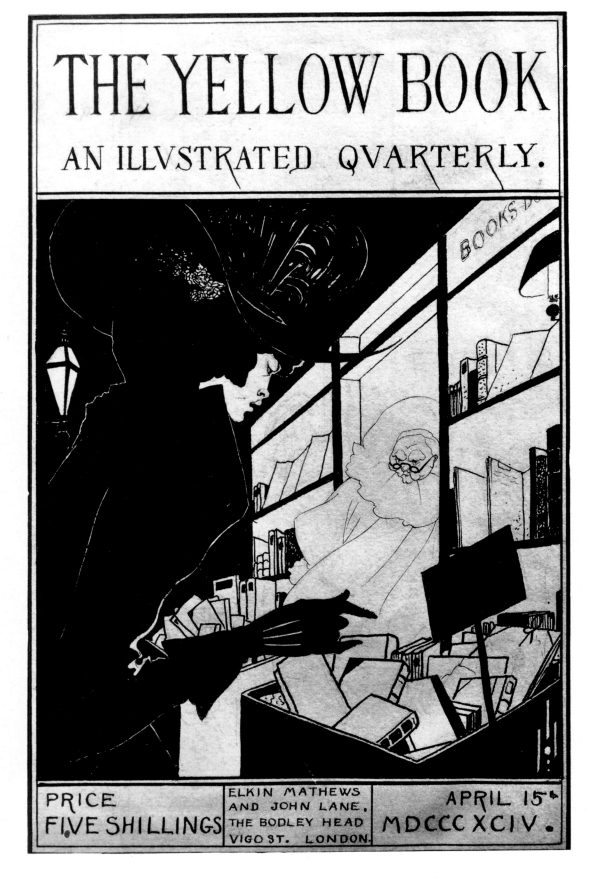

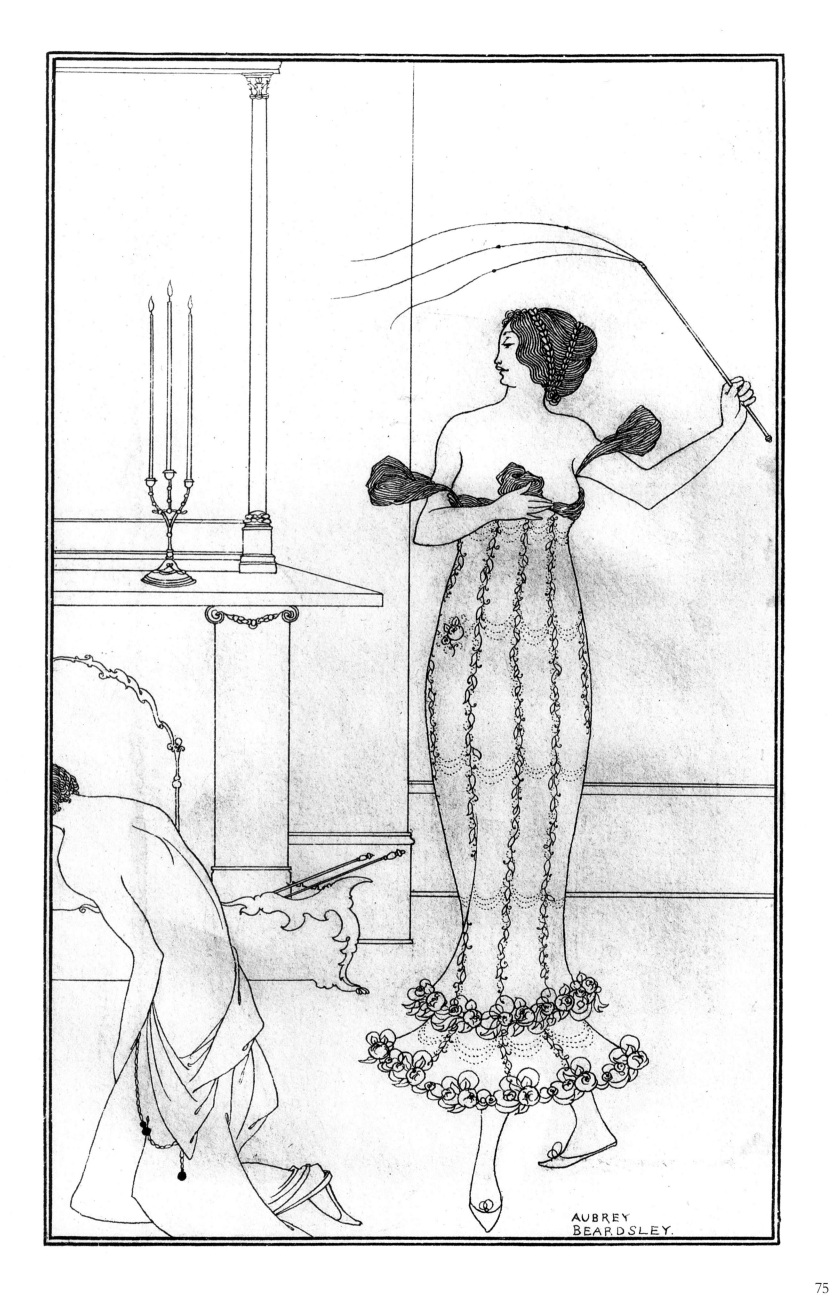

The Slippers of Cinderella,
1894
Indian ink and colored wash
Formerly Bonham's, London

The Mirror of Love, 1895
Indian ink
$10\frac{13}{16} \times 6$ inches (27.7 × 15.3 cm)
(Reproduced larger than actual size)
Courtesy of the Trustees of the Victoria
and Albert Museum, London

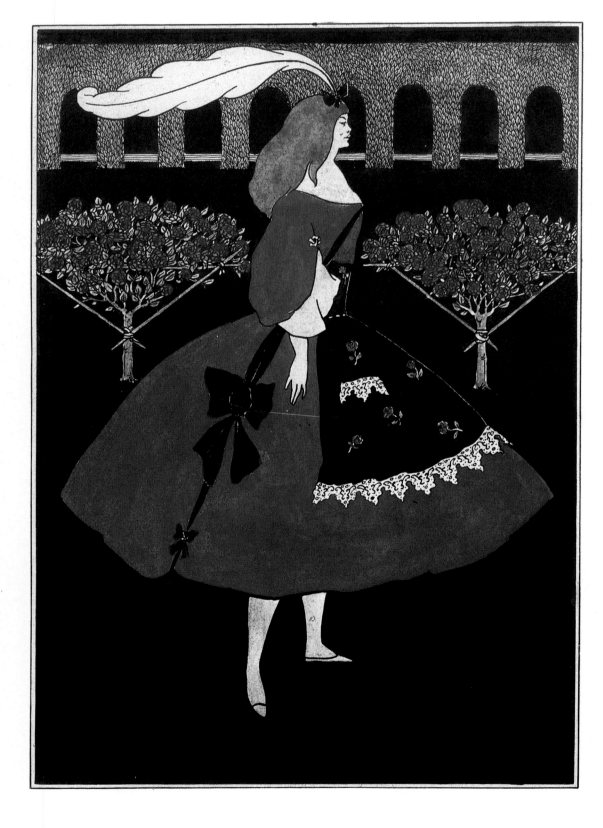

The Slippers of Cinderella,
1894
Indian ink and colored wash
Formerly Bonham's, London

The Mirror of Love, 1895
Indian ink
$10\frac{13}{16} \times 6$ inches (27.7 × 15.3 cm)
(Reproduced larger than actual size)
Courtesy of the Trustees of the Victoria
and Albert Museum, London

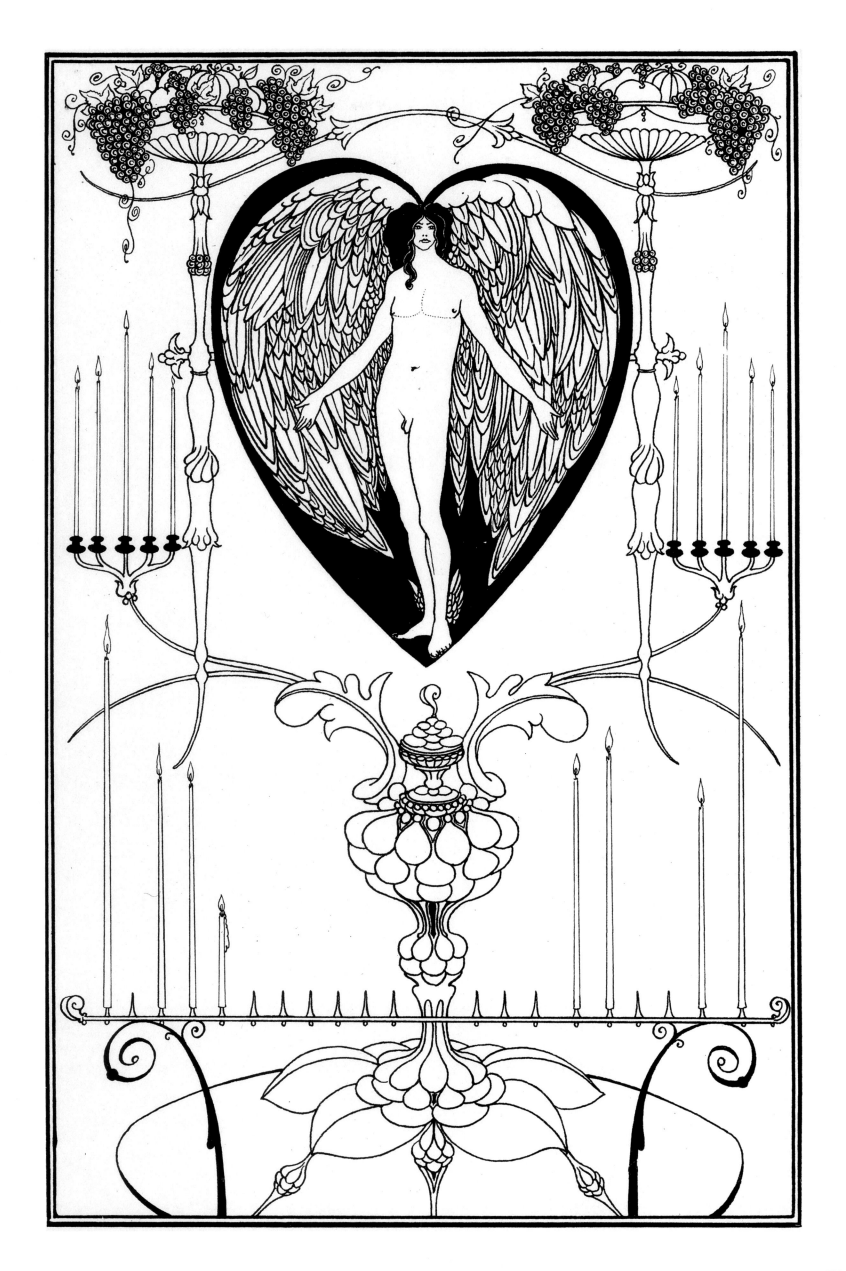

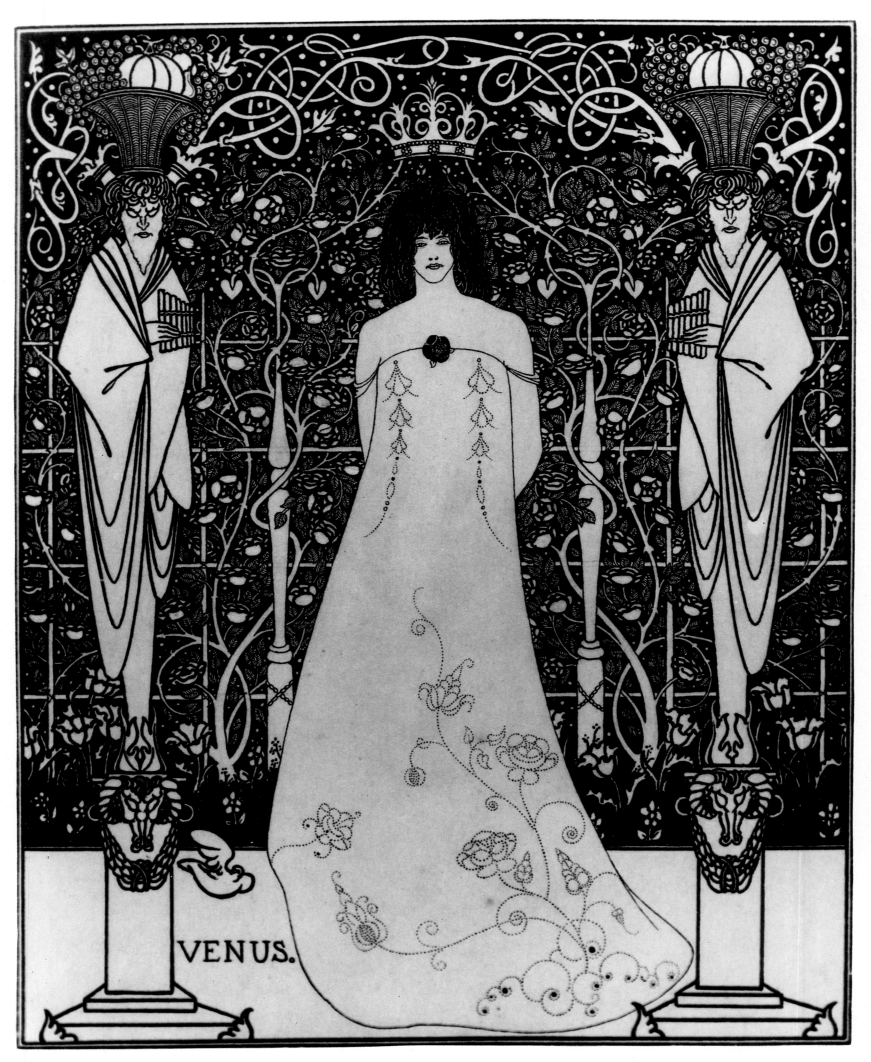

Venus between Terminal Gods, 1895
Design for *The Story of Venus and Tannhäuser*
Indian ink touched with white
8⅞ × 7 inches (22.5 × 17.8 cm)
(Reproduced larger than actual size)
Cecil Higgins Art Gallery, Bedford

Isolde, 1895
Color lithograph in red, green, gray and black
Private Collection

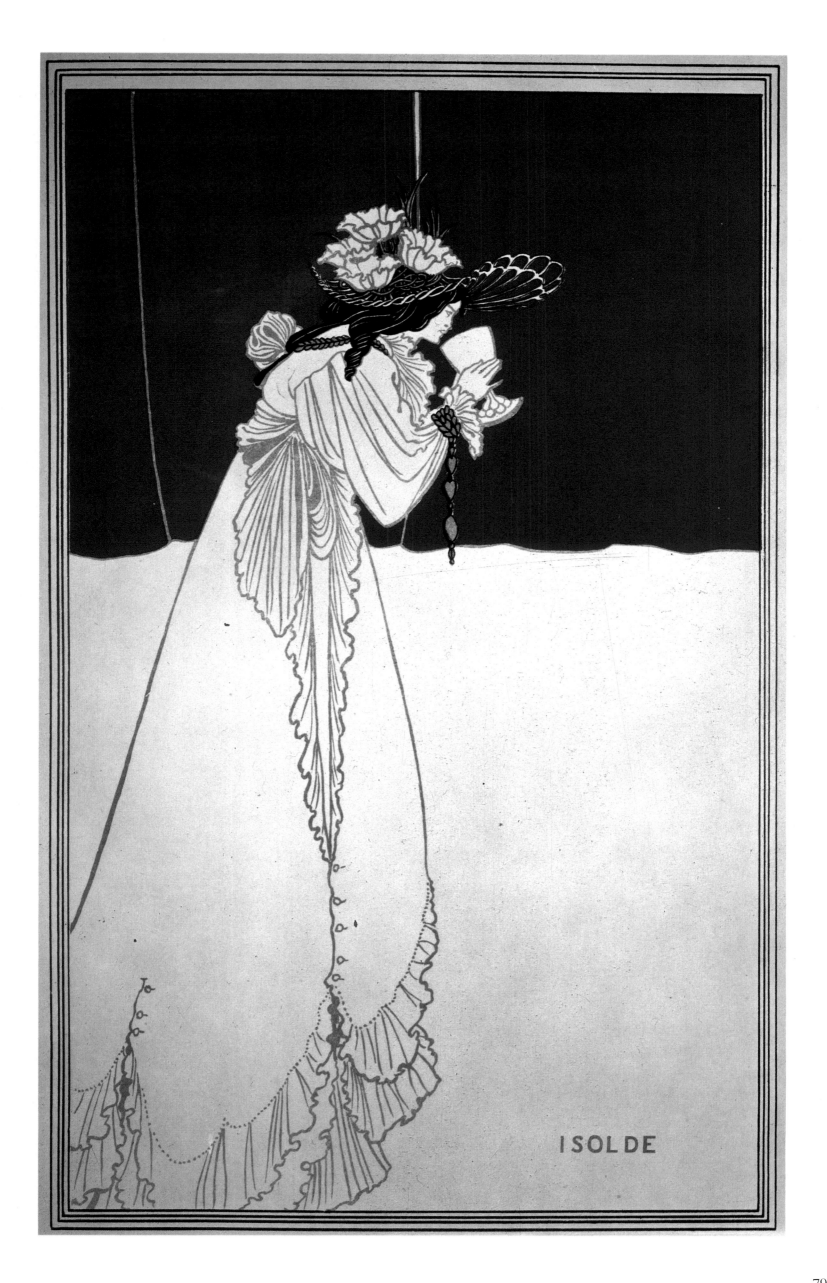

ISOLDE

Lady Gold's Escort, 1894
Drawing from page 53 of *The Yellow
Book*, volume 3
From the line-block
Courtesy of the Trustees of the Victoria
and Albert Museum, London

Messalina Returning Home,
1895
Pencil, Indian ink and watercolor
11 × 7 inches (28.6 × 17.9 cm)
(Reproduced larger than actual size)
Tate Gallery, London

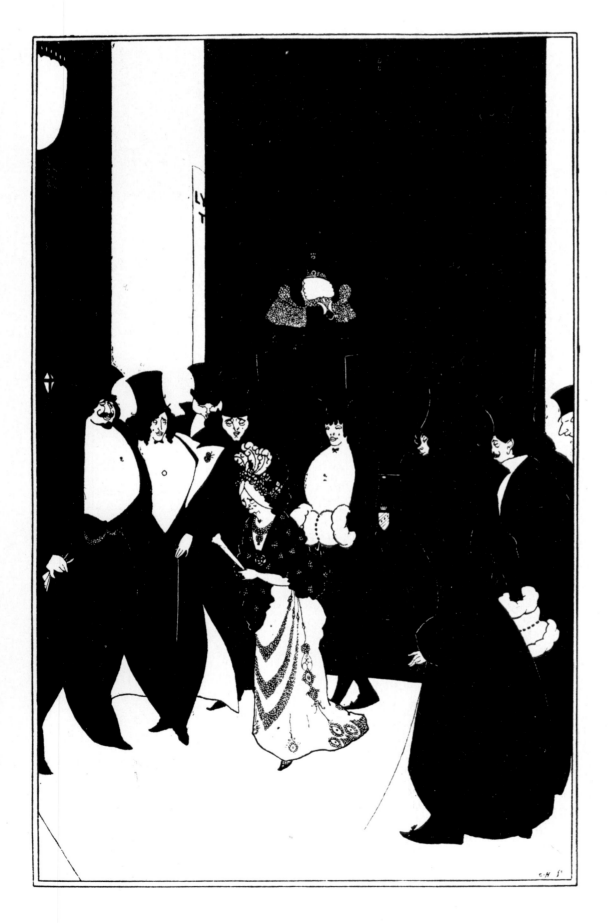

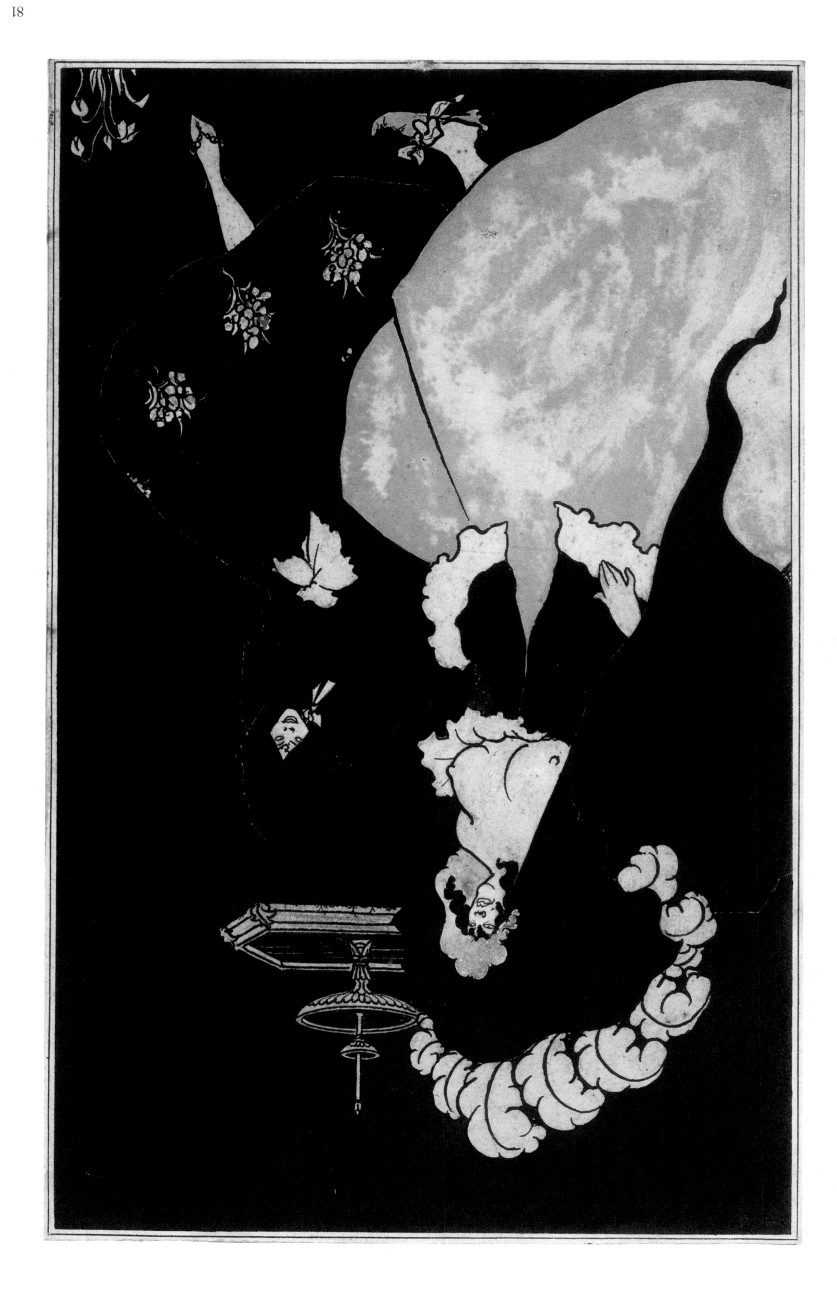

Design for the Front Endpapers of 'Pierrot's Library', 1896
From the line-block
Courtesy of the Trustees of the Victoria and Albert Museum, London

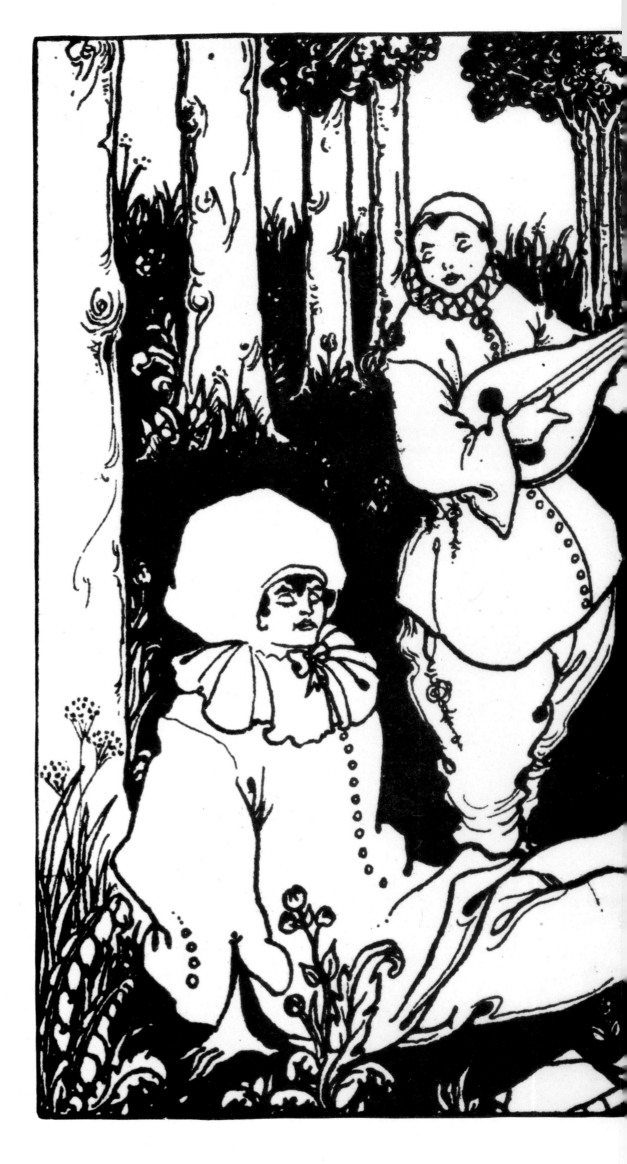

**Design for the Back
Endpapers of 'Pierrot's
Library',** 1896
From the line–block
Courtesy of the Trustees of the Victoria
and Albert Museum, London

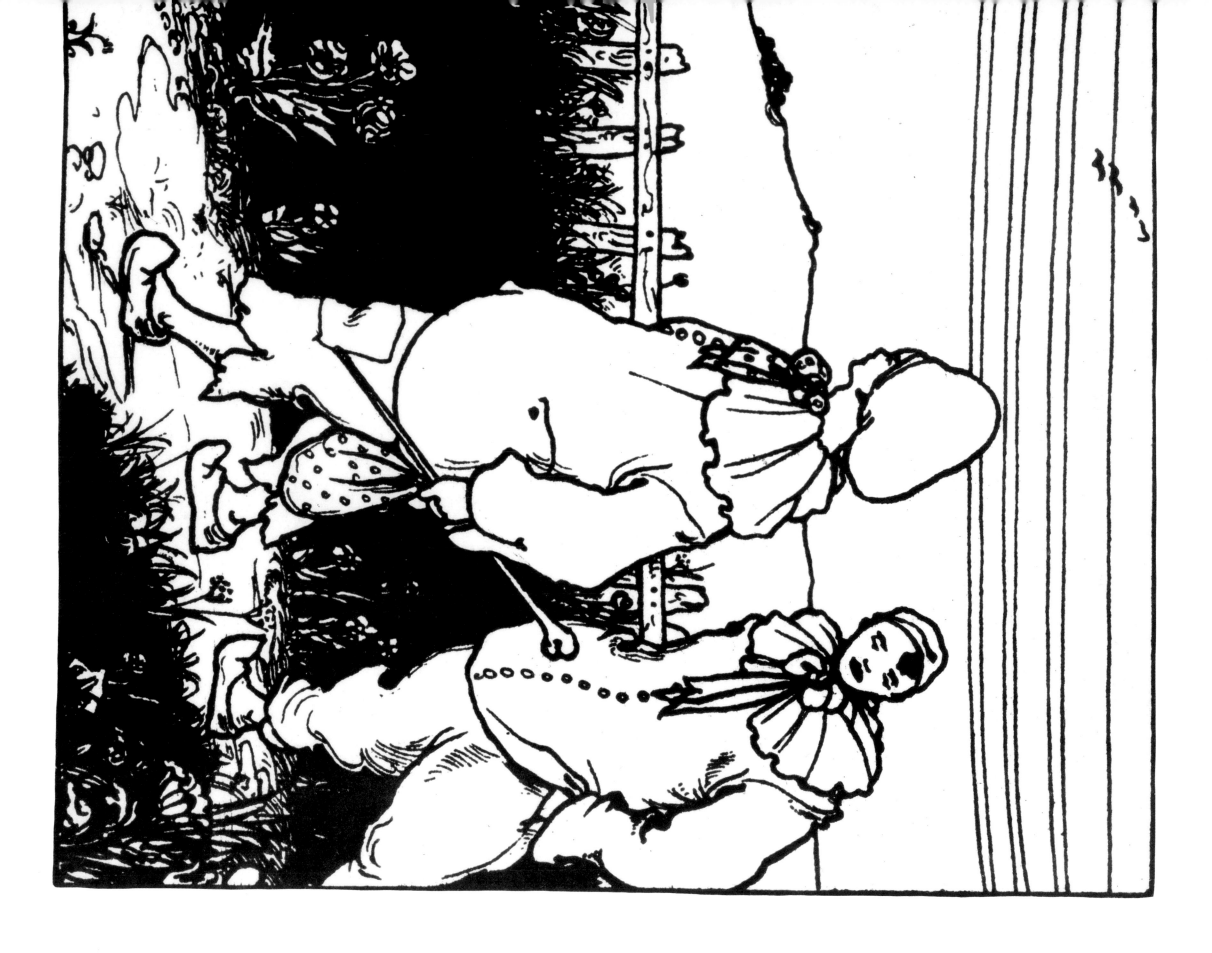

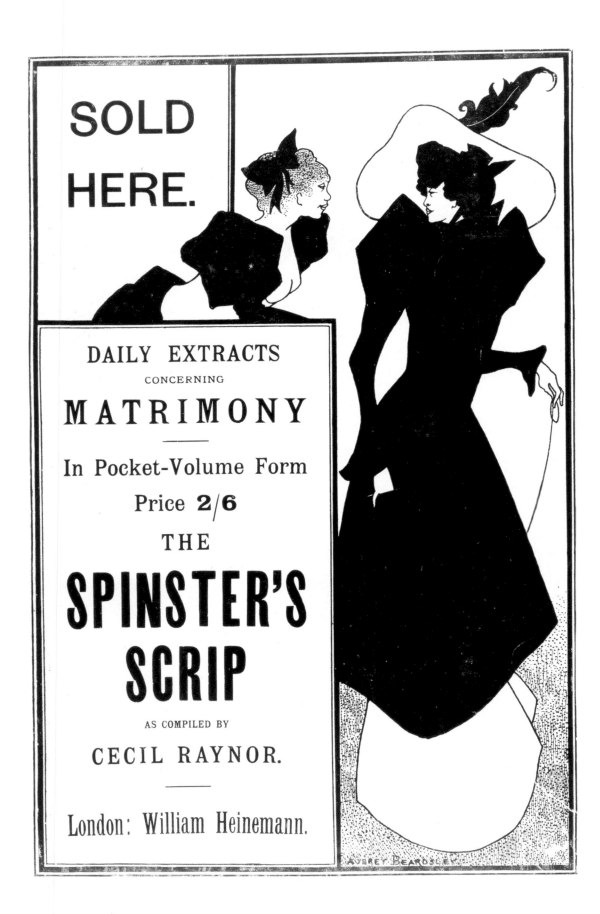

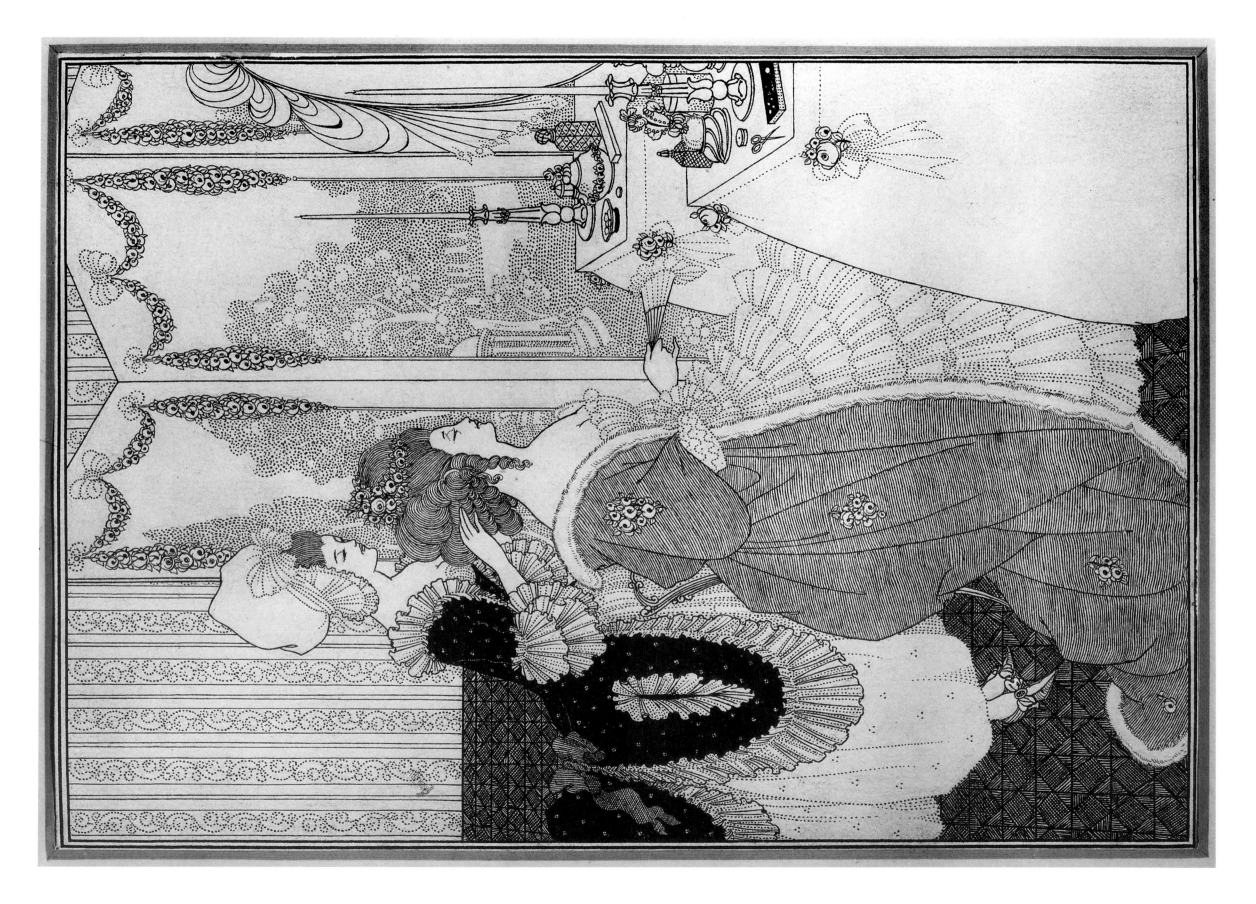

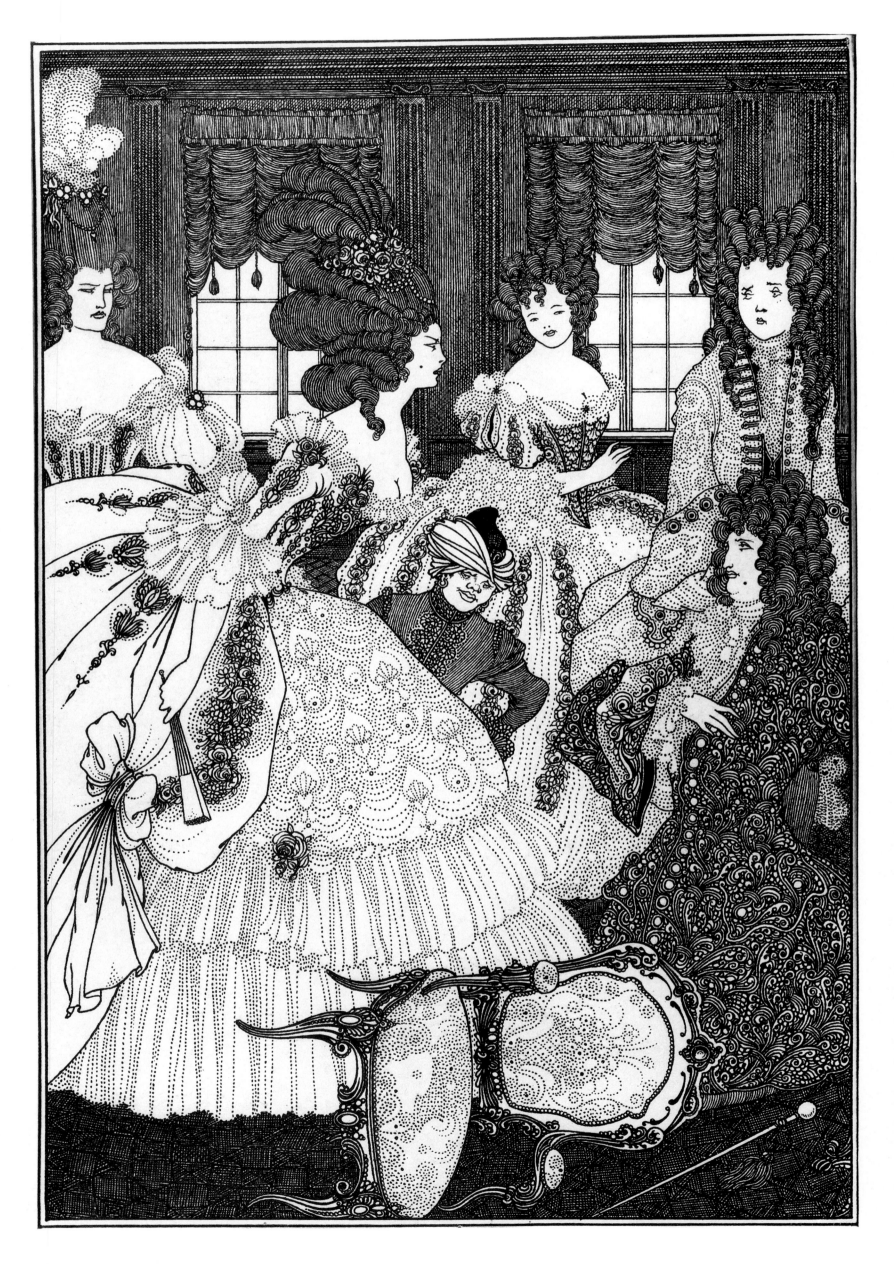

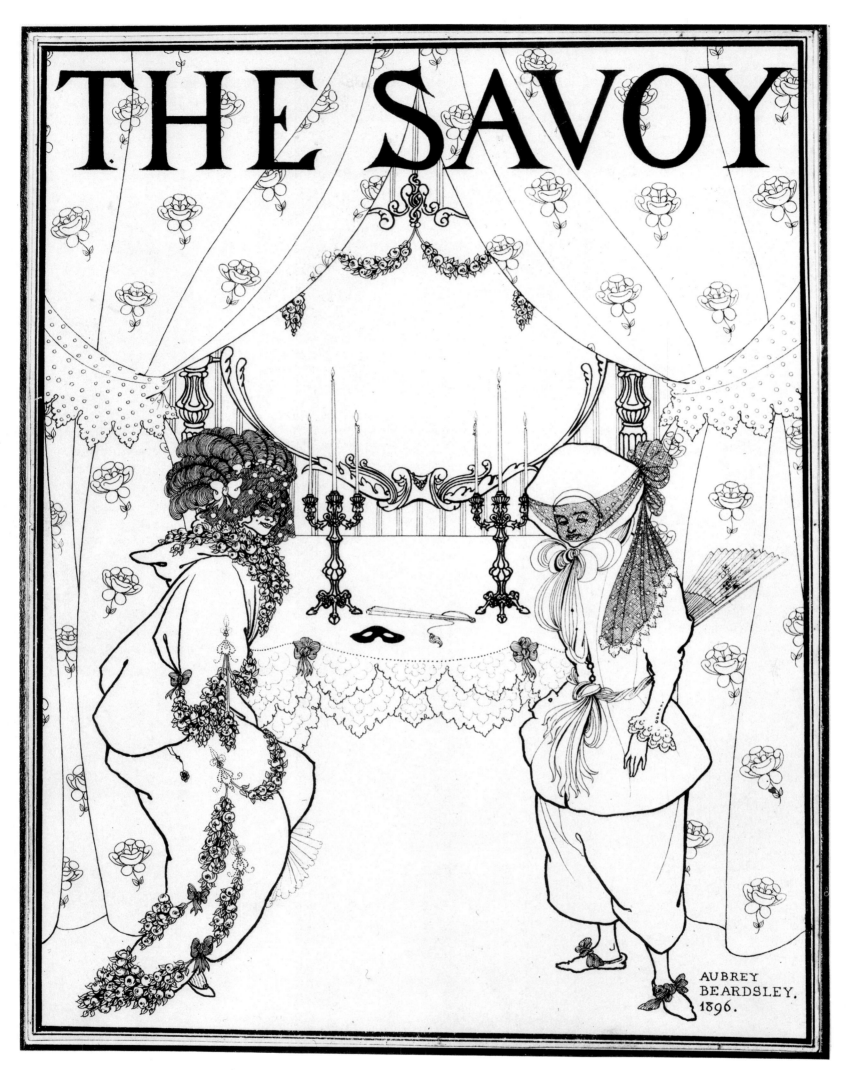

**The Battle of the Beaux and
the Belles,** 1896
Drawing for *The Rape of the Lock*
Indian ink
10⅛ × 6¹⁵⁄₁₆ inches (25.7 × 17.6 cm)
Barber Institute of Fine Arts,
University of Birmingham

**Title-page of 'The Savoy,'
No 1,** 1896
Indian ink and pencil
14⅜ × 11 inches (36.9 × 28 cm)
Fogg Art Museum, Harvard
University, Cambridge, Massachusetts
Grenville L Winthrop Bequest

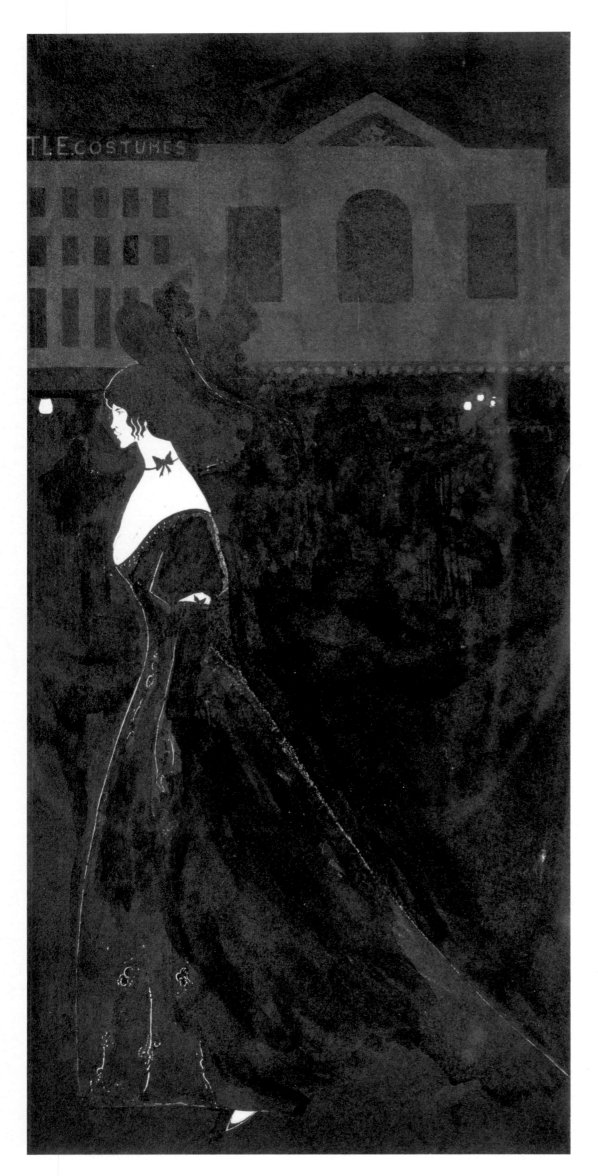

The Abbé, 1896
Indian ink
9¹³⁄₁₆ × 6⅞ inches (25.1 × 17.7 cm)
(Reproduced larger than actual size)
Courtesy of the Trustees of the Victoria
and Albert Museum, London

A Nightpiece, 1894
Illustration to the *Yellow Book*, volume 1
Indian ink and wash
12⅝ × 6⅛ inches (32 × 15.6 cm)
Fitzwilliam Museum, Cambridge

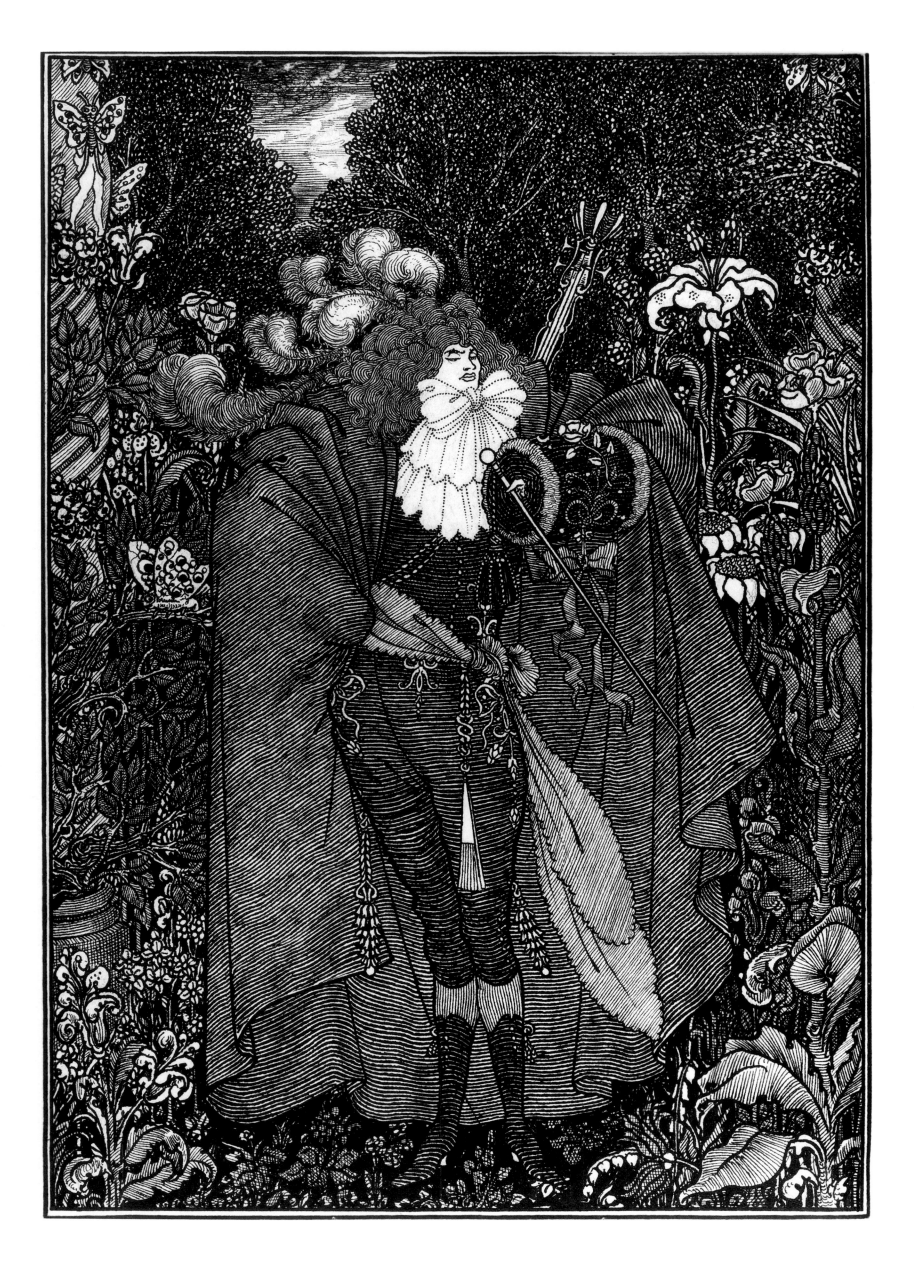

**The Return of Tannhäuser
to the Venusberg,** 1896
From the line-block
Courtesy of the Trustees of the Victoria
and Albert Museum, London

**The Ascension of Saint Rose
of Lima,** 1896
From the line-block
Private Collection

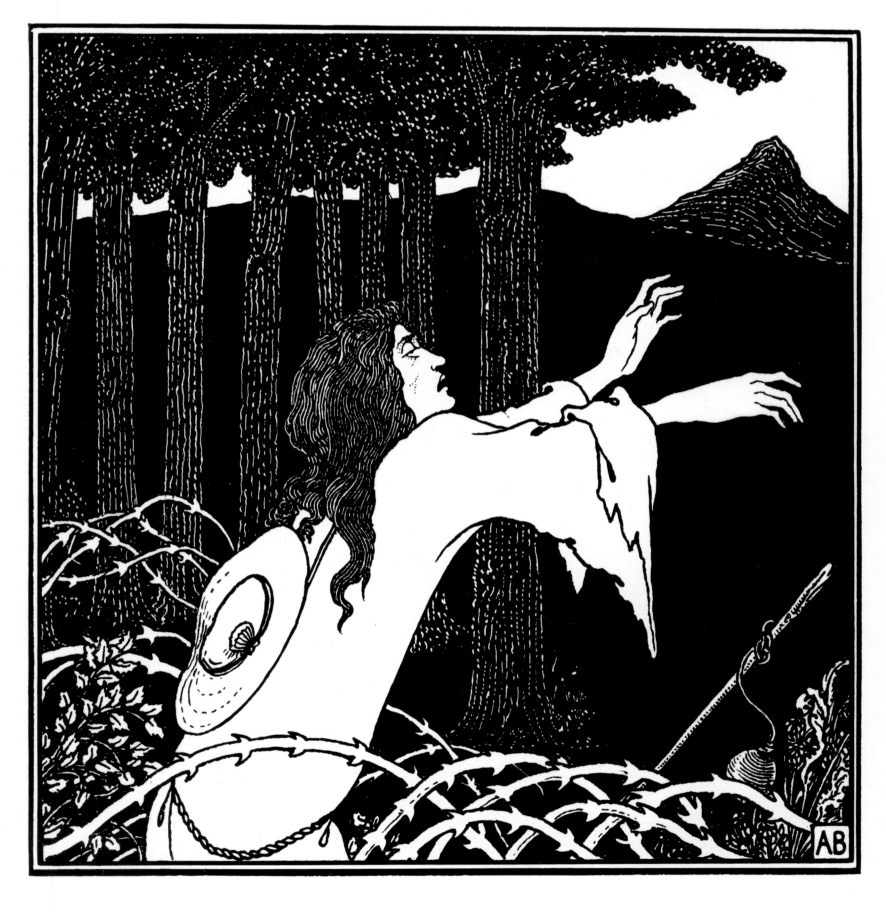

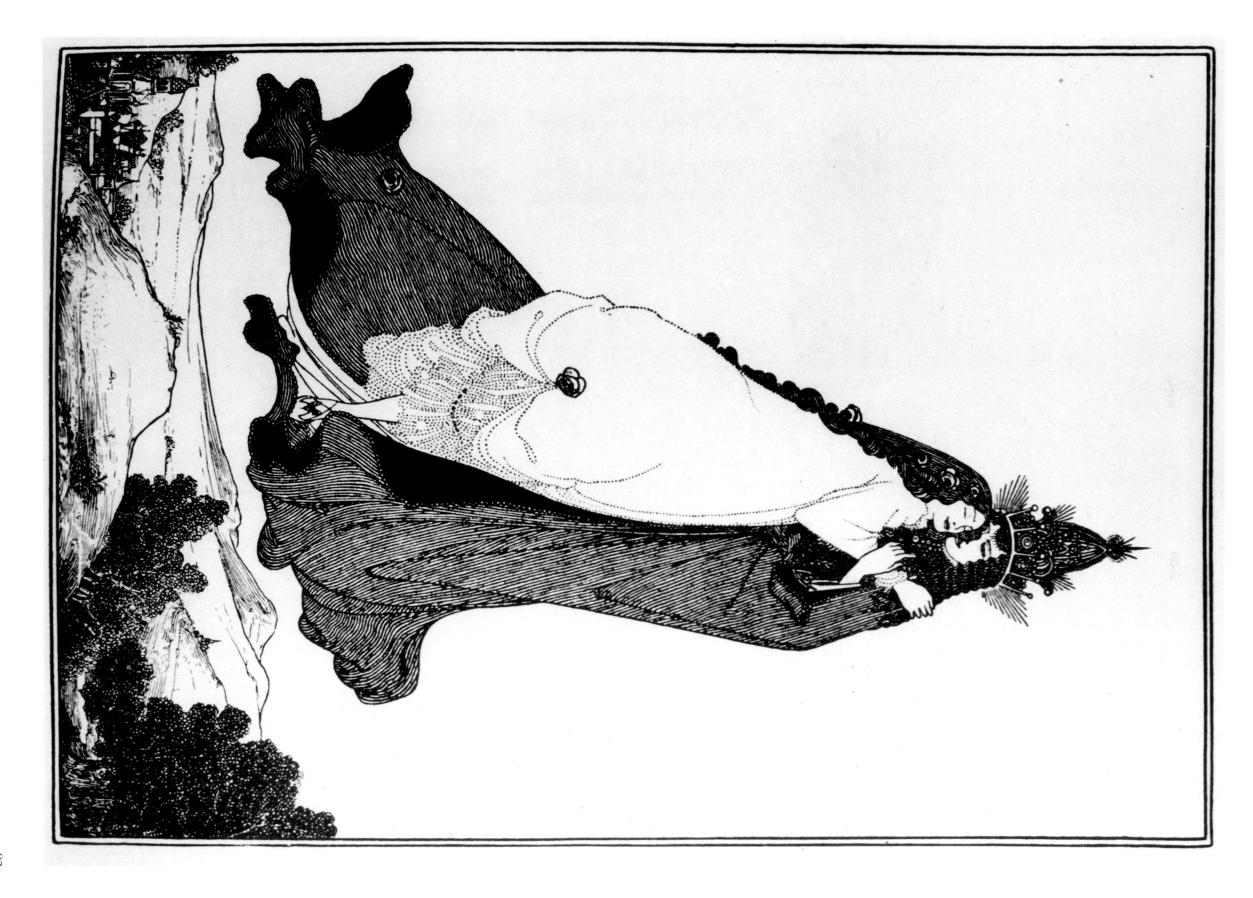

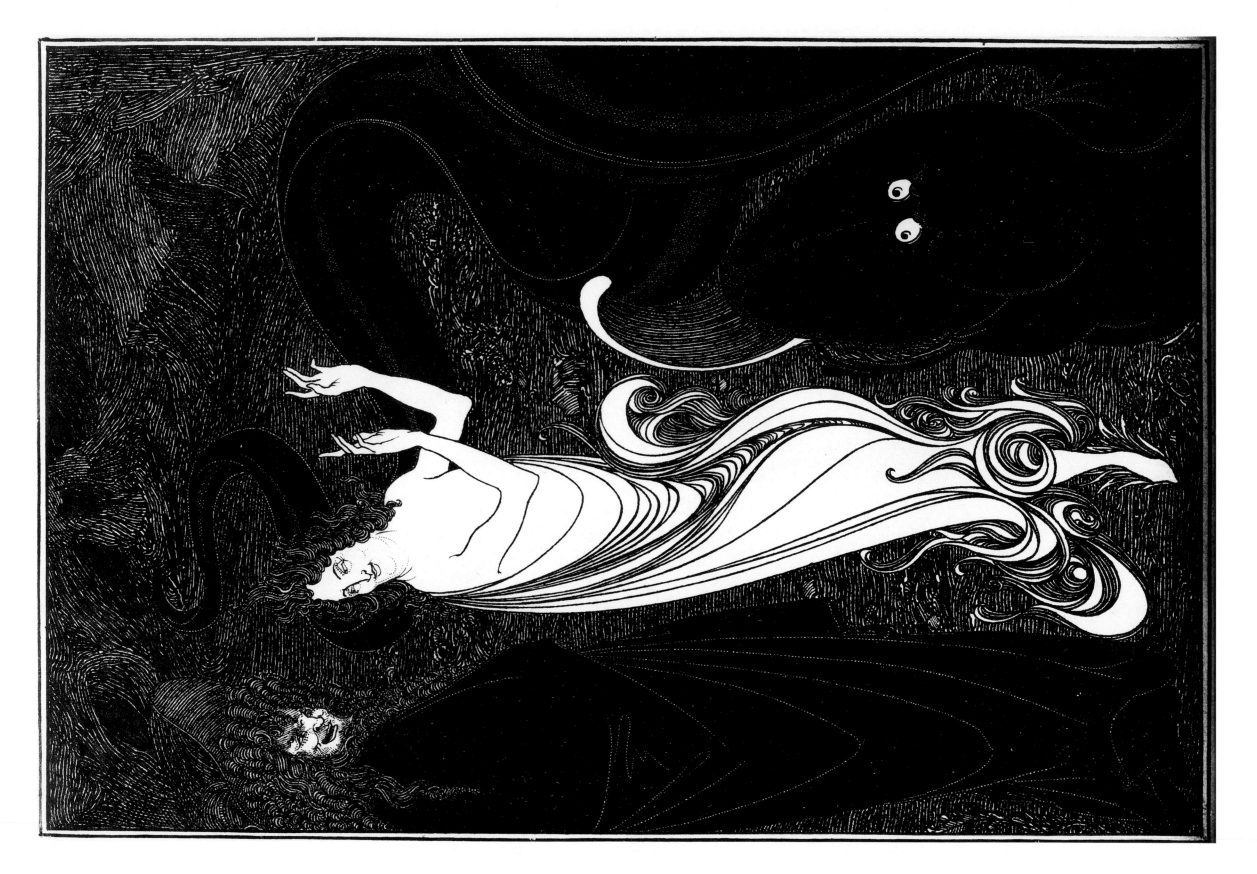

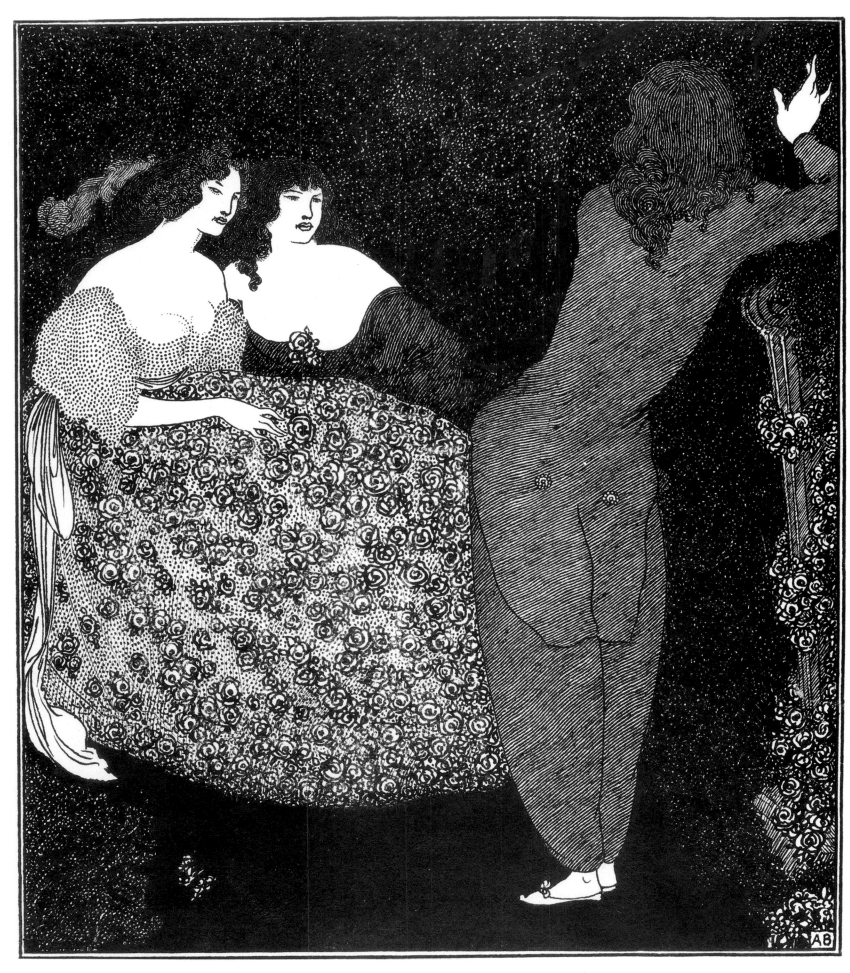

The Third Tableau of 'Das Rheingold' from 'The Savoy', April 1896
Indian Ink
10¹⁄₁₆ × 6⅞ inches (25.6 × 17.4 cm)
(Reproduced larger than actual size)
Museum of Art, Rhode Island School of Design
Museum Appropriation

A Repetition of 'Tristan und Isolde', 1896
Indian ink
7¼ × 6⅜ inches (18.6 × 16.4 cm)
(Reproduced larger than actual size)
Courtesy of the Trustees of the Victoria and Albert Museum, London

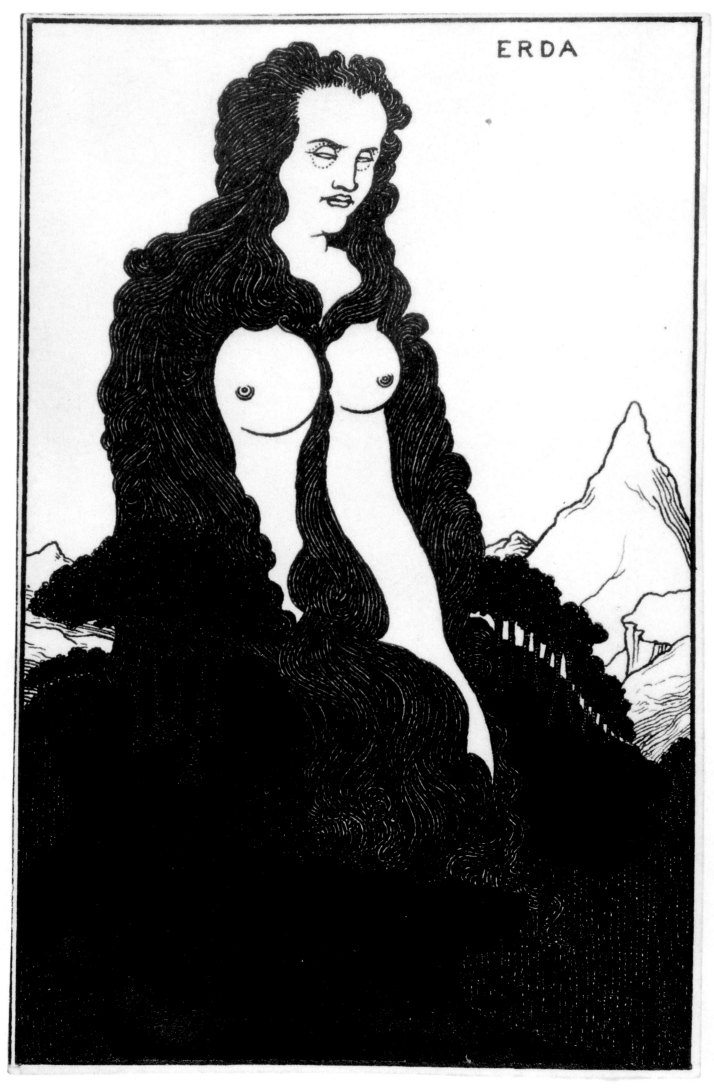

ERDA

Erda, 1896
Indian ink
5⁷⁄₁₆ × 3½ inches (13.8 × 8.9 cm)
Courtesy of the Trustees of the British
Museum, London

**Lysistrata Shielding her
Coynte,** 1896
10¼ × 7 inches (26 × 17.8 cm)
Indian ink
Courtesy of the Trustees of the Victoria
and Albert Museum, London

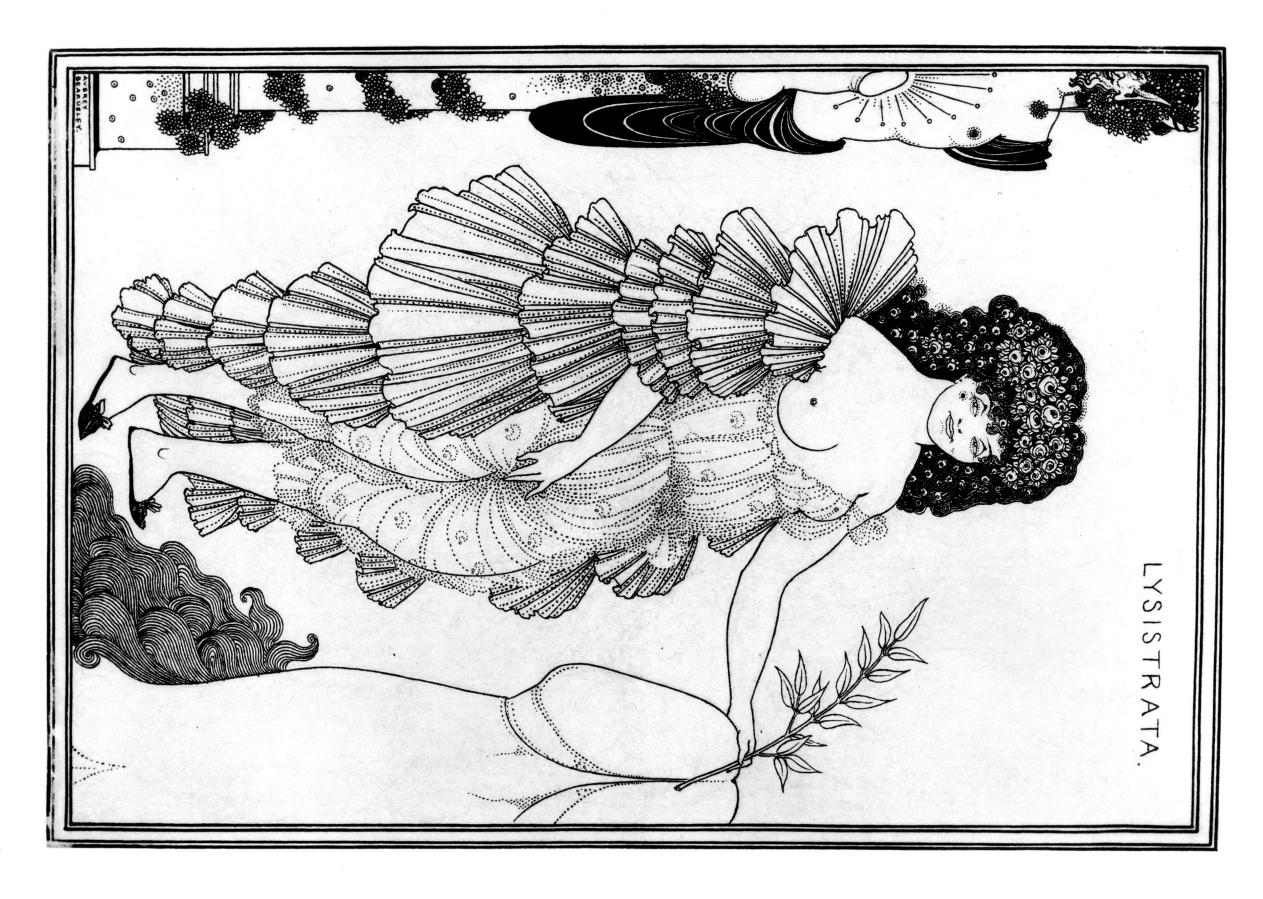

LYSISTRATA.

Second Frontispiece to 'An Evil Motherhood', 1896
From the line-block
Courtesy of the Trustees of the Victoria and Albert Museum, London

Lysistrata Haranguing the Athenian Women, 1896
Indian ink
10¼ × 7 inche s(26 × 19.8 cm)
(Reproduced larger than actual size)
Courtesy of the Trustees of the Victoria and Albert Museum, London

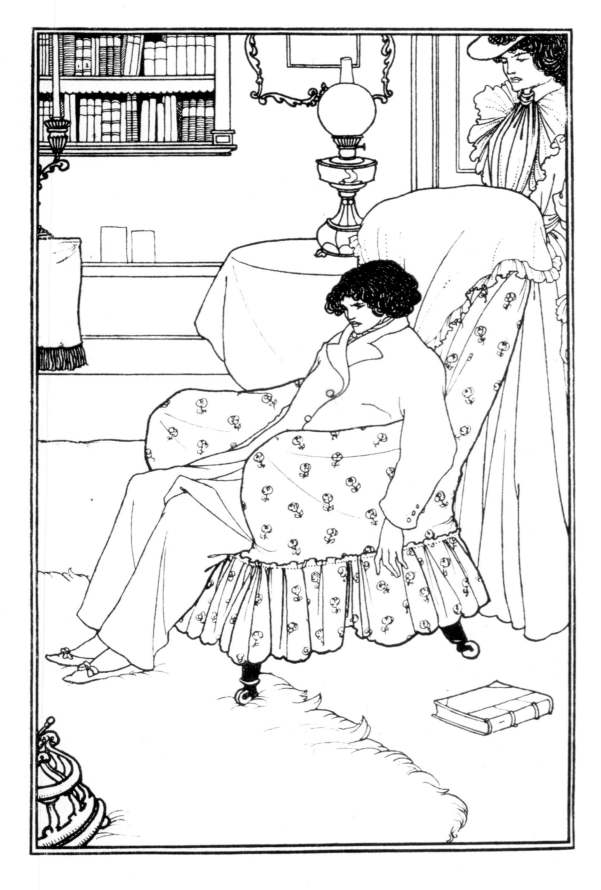

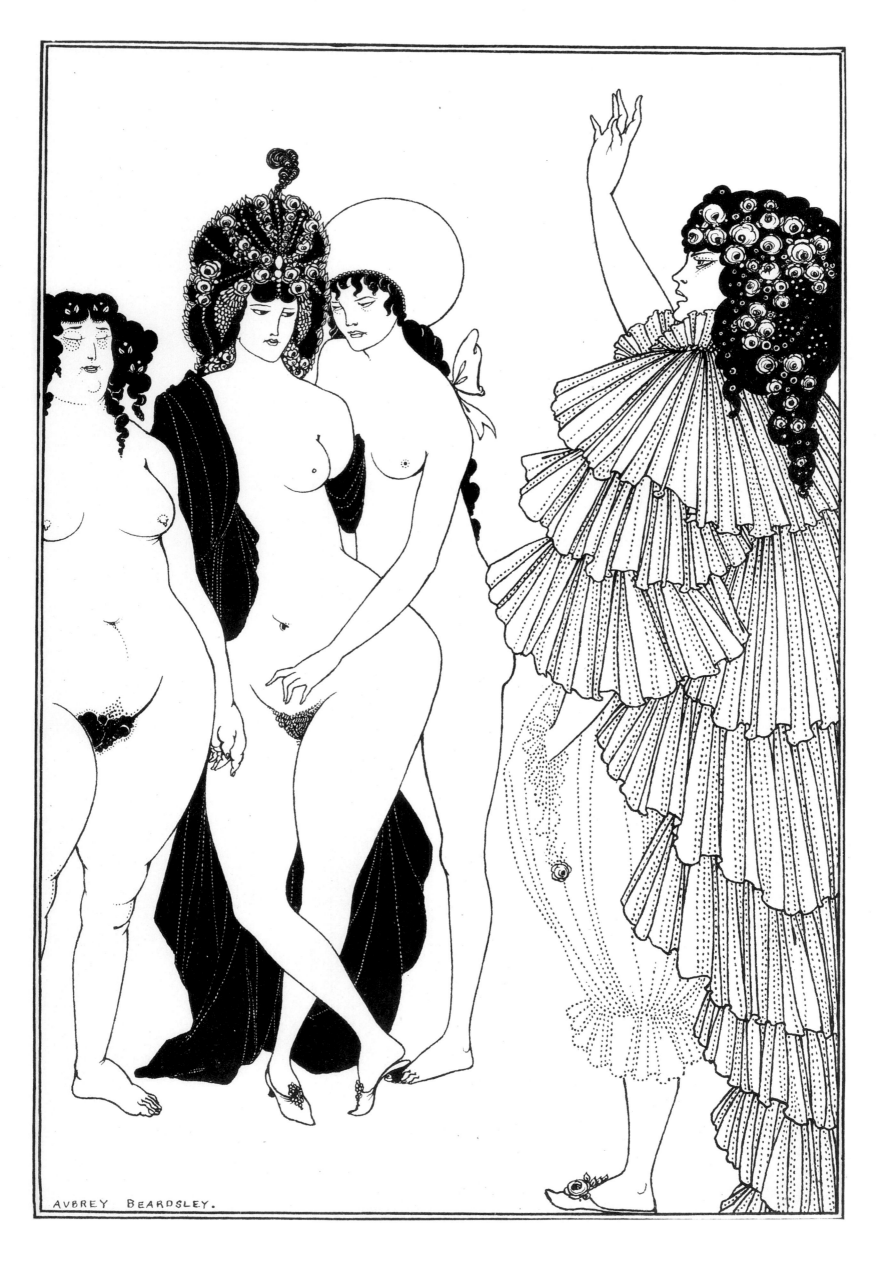

AVBREY BEARDSLEY.

**Design for the Front Cover
of 'The Rape of the Lock',**
1896
Indian ink
9⅞ × 6¹⁵⁄₁₆ inches (25 × 17.6 cm)
Courtesy of the Trustees of the Victoria
and Albert Museum, London

**Lysistrata Defending the
Acropolis,** 1896
Indian ink with traces of pencil
10¼ × 7 inches (26 × 17.8 cm)
(Reproduced larger than actual size)
Courtesy of the Trustees of the Victoria
and Albert Museum, London

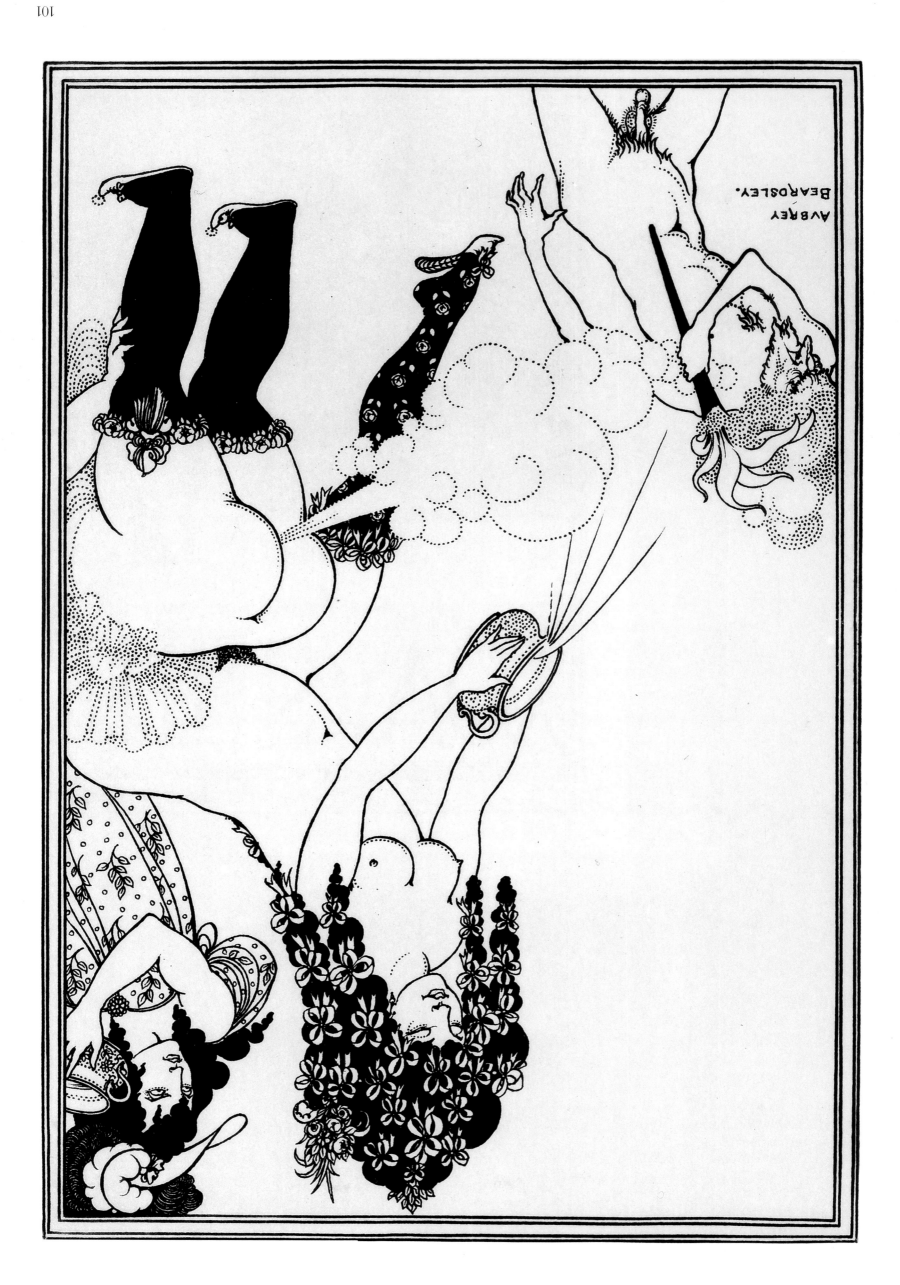

Front Cover of 'The Savoy',
1896
Pink boards stamped with design and
title in black
Courtesy of the Trustees of the Victoria
and Albert Museum, London

**Cinesias Entreating
Myrrhina to Coition,** 1896
Indian ink
10 × 7 inches (26 × 18 cm)
(Reproduced larger than actual size)
Courtesy of the Trustees of the Victoria
and Albert Museum, London

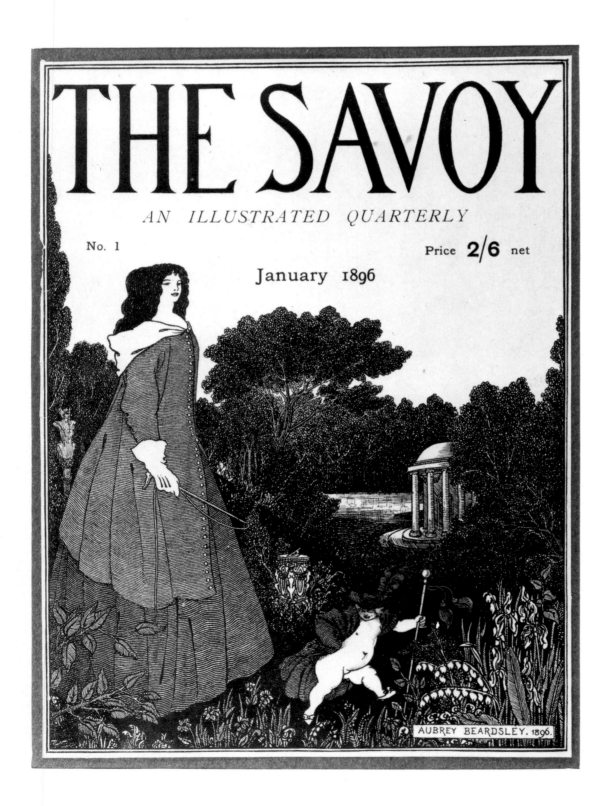

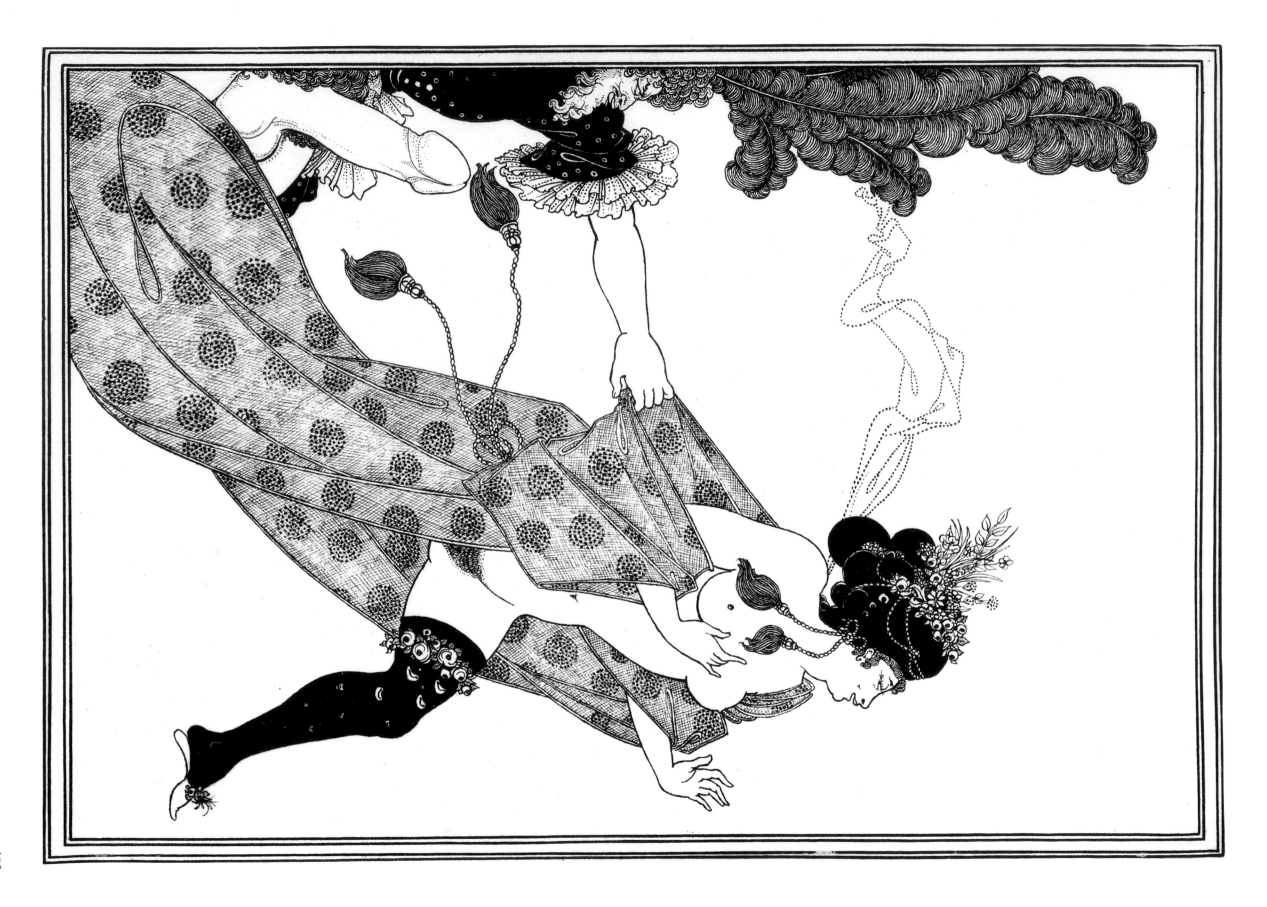

Virgin and Child, 1896
Christmas card inserted in *The Savoy*,
no. 1
From the line-block
Courtesy of the Trustees of the Victoria
and Albert Museum, London

**Frontispiece to 'The Pierrot
of the Minute',** 1897
From the line-block
Courtesy of the Trustees of the Victoria
and Albert Museum, London

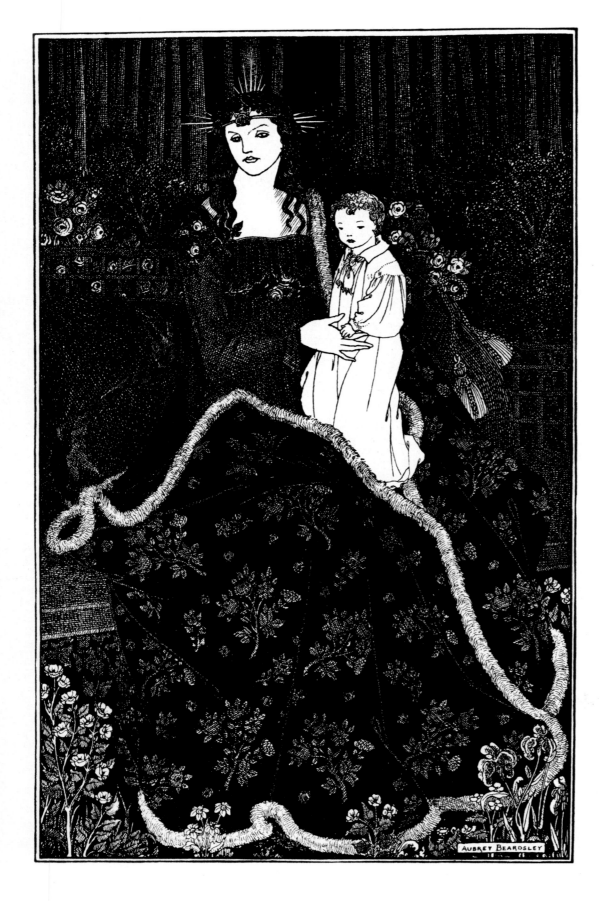

AUBREY BEARDSLEY

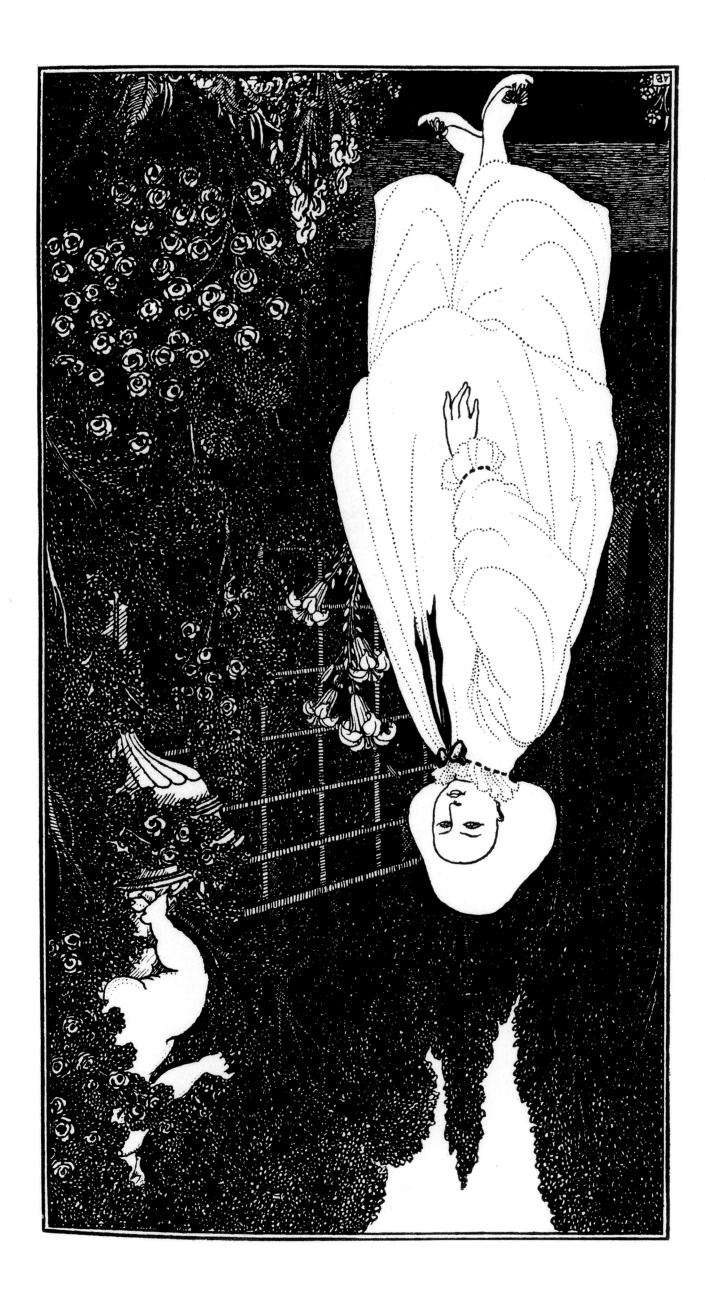

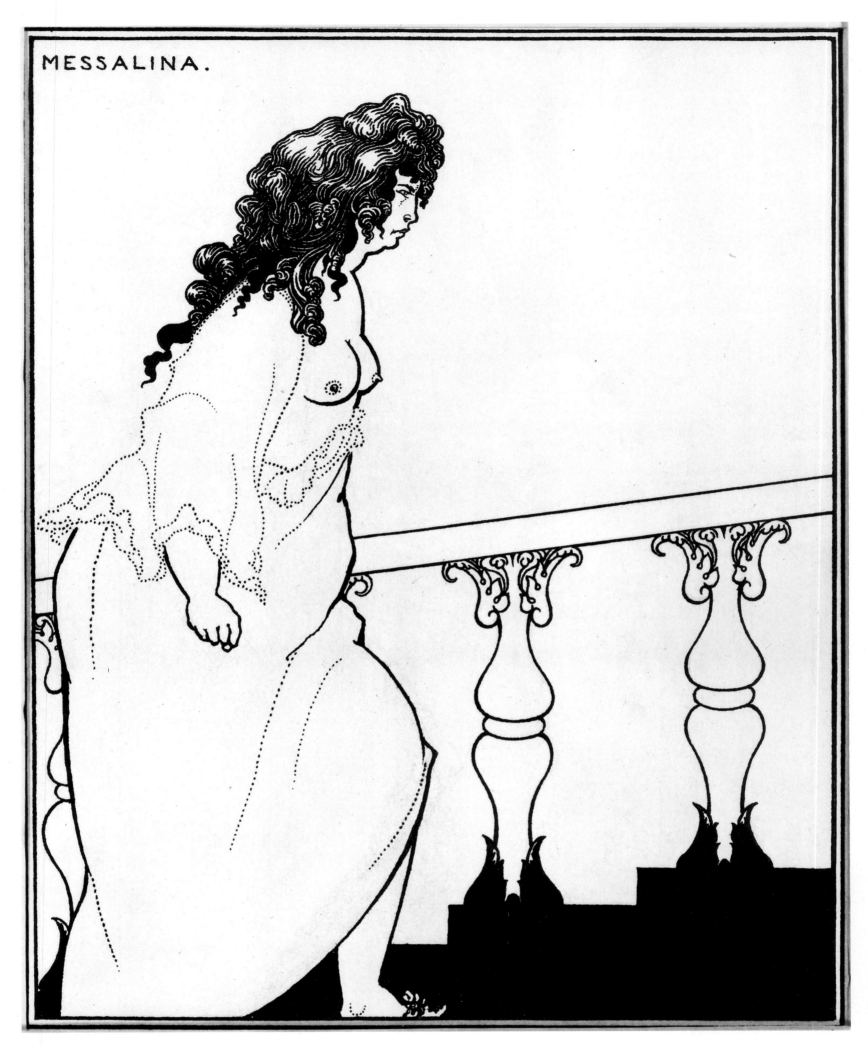

MESSALINA.

**Messalina Returning from
the Bath,** 1897
Indian ink
6⅞ × 5⅝ inches (17½ × 14¼ cm)
(Reproduced larger than actual size)
Courtesy of the Trustees of the Victoria
and Albert Museum, London

**Front cover of 'The Houses
of Sin' by Vincent
O'Sullivan,** 1897
Published by Leonard Smithers,
London
Courtesy of the Trustees of the Victoria
and Albert Museum, London

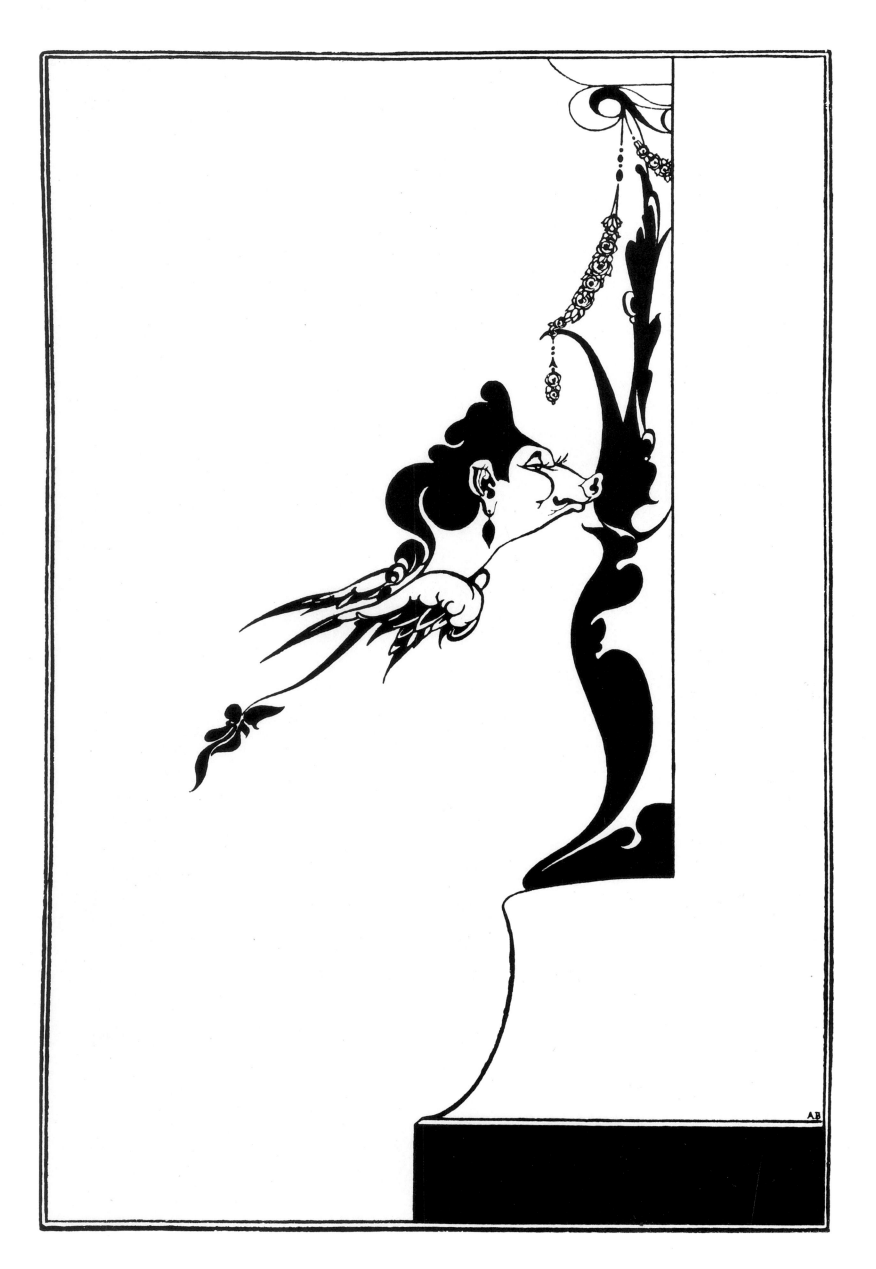

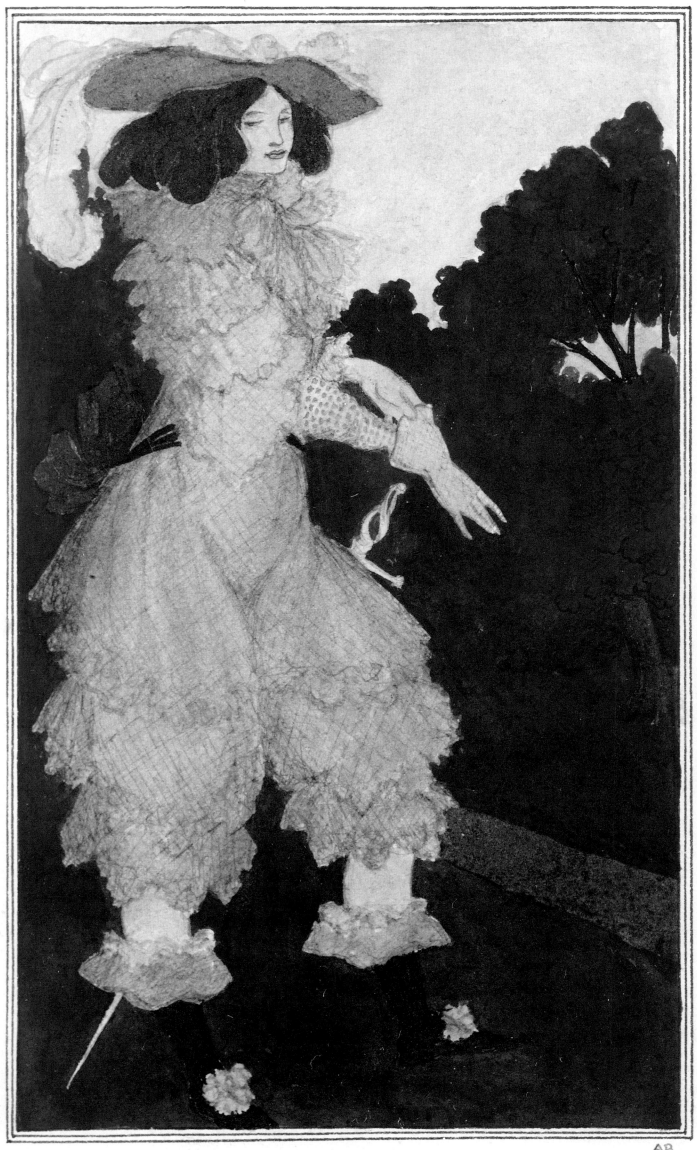

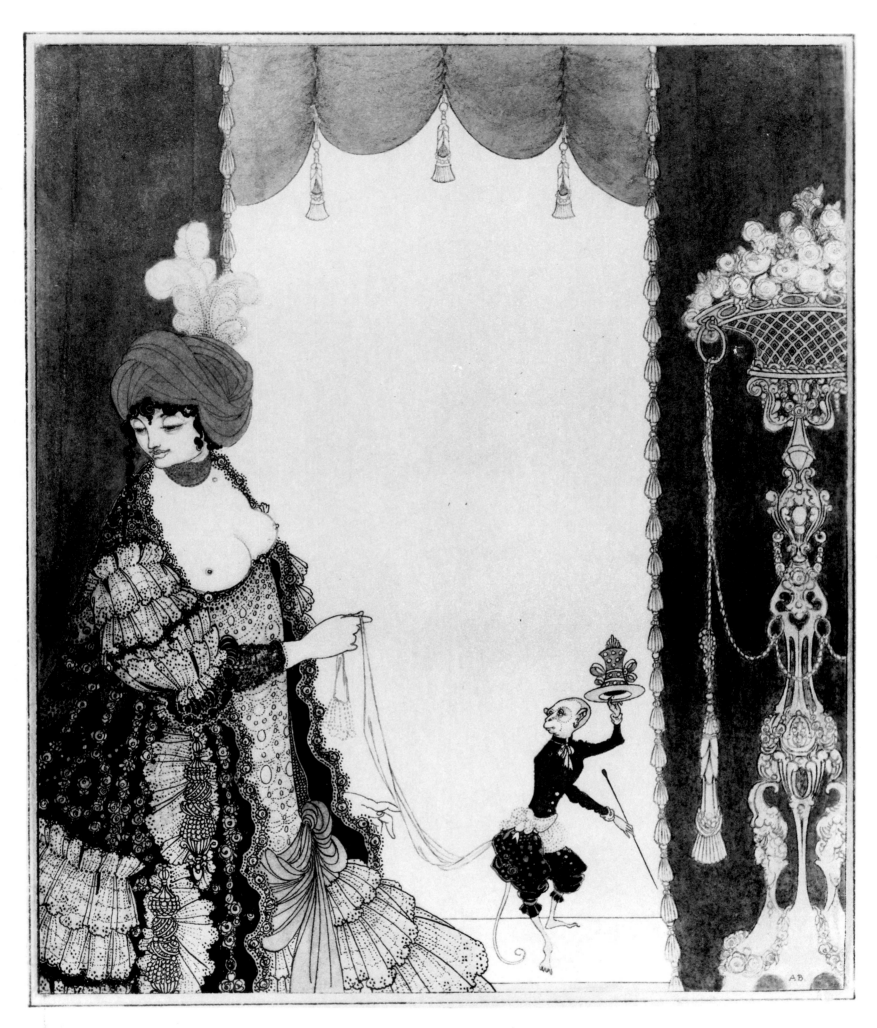

Drawing for the Frontispiece of 'Mademoiselle de Maupin',
1897
Pen, ink, green and pink watercolor
Fogg Art Museum, Harvard
University, Cambridge, Massachusetts,
Grenville L Winthrop Bequest

The Lady with the Monkey,
c. 1897
Drawing illustrating *Mademoiselle de Maupin* by Théophile Gautier
Pen, ink and wash
7⅞ × 6⅝ inches (20.1 × 17 cm)
(Reproduced larger than actual size)
Courtesy of the Trustees of the Victoria
and Albert Museum, London

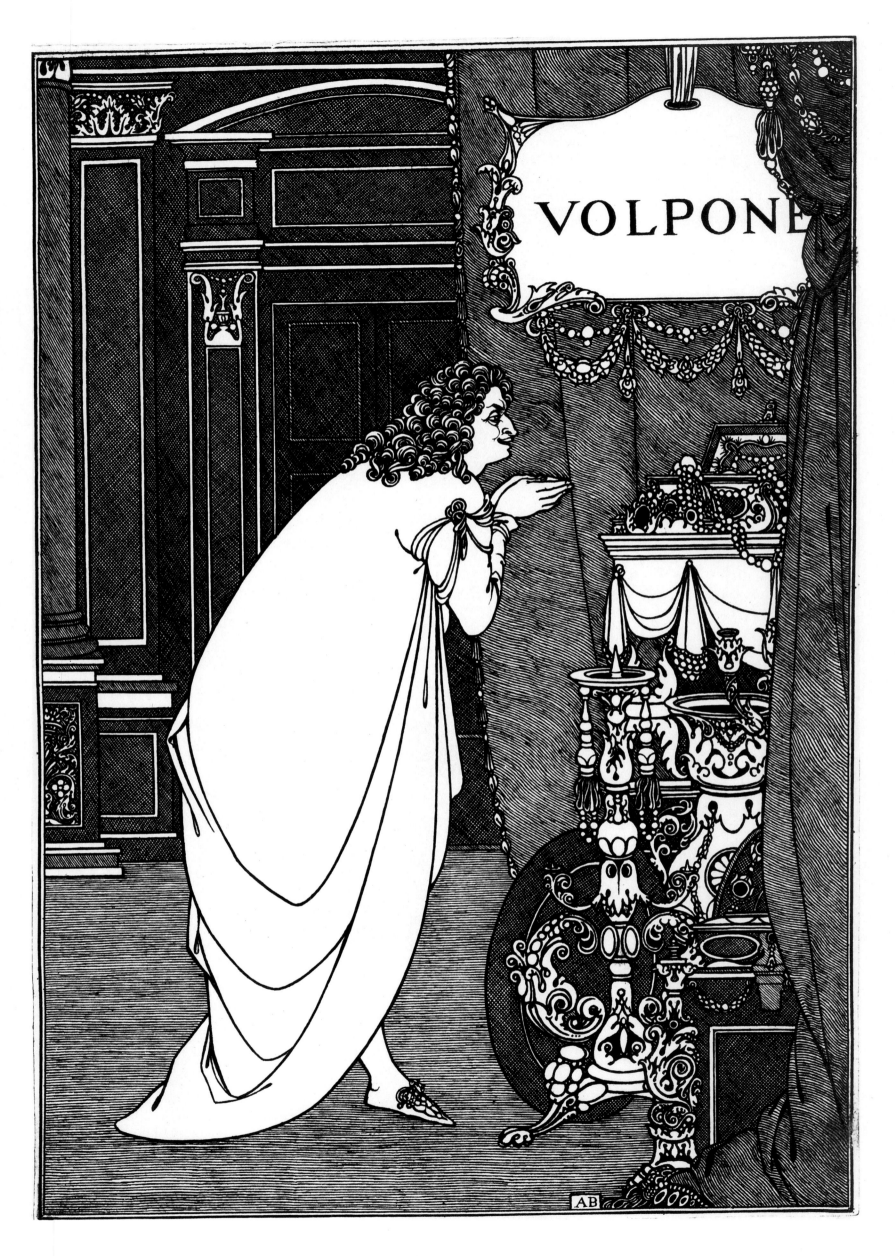

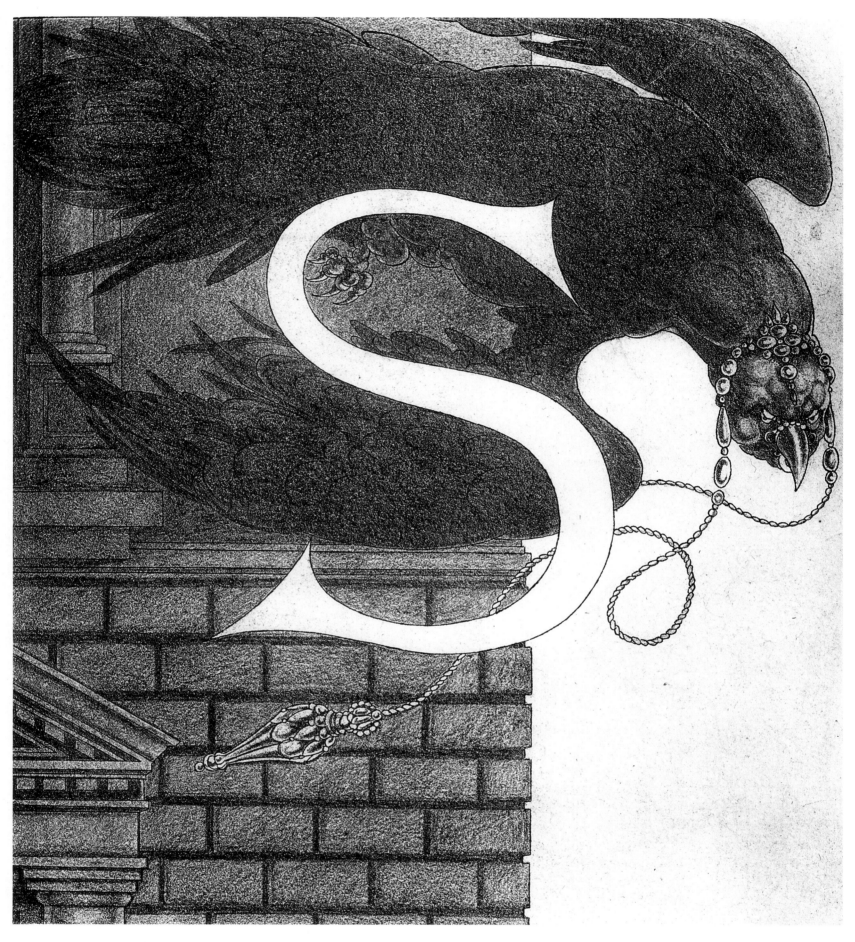

Volpone Adoring his
Treasures, 1898
Pen, ink, and pencil
4¹¹⁄₁₆ × 6⅝ inches (11.9 × 16.8 cm)
Princeton University Library

Design for the initial 'S,'
'Volpone', 1898
Pen, ink and pencil
6¹⁵⁄₁₆ × 6¼ inches (17.7 × 16 cm)
(Reproduced larger than actual size)
Fogg Art Museum, Harvard
University, Cambridge, Massachusetts
Grenville L Winthrop Bequest

Acknowledgments

The publisher would like to thank Cathy Shilling who designed this book, and Sara Antonecchia, the picture researcher. We would also like to thank the following agencies, institutions, and individuals for supplying the illustrations.

The Art Institute of Chicago: pages 34-35 (Deering Collection 1927.1624), 46 (Gift of Robert Allerton)

Barber Institute of Fine Arts, University of Birmingham: page 84

Formerly Bonham's, London/Bridgeman Art Library: page 76

Courtesy of the Trustees of the British Museum, London: pages 7 (right), 8 (right), 26 (right), 55, 96

Cecil Higgins Art Gallery, Bedford: page 78

The Cleveland Museum of Art: page 87 (Dudley P Allen Fund, 53.136)

Reproduced by Permission of the Syndics of the Fitzwilliam Museum, Cambridge: pages 40, 90

Fogg Art Museum, Harvard University Art Museums, Cambridge, Massachusetts: 1, 17, 47, 53, 56, 70, 73, 74, 89, 108, 111 (all Bequest of Grenville L Winthrop), 33, 43 (both Bequest of Scofield Thayer)

Courtesy of the Freer Gallery of Art, Smithsonian Institution, Washington DC: pages 10, 12

International Museum of Photography at George Eastman House: page 24

Musée Gustave Moreau, Paris: Page 18

Museum of Art, Rhode Island School of Design: page 94 (Museum Appropriation)

Princeton University Library: page 14 (below), 28, 30-31, 32, 51, 57, 110

Private Collection: pages 6, 7 (left), 8 (top), 11, 15 (above, above right and right), 19 (above), 20 (both), 21 (below), 22 (left), 38, 44, 93

Private Collection/Bridgeman Art Library: pages 2, 39, 60, 69, 79

Tate Gallery, London: pages 9, 16, 59, 63, 64, 65, 66, 81

Courtesy of the Trustees of the Victoria and Albert Museum, London: pages 13, 15 (below right), 19 (below), 20 (above), 22 (right), 23, 25, 26 (left), 29, 36-37, 41, 42, 45, 50, 52, 54, 62, 67, 71, 72, 74, 77, 80, 82-83, 84-85, 86, 91, 92, 95, 97, 98, 99, 100, 101, 102, 103, 104, 105, 106, 107, 109 /**Bridgeman Art Library:** page 61

William Morris Gallery, Walthamstow: page 14 (above)

Extracts from Beardsley's letters are from *The Letters of Aubrey Beardsley*, eds H Maas, J L Duncan, and W G Good (Cassell, London, 1971; © Henry Maas, J L Duncan and W G Good)